Accessible Filmmaking

Translation, accessibility and the viewing experience of foreign, deaf and blind audiences has long been a neglected area of research within film studies. The same applies to the film industry, where current distribution strategies and exhibition platforms severely underestimate the audience that exists for foreign and accessible cinema. Translated and accessible versions are usually produced with limited time, for little remuneration, and traditionally involving zero contact with the creative team.

Against this background, this book presents accessible filmmaking as an alternative approach, integrating translation and accessibility into the filmmaking process through collaboration between translators and filmmakers. The book introduces a wide notion of media accessibility and the concepts of the global version, the dubbing effect and subtitling blindness. It presents scientific evidence showing how translation and accessibility can impact the nature and reception of a film by foreign and sensory-impaired audiences, often changing the film in a way that filmmakers are not always aware of. The book includes clips from the award-winning film *Notes on Blindness* on the Routledge Translation Studies Portal, testimonies from filmmakers who have adopted this approach, and a presentation of the accessible filmmaking workflow and a new professional figure: the director of accessibility and translation.

This is an essential resource for advanced students and scholars working in film, audiovisual translation and media accessibility, as well as for those (accessible) filmmakers who are not only concerned about their original viewers, but also about those of the foreign and accessible versions of their films, who are often left behind.

Pablo Romero-Fresco is Ramón y Cajal researcher at Universidade de Vigo (Spain) and Honorary Professor of Translation and Filmmaking at the University of Roehampton (London, UK). He is also a filmmaker and the leader of GALMA (Galician Observatory for Media Accessibility).

This research has been conducted within the frameworks and with the support of the EU-funded projects ILSA: Interlingual Live Subtitling for Access (2017-1-ES01-KA203-037948) and EASIT: Easy Access for Social Inclusion Training (2018-1-ES01-A203-050275), the Spanish-government-funded projects Inclusión Social, Traducción Audiovisual y Comunicación Audiovisual (FFI2016-76054-P) and EU-VOS. Intangible Cultural Heritage. For a European Programme of Subtitling in Non-hegemonic Languages (Agencia Estatal de Investigación, ref. CSO2016-76014-R) and the Galician-government-funded project Proxecto de Excelencia 2017 Observatorio Galego de Accesibilidade aos Medios.

Accessible Filmmaking

Integrating translation and accessibility into the filmmaking process

Pablo Romero-Fresco

Routledge
Taylor & Francis Group

LONDON AND NEW YORK

First published 2019
by Routledge
2 Park Square, Milton Park, Abingdon, Oxon OX14 4RN

and by Routledge
52 Vanderbilt Avenue, New York, NY 10017

Routledge is an imprint of the Taylor & Francis Group, an informa business

British Library Cataloguing-in-Publication Data
A catalogue record for this book is available from the British Library

Library of Congress Cataloging-in-Publication Data
Names: Romero-Fresco, Pablo, author.
Title: Accessible filmmaking: integrating translation and
 accessibility into the filmmaking process / Pablo Romero-Fresco.
Description: London; New York, NY: Routledge, 2019. | Includes
 bibliographical references and index. |
Identifiers: LCCN 2018056629 (print) | LCCN 2019006933
 (ebook) | ISBN 9780429053771 (eBook) | ISBN 9781138493001
 (hardback) | ISBN 9781138493018 (pbk.)
Subjects: LCSH: Motion pictures—Titling. | Dubbing of motion
 pictures.
Classification: LCC PN1995.9.T685 (ebook) | LCC PN1995.9.T685
 R66 2019 (print) | DDC 777/.55—dc23
LC record available at https://lccn.loc.gov/2018056629

ISBN: 978-1-138-49300-1 (hbk)
ISBN: 978-1-138-49301-8 (pbk)
ISBN: 978-0-429-05377-1 (ebk)

Typeset in Goudy
by Apex CoVantage, LLC

Visit the Routledge Translation studies portal: http://cw.routledge.
com/textbooks/translationstudies

Contents

Abbreviations

AD Audio description
AFM Accessible filmmaking
AVT Audiovisual translation
CPS Characters per second
DAT Director of accessibility and translation
MA Media accessibility
SDH Subtitling for the deaf and hard of hearing.
TS Translation studies
WPM Words per minute.

Contributors

Author: Pablo Romero-Fresco

Pablo Romero-Fresco is a Ramón y Cajal researcher at Universidade de Vigo (Spain) and Honorary Professor of Translation and Filmmaking at the University of Roehampton (London, UK). He is the author of the book *Subtitling Through Speech Recognition: Respeaking* (Routledge) and the editor of *The Reception of Subtitles for the Deaf and Hard of Hearing in Europe* (Peter Lang). He is currently working with several governments, universities, companies and user associations around the world (including the British, Canadian and Spanish governmental regulators and the British Film Institute) to integrate translation and accessibility into the filmmaking process and to improve access to live events for people with hearing loss. His *Accessible Filmmaking Guide* is being used by many international public broadcasters and producers to introduce a more inclusive and integrated approach to translation and accessibility in the filmmaking industry. He is the leader of the international research centre GALMA (Galician Observatory for Media Accessibility), for which he has been coordinating several international projects on media accessibility and accessible filmmaking, such as "ILSA: Interlingual Live Subtitling for Access". Pablo is also a filmmaker. His first documentary, *Joining the Dots* (2012), was screened during the 69th Venice Film Festival as well as at other festivals in London, Poland, France, Switzerland and Austria and was used by Netflix as well as schools around Europe to raise awareness about audio description.

Collaborators: Louise Fryer and Josh Branson

Dr Louise Fryer is one of the UK's most experienced describers. She has described at the National Theatre since it started offering AD in 1993. For the BBC, she helped develop the pilot TV Audio Description Service (AUDETEL). She has described films and was the accessibility advisor for the BAFTA-nominated *Notes on Blindness* (Midleton/Spinney 2016). She also helps companies interested in developing integrated approaches for live performance. She is a Senior Teaching Fellow at University College London (UCL). Her company, Utopian Voices Ltd., is a partner in the Erasmus+ funded research

project ADLAB-PRO, creating an online curriculum and teaching resources for AD trainers. Louise is the author of *An Introduction to Audio Description: A Practical Guide* (Routledge). Louise has written the content on audio description included in this book (Sections 3.7 and 4.4.7).

Joshua Branson is a PhD student at the University of Roehampton (UK), where his research focuses on accessible filmmaking and the role of director of accessibility and translation, as applied to the film *Chaplin* (Middleton & Spinney, 2019). He holds a BA in European Studies and Modern Languages (Spanish and Italian) from the University of Bath (UK), an MA in Audiovisual Translation from the University of Roehampton, and he is a member of the Galician Observatory for Media Accessibility. In 2018 he was awarded a special commendation from the Institute of Translation and Interpreting in the Best Academic Research category for his MA dissertation on accessible filmmaking. He has presented papers on accessible filmmaking at conferences in Germany, Poland, Spain and the UK, and his research interests also include eye tracking and integrated (sub)titles. Alongside his academic research he also works as a subtitler, translating from Italian into English and creating intralingual subtitles for English-language films. Josh has co-authored Chapter 5 in this book.

Kate Dangerfield is a PhD student at the University of Roehampton and a member of GALMA (Galician Observatory for Media Accessibility). Her research is practice-based and focuses on accessible filmmaking. For the practice element of her research, Kate designed and delivered The Accessible Filmmaking Project in collaboration with Sense, a UK disability charity that supports people with complex communication needs including those who are deafblind. The project was funded by the British Film Institute. She has presented her research at academic conferences in Italy, Germany, Poland, Spain, Sweden and the UK, and a short film about the project was screened at the Victoria and Albert Museum in London as part of the Open Senses festival. Other accessible filmmaking projects have included the documentary *A Grain of Sand*, collaborations with Sense and Studio Wayne McGregor, Open Senses festival, Marcus Innis and Moorfields Eye Hospital, BitterSuite, the Centre for Voluntary Sector Leadership (Open University) and PAL.TV, and the multisensory book launch of *A Blind Bit of Difference*. Kate has contributed to Chapter 2 in this book, especially with the distinction between access to content and access to creation.

Acknowledgements

This book brings together two of my biggest passions, film and language, which means that I have probably been writing it or thinking about it for many years now.

I first thought of accessible filmmaking sometime in 2012, as I was taking the MA in Filmmaking at Kingston University, in London. My thanks go to the teaching staff there, and especially to the late Mick Kennedy for his insightful lectures and to Roy Perkins for his wisdom and generosity.

My first attempt to apply accessible filmmaking in practice was in the short documentary *Joining the Dots* (2012), thanks to the support of my fellow film-makers and friends Geetika Sood, Panagiotis Papantonopoulos, Linda Koncz and Martina Trepczyk, and to the generosity of the participants in the film, especially Joan Greening and Max and Trevor Franklin.

The second attempt was in the slums of Kibera (Nairobi, Kenya), where Martina Trepczyk, David Ruhmer, Panagiotis Papantonopoulos and I made the short films *Joel* and *Brothers and Sisters* with the support of, and with great admiration for, Abdul Kassim and everyone else at the Kibera Girls Soccer Academy. Thank you, Isabel Santaolalla, for opening this door for us. This would not have been possible without you.

The third and last attempt so far, in the feature-length documentary *Donde se acaba la memoria* (*Where Memory Ends*), leaves me personally and professionally indebted to Ian Gibson, Cheli Durán, Mike Dibb, Xacio Baño, Emilio, Fer and of course to David Ruhmer and Martina Trepzcyk.

None of this would have happened if I had not been granted a research leave at the University of Roehampton (London, UK), where I worked from 2008 to 2017 and where I wrote most of the book. I still have a family there that I miss: Lucile Desblache, Dionysis Kapsaskis, Andy Walker, Miguel Bernal-Merino, Inma Pedregosa, Lourdes Melcion, Elvira Antón, Isabel Santaolalla, Vicens Colomer, Annabelle Mooney, Martina Kutame, Tope Omoniyi, Eva Eppler, Susie Hyde, Ana Acevedo, Karine Chevalier, Mark Jary, Jane Davies, William Brown, Caroline Bainbridge, Richard Keogh, Peter Evans, Mike Witt, Andrea Esser, Jeremy Bubb and Ian Shand. Thank you all for being such great colleagues.

Also in London, my warmest thanks to María, Nacho, Greg, Scott, Emily and Finn for sharing all this with me and for their friendship.

I am really grateful to all my students and to the colleagues who have believed in accessible filmmaking and have taken their time to support, disseminate, criticise or improve the content of this book: Jo-Jo Ellison, Frederic Chaume, Aline Remael, Jorge Díaz-Cintas, Giselle Spiteri Miggiani, Elena di Giovanni, Agnieszka Szarkowska, Carlo Eugeni, Pilar Orero, Eliana Franco, Anna Jankowska, Jan-Louis Kruger, Charlotte Bosseaux, Maria Pavesi, Carole O'Sullivan, Joselia Neves, Patrick Zabalbeascoa, Mara Campbell, Liliana Tavares, Daniela Trunfio, Ken Loach, Alastair Cole, James Spinney and Tim Middleton.

A special mention goes to Max Deryagin, Sean Zdenek and Wendy Fox for their inspiring work, to Fede Spoletti for his constant support and particularly to Louise Fryer, for coming on board from the very beginning and for writing the sections of the book devoted to audio description.

The book has been finished back home, in Galicia, where I have been fortunate to have the support of Pepe Coira, Alfonso Pato, Xaime Varela and Margarita Ledo. Here, I could not be more grateful to my new academic family (which was also the first one back in 1999, when I was an undergraduate student), Lourdes Lorenzo, Ana Pereira and Luis Alonso, and to the whole GALMA team, especially Pedriño, Sofía, Naza, Tanja, Zoe and Hayley. I'm particularly grateful to Josh, co-author of Chapter 5, for turning theory into practice, and to Kate, whose work inspired Chapter 2, for taking accessible filmmaking to a whole new level.

A final word of gratitude goes to Gian Maria Greco, for hours and hours of conversations and for his rigour and unyielding commitment to the accessibility cause.

This book is dedicated to…

everyone I haven't remembered to mention.
the film viewers who are generally forgotten by filmmakers.
the accessible filmmakers who are willing to keep them in mind.

my family and especially my mum, who introduced me to cinema.
Ángel Fernández-Santos, who taught me how to watch films.

Brais and Uxía -without you, this book would have probably been finished in half the time and with twice as much sleep, but I wouldn't be anywhere near as happy as I am now.

Most of all, this book is dedicated to Sabe, por darlle sentido a todo.

Saudiña,
Pablo Romero-Fresco
Vigo, 2019

Chapter 1

Introduction
The end of a long divorce

1.1 The divorce

More than 120 years after it was born, film has evolved immensely, turning into one of the leading artistic modes of our times. Over this period, film has borrowed from, and in some cases even claimed ownership over, different areas that are now essential in the production of films, such as photography, design, animation, technology, etc. Translation and accessibility are exceptions to this rule. In an increasingly diverse and multilingual world, translating films and making them accessible for audiences with sensory impairments is an essential requirement, yet film translation is much less visible now than when it was first used at the beginning of the 20th century. Back then, even before sound was introduced in cinema, when the intertitles used in silent film had to be translated, translation was included within the post-production stage and it was thus part of the film-making process (Izard, 2001, p. 190). The production of the first talkies brought about the first unsuccessful attempts at dubbing and subtitling and, subsequently, a new solution: the so-called "multiple-language versions" (Vincendeau, 1988), also known as "multilinguals" or "foreign language versions" (Ďurovičová, 1992). Films were made and remade in 2 or 3 languages by the same director and sometimes in up to 14 languages with a different director for each language version. The cast could remain the same or change depending on the film and the number of versions to be produced (Vincendeau, 1999, pp. 208–209). Translation was then at the very core of the production process. However, once dubbing and subtitling techniques improved, studios opted for these modes, which would reduce the cost of their translations to some 10% of the film budget. Increasingly outsourced and unsupervised by filmmakers, translations lost their status as part of the filmmaking process and became part of the distribution process, as is the case now. The divorce between film and translation/accessibility was consummated, and it is now visible in training, research and professional practice.

Indeed, most film courses, whether offered at universities or at film schools, ignore film translation, just as most audiovisual translation (AVT) courses do not include training on filmmaking (Romero-Fresco, 2019). Similarly, film studies is now an established area of research that looks at the narrative, artistic, cultural, economic and

political implications of film, while building bridges with media, cultural, television or gender studies. However, in over 100 years of life, the discipline has not yet explored in detail what happens when films are translated and made accessible or analysed the experience of foreign or sensory-impaired viewers.[1] But nowhere is this divorce more evident than in the professional practice, where translation and accessibility have become an afterthought in the filmmaking process. Unlike other important elements in film, translation and accessibility are not supervised or controlled by the filmmaker or the creative team, which means that foreign, deaf and blind audiences are simply not considered in this process.

The numbers tell a sad story. As can be seen in Tables 1.1 and 1.2, more than half of the revenue obtained by the top-grossing and Best Picture Oscar-winning films from the beginning of the 21st century come from foreign markets.

Leaving out those English-speaking countries where these films are shown in their original versions (Australia, UK, etc.), the dubbed and subtitled versions provide an average of 45% of a film's total revenue, to which one would need to

Table 1.1 Domestic and overseas revenue as percentage of total gross for top-grossing films (2001–2017); percentage of total revenue generated by dubbed or subtitled prints.

Film	Foreign gross	Domestic gross	Total revenue dubbed/subtitled
Harry Potter and the Sorcerer's Stone (2001)	67.4%	32.6%	56.4%
Spider-Man (2002)	50.9%	49.1%	43%
The Lord of the Rings: The Return of the King (2003)	66.3%	33.7%	53.1%
Shrek 2 (2004)	52%	48%	38%
Star Wars: Episode III (2005)	55.2%	44.8%	43.2%
Pirates of the Caribbean: Dead Man's Chest (2006)	60.3%	39.7%	48.2%
Spider-Man 3 (2007)	62.2%	37.8%	52.2%
The Dark Knight (2008)	56.8%	63.2%	33.7%
Avatar (2009)	72.7%	27.3%	63.5%
Toy Story 3 (2010)	61%	39%	46.3%
Harry Potter and the Deathly Hallows: Part 2 (2011)	71.3%	28.7%	58.8%
The Avengers (2012)	59%	41%	49.8%
The Hunger Games: Catching Fire (2013)	50.9%	49.1%	40.3%
American Sniper (2014)	36%	64%	29.4%
Star Wars: The Force Awakens (2015)	54.7%	45.3%	43.4%
Rogue One: A Star Wars Story (2016)	49.6%	51.4%	38.2%
Beauty and the Beast (2017)	61.1%	38.9%	49.8%
Average	**58.1%**	**41.9%**	**46.31%**

Table 1.2 Domestic and overseas revenue as percentage of total gross for Best Picture Oscar winners (2000–2017); percentage of total revenue generated by dubbed or subtitled prints.

Film	Foreign gross	Domestic gross	Total revenue dubbed/subtitled
A Beautiful Mind (2001)	45.5%	54.5%	38.2%
Chicago (2002)	44.4%	55.6%	32%
The Lord of the Rings: The Return of the King (2003)	67.3%	32.7%	53.1%
Million Dollar Baby (2004)	53.6%	46.4%	46%
Crash (2005)	44.5%	55.5%	31.6%
The Departed (2006)	54.3%	45.7%	42.2%
No Country for Old Men (2007)	56.7%	43.3%	45.3%
Slumdog Millionaire (2008)	62.6%	37.4%	44.6%
The Hurt Locker (2009)	65.4%	34.6%	51.5%
The King's Speech (2010)	66.5%	33.5%	40.2%
The Artist (2011)	66.5%	33.5%	51.2%
Argo (2012)	41.5%	58.5%	30.4%
12 Years a Slave (2013)	69.8%	30.2%	48.3%
Birdman (2014)	59%	41%	46%
Spotlight (2015)	49%	51%	34.5%
Moonlight (2016)	57.2%	42.8%	46%
Average	**56.5%**	**43.5%**	**43%**

add the accessible versions screened for deaf and blind audiences both in the US and abroad. In other words, translation and accessibility account for almost half of the revenue obtained by these films. However, only around 0.1% of their budgets are devoted to translation and accessibility (Lambourne, 2012). Although from a financial point of view this seems like a very profitable business, there are both economic and artistic reasons to call for an urgent and much-needed change.

1.2 The damage: the maker–expert–user gap

Almost 40 years of research on AVT and media accessibility (MA) have shown that the relegation of translation and accessibility to a mere footnote in the film-making process has had a negative impact on films and their reception by foreign/deaf/blind viewers. This calls into question the extent to which their experience is as similar as it should be to that of the original film viewers. Some examples of this will be shown in Chapter 3. Filmmakers such as Ken Loach or Quentin Tarantino are now beginning to denounce that their vision is being altered in translation and that they have no say over this (or, even worse, no knowledge about it), as power is transferred to the distribution companies (de Higes, 2014). Meanwhile, despite their thorough and specialised training, audiovisual translators work

under very tight conditions, often having to translate a film in no more than three days for an average of £300 and with no access whatsoever to any of the people who have made the film. It is difficult to think of any other professional area in the film industry showing such a sharp contrast between its importance in the film and its working conditions. As a matter of fact, the latter are getting worse, while translation and accessibility are only becoming more important in an increasingly multicultural, ageing and diverse society in which:

- Multilingual films (i.e. films with several languages in their original version) are becoming more common, which means that there is a need to engage with translation even before the films are translated for foreign/accessible markets.
- There is an increasing presence of creative text on screen to convey digital text-based communication, so unless translation is also approached creatively at the post-production level, the experience of original and translation viewers will be dramatically different.
- Foreign/deaf/blind viewers can access the original version and compare it with the translated/accessible one, which makes the discrepancies more obvious.
- Recent experimental research on film shows that contemporary filmmakers are using cinematic tools to exert more control over the viewers' attention, an aim that only applies to the viewers of original films (Cutting, Brunick, DeLong, Iricinschi, & Candan, 2011). Once again, foreign and sensory-impaired viewers are excluded from this trend, which means that the gap between the experience of original and translation viewers is widening.

A pessimistic view of this current landscape can lead to the belief that no improvement is possible, since most filmmakers do not care about translation and accessibility. However, it may just be that most filmmakers are simply unaware of the extent to which their films change in translation, and are thus not given the chance to care about this aspect of their films. Admittedly, whether or not they know about it, the fact remains that they are to some extent neglecting their foreign/sensory-impaired audience by abdicating responsibility to translators who are neither trained nor paid for making key decisions that can have a significant impact on the nature and reception of the translated/accessible film.

This is closely related to what Greco (2013) defines as the maker–user gap, that is, a "multifaceted gap that can exist between those who make and those who use an artefact". More specifically in the case of MA, Greco (ibid., 2018) refers to the maker–expert–user gap, which is adapted by Branson (2018) to the area of filmmaking, as shown in Figure 1.1.

Branson's figure points to the existence of three different gaps in the current way in which translation and MA are approached. Firstly, as explained above, the relegation of MA and translation as an afterthought in the distribution process means that there is a disconnect between those creating

Figure 1.1 Greco's maker-expert-user gap, as adapted by Branson (2018).

films and those producing translated and accessible versions. Translators and MA professionals typically do not have access to the creative team, hence the first gap between filmmakers and MA professionals. Secondly, filmmakers have no control over the foreign and accessible versions of their films, no awareness of how their films are translated or rendered accessible or how they are received by foreign and sensory-impaired viewers, which leads to the second gap between filmmakers and sensory-impaired and foreign users. Finally, the third gap is between MA professionals and the viewers, because, with a few exceptions, sensory-impaired or foreign spectators are normally not involved in the production or testing of accessible versions. According to Greco (2013), these three gaps can be regarded as "ontological (maker and user are inherently different beings), epistemological (maker and user experience the world differently), linguistic-pragmatic (maker and user relate to each other in different ways) and ethical (maker and user respond to different ethical rules)".

1.3 A potential reconciliation: accessible filmmaking

Accessible filmmaking (AFM) aims to integrate AVT and accessibility into the filmmaking process, which requires the collaboration between the translator and the film's creative team. Put in another way, AFM is the consideration of translation and/or accessibility during the production of audiovisual media (normally through the collaboration between the creative team and the translator) in order to provide access to content for people who cannot access or who have difficulty

Figure 1.2 The maker–expert–user gap, as adapted in this book

accessing it in its original form. AFM does not aim to compromise the filmmakers' vision or constrain their freedom. Instead, it reveals to them often unknown aspects of how their films are changed in their translated and accessible versions. It also presents them with different options so that they can make choices that determine the nature of these translated/accessible versions. Until now, these choices were made exclusively by the translator or the distributor. Rather than compromising the filmmakers' vision, this collaboration will help to preserve it across different audiences. As will be seen in the examples included in this book, this not only improves the experience of the majority of viewers but also helps filmmakers to see their films through different eyes.

The aim of this book is to introduce AFM as a potential solution to bridge the above-mentioned maker–expert–user gap for those filmmakers who would like to ensure that their vision is maintained once their films are translated and made accessible.

As shown in Figure 1.2, the gap between filmmaking and AVT/MA and between the professionals working in these areas is addressed in Chapter 2, which presents a wider and more compatible notion of film studies and MA, and in Chapter 4, which articulates the discussion between filmmakers and MA experts. The gap between filmmakers and viewers is tackled in Chapter 3, which provides filmmakers with research-based information regarding how foreign and sensory-impaired viewers receive their films. Finally, Chapter 5 presents the cost and the workflow required for a film to adopt an AFM approach and introduces the role of the director of accessibility and translation, who may work with sensory-impaired consultants, thus helping to bridge the third gap between MA experts and sensory-impaired users.

Since it was first introduced, AFM has received the endorsement of renown filmmakers such as Ken Loach, institutions such as Ofcom and the British Film Institute (BFI) in the UK and the International Telecommunication Union, a specialized agency of the United Nations responsible for issues regarding information and communication technologies, which has singled it out as the way forward in terms of translation and accessibility. AFM has been incorporated into training, research and professional practice all over the world (see Section 2.3.3 in Chapter 2). Although this book includes examples from some of the documentaries and fiction films that have implemented this model, as well as testimonies from their directors (see Chapter 5), the "accessible filmmaker" targeted here is a much wider concept, encompassing any professional or amateur practitioner involved in the different stages of the filmmaking process. We are thus referring not only to directors, but also to scriptwriters, cinematographers, editors, text designers, etc. as well as to amateur filmmakers who may wish to upload a short film made with their phone to the Internet, bearing in mind not just the original audience but also the viewers of the translated and/or accessible version.

In other words, everyone who would like to make film for all.

Note

1 A few exceptions are MacDougall (1998), Egoyan (2004), Nornes (2007) or Eleftheriotis (2010).

Chapter 2

Setting the scene

In support of a wide notion of accessibility, translation and film

As mentioned in the introduction, despite the integral role played by translation and accessibility in film, AVT and film studies have traditionally been two worlds apart. By presenting a model that integrates translation and accessibility into the filmmaking process through collaboration between filmmakers and translators, AFM aims to bridge this gap, if only partially. This chapter covers the theoretical framework underlying AFM, which is based on a new and wide notion of AVT and film studies.

2.1 In support of a wide notion of accessibility and translation[1]

2.1.1 AVT and MA: a housing problem

The beginning of the 21st century, especially the end of its first decade, was a prolific period for research on AVT. The literature in the field included constant allusions to how this area was coming of age (Díaz Cintas, 2008a), often followed by accounts of what makes AVT distinct. Cases were made as to why AVT deserved to have a separate room, as it were, in the translation studies (TS) building, which, in turn, had managed to become independent from linguistics and comparative literature from the late 1950s onwards (Catford, 1965; Holmes, 1988; Nida, 1964; Vinay & Darbelnet, 1995). Ten years later, and largely thanks to the unrelenting development of technology, the pervasiveness of screens and changes in viewing habits, the same AVT scholars now refer to "the incipient maturity" of AVT (Díaz Cintas, J. & Neves, 2015, p. 3). They wonder whether AVT has "outgrown the limits" of TS (Díaz Cintas, J. & Neves, 2015, p. 2) and should perhaps act as the "connecting bridge" between TS and other fields of knowledge (Díaz Cintas, J. & Neves, 2015, p. 3). Although the consolidation of AVT may still be a few steps away (the recent launch of the *Journal of Audiovisual Translation* being an essential one), it could be argued that AVT is in the process of constructing its own building within the larger TS estate, with a room devoted to MA. But just as TS can hardly cope with the unrelenting

movement of AVT, it is worth considering whether the constant evolution of MA sits easily within the current margins of AVT.

From the very first publications about MA, this subarea within AVT has been concerned with modalities such as subtitling for the deaf and hard of hearing (SDH) and audio description (AD). This corresponds to the first of the three different accounts of MA that, according to Greco (2018), have been embraced over the years, in this case one that is specifically framed for persons with sensory disabilities. This first particularist account, as he labels it, has enabled deaf and blind user associations to acquire a leading role in the ongoing battle to increase the amount and quality of access services around the world. A second particularist account identified by Greco (2018) extends the scope of MA to both sensory and linguistic barriers, as shown in EU-funded projects such as DTV4ALL and HBB4ALL, which involved experiments with hearing, hard-of-hearing and deaf participants. However, recent developments suggest that there may be scope for a wider, or more universalist (Greco, 2018), account of MA. The EU Audiovisual Media Services Directive identifies the provision of MA as a necessary requirement not only for persons with sensory impairments, but also for older adults to participate and be integrated into the social and cultural life of the EU. More importantly, the latest international standard on subtitling, ISO/IEC DIS 20071–23 (AFNOR, 2017, p. vi), cites as its main target users

> persons with hearing loss, persons who are deaf or hard of hearing, persons with learning difficulties or cognitive disabilities, persons watching a movie in a non-native language, persons who need the content to be in another language, persons who cannot hear the audio content due to environmental conditions, or circumstances where the sound is not accessible (e.g., noisy surroundings), the sound is not available (e.g., muted, no working speakers), or the sound is not appropriate (e.g., a quiet library).

Very much in line with the often-quoted report from Ofcom (2006, p. 13) stating that of the 7.5 million users of SDH in the UK 6 million do not have a hearing loss, current legislation now seems to acknowledge that access services do not only benefit persons with sensory impairments but also the elderly, people with learning disabilities and, crucially, people watching media in a foreign language. What then is the difference between AVT and MA? To what extent can MA be considered as a room within the overall AVT building? Is dubbing not another form of MA? After all, the role of AVT is to provide linguistic access to foreign-language content, so the boundaries between AVT and MA are somewhat blurred, as is the consideration of the latter as a subarea within the former.

Apart from these epistemological considerations, the particularist or traditional notion of MA as concerning only (or mainly) people with hearing or visual loss poses a series of problems. Firstly, from a terminological point of view,

well-established labels such as SDH, by far the most commonly used term for this subtitling modality, becomes somewhat questionable or reductionist. This has been acknowledged by Joselia Neves, author of the first PhD thesis (2005) on the subject and one of the leading scholars in the field, who is currently referring to "enriched subtitles" in order to "do away with much of the confusion and inaccuracy of the terminology that is presently in use, while removing the stigma of disability and allowing for developments already in progress" (Neves, 2018, p. 84).

Secondly, and most importantly, this narrow view of MA limits its potential impact on areas where it should be a driving force for social change. Greco (2016) makes this point in relation to human rights, an area where most scholars and institutions do not see MA as relevant to their work. Instead, MA is referred to only as it concerns persons with disabilities, thus overlooking the benefits it can bring about for the elderly, linguistic minorities or migrants. This is what he describes as the "ghetto effect", which, although in some cases can benefit blind and deaf minorities, often prevents MA from reaching its full potential for change. A clear example is that of South Africa. Despite the fact that the South African Constitution guarantees equal status to 11 languages and that the 1999 Broadcasting Act requires that the South African Broadcasting Corporation (SABC) "make services available to South Africans in all the official languages" (BA, 1999), 76% of SABC's programmes are in English (Dibetso, L.T. and Smith, 2012) and SABC has adopted an English-only subtitling policy. As argued by Greco (2016, p. 26), one would expect MA to be at the heart of the human rights discussion regarding language equality in South Africa, but this is not the case. MA is regarded as an issue concerning people who are deaf and/or blind, as shown by the fact that the SABC only refers to subtitling in the section about persons with disabilities. In contrast, a wider notion of MA that includes persons with and without disabilities can be used as a "proactive principle for achieving human rights" (2016, pp. 23–24), one that can help to improve literacy, promote education and increase both social cohesion and quality of life, as per the principles included in the South African constitution.

From this wider viewpoint, MA is no longer exclusively focused on persons with sensory disabilities (or on them and foreign audiences), but "concerns access to media products, services, and environments for all persons who cannot, or cannot completely, access them in their original form" (Greco 2016, p. 23). This wider and universalistic notion of MA is more inclusive and empathetic, as it makes everyone (whether or not they have disabilities) share the same need for accessing original content.

Yet, this is not without problems. Most of the practical and theoretical work in MA since the very first studies in the US in the 1970s (Fischer, 1971; Gates, 1970; Nix, 1971), regardless of whether it adopts a wide or narrow notion, focuses on providing access for persons with disabilities (often deaf and blind) to content made by persons without disabilities. This access to content is of course useful, but if not accompanied by other types of access it can be seen to promote a

paternalistic and self-serving approach that perpetuates the agency of people without disabilities and the passive role of people with disabilities. A fuller and fairer view of MA must thus include access to creation (Dangerfield, 2018), so that groups that have traditionally not been given the opportunity to create can make audiovisual media products that will need to be accessed by all, including the able.

2.1.2 Access to content

One of the aims of AFM is to address the long-standing gap between film(making) and accessibility/translation in terms of research, training and professional practice, or, perhaps more specifically, the unequal relationship between these two areas, that is, the invisibility of translation/accessibility within the film industry. How is it possible that MA, being as prominent as it is in society (legislation, parliamentary debates and public opinion), is still considered a mere footnote in the film industry? The answer to this question will be partly discussed in Section 2.2.1 of this chapter, which will deal with film studies. However, the traditional distinction between AVT and MA challenged here may also have had a negative impact on their visibility.

Let us take the example of the UK, arguably one of the leading countries in the world regarding MA. User associations such as the Royal National Institute for the Blind and Action on Hearing Loss regularly contribute to (and shape) public debate, the governmental regulator Ofcom sets high quotas for access services on TV (100% subtitling for the past three years) and assesses their quality (Romero-Fresco, 2016) and even Deaf viewers are to some extent catered for with programmes presented in sign language. After a long and successful campaign launched in 2017, Action on Hearing Loss managed to persuade Parliament to discuss the need to introduce subtitling for video-on-demand content and to draft legislation that can force broadcasters to provide this service. MA rides the wave of political correctness and equal rights and is a key issue in society. However, when it comes to cinema, the situation is very different. Accessibility is still not visible within the British film industry, where it remains a side issue, tackled at the end of the process, outside the control of the filmmaker, in a short period of time and for very little remuneration. As a tentative reason, it may be possible to argue that the same ghetto effect that has helped deaf and blind lobbies achieve progress and improvement within a narrow notion of MA has also singled out these groups as a minority in the eyes of the film industry.

Why not then widen the concept of MA to include, and even go beyond, AVT and thus have blind and deaf audiences join forces with foreign viewers and other audiences? Currently, not even the link between deaf/blind and foreign viewers is being made. Yet, even though key conferences on MA such as the annual UK Council of the Deaf do not mention translation, foreign viewers are the main consumers of SDH, so all these groups are in the same boat. Strengthening the link between these audiences would be a win-win scenario. Foreign viewers can benefit from the legitimacy and impact obtained by MA through legislation and

human rights debates, whereas the traditional groups included within MA (deaf and blind) will finally enlarge their size and gain the strength in numbers that they need. As shown in Chapter 1, approximately half of the revenue obtained by the top-grossing films from the beginning of the 21st century comes from foreign and accessible versions. In other words, we are no longer referring to a minority, but to the lion's share of the audience.

Film production companies such as Archer's Mark have embraced this inclusive AFM model. They are now implementing it in all their films, and they have been involved in the production of the Accessible Filmmaking Guide (Romero-Fresco, Fryer, & Louise, 2018), produced by the BFI. Production and localisation managers at Netflix have asked for this guide, as they are in an ideal position to apply it: (1) they used *Joining the Dots* (Romero-Fresco, 2012a), a short documentary about blindness made as per the AFM model, as a means to raise awareness within the company about the essential role played by accessibility; (2) most of their profit comes from the translated versions of the films they host; and (3) they engage with both film production and film translation/accessibility, so they can easily integrate the latter within the former. A prime example of this is the award-winning documentary *Notes on Blindness* (Middleton & Spinney, 2016). Produced by Archer's Mark and acquired by Netflix, it included translation and accessibility from inception, and it has been praised by *The Guardian* (C. Phillips, 2016) for its beauty, thoughtfulness and accessibility. Indeed, the films that are adopting the AFM model are becoming flagships for a new inclusive and collaborative approach to accessibility, which helps their promotion and distribution. This is the case for *Xmile* (Font, 2016), the first fully accessible Spanish short film made according to the principles of AFM, which was presented and discussed at the Spanish Senate as part of an ongoing campaign to include AFM in the Spanish legislation on MA. *Xmile*'s implementation of the AFM model involved the participation of sensory-impaired consultants, which has also been envisaged for Archer's Mark's forthcoming production *Chaplin* (Middleton & Spinney, 2019) and which contributes further to increasing the visibility of accessibility and its integration into the production process.[2]

However, even if in some films this new approach manages to replace the industrialised model that relegates translation and accessibility as an afterthought in the creative industry, it would be an error to think that a full integration of accessibility within the production process is the ideal end. This is only part of the story. It is a very positive step forward, but it relates only to access (for everyone) to content (made by some, mostly the able). Access to creation is still to be addressed and, with it, access to funding and access to equipment.

2.1.3 Access to creation

In the Accessible Filmmaking Project, funded by the BFI and the UK-based disability charity Sense, filmmaker and researcher Kate Dangerfield (2017) set out to make a documentary about deafblindness based on a series of filmmaking workshops that she delivered at Sense in 2016 and 2017. The plan was to involve the deafblind

participants in the provision of accessibility for the film (access to content), but it soon became clear to her that the participants needed to tell their own stories, thus becoming co-directors of the film. This revealed some of the many obstacles faced by people with disabilities when they try to have access to (audiovisual) creation. Figure 2.1 sums up the different types of access involved in this process:

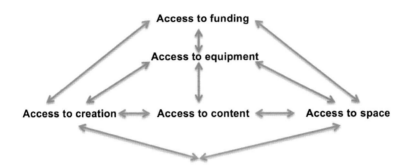

Figure 2.1 The different types of access involved in AFM (Dangerfield, 2018)

Many of these obstacles were overcome with special equipment and assistive technology that made it possible to attach the cameras to the bodies or the wheelchairs of the deafblind participants. The resulting documentary, mostly filmed in first-person point of view, is an inclusive, immersive and innovative piece of filmmaking that grants people without disabilities access to the world of the disabled and that replaces the ocularcentric focus of contemporary filmmaking (Elsaesser & Hagener, 2015) by a more haptic approach. After all, touch is the most important sense for many people who are deafblind, and this may well be regarded as a cinema of the senses (Laine, 2015), as well as a new approach to filmmaking that taps into current debates on the democratisation of cinema, and especially the birth of the so-called non-cinema (Brown, 2016a).

The notion of non-cinema draws on movements such as, on the one hand, Third Cinema (Getino & Solanas, 1969), which rejects both the bourgeois values of the First Cinema made in Hollywood and the individualism of the Second Cinema (European art film) in favour of collective productions aiming at revolutionary activism, and, on the other hand, guerrilla filmmaking (Lee, 1987), which is characterised by low budgets, minimal crews, simple props and real locations without filming permits. Non-cinema combines some of the political and financial aspects of Third Cinema and guerrilla filmmaking but also adds its own idiosyncratic nature, tinged with ethical implications. Brown (2018) argues that the future of cinema is not to be found in the centre but at the margins: overlooked, underfunded and not considered as cinema by distributors, exhibitors and audiences. Non-cinema refers to digital films made in an underground capacity, defying film councils and classification boards, without access to good acting, good lighting and theatrical distribution and often engaging with the "un-, under- or even mis-represented in mainstream media, including the plight of racial, sexual

and other minorities across a variety of contexts" (Brown, 2016b). Non-cinema asks us to engage politically and ethically with digital cinema. It is, as Brown (2016a, p. 105) puts it, "politically imperfect cinema for the digital age" that proposes "the inclusion of the overlooked and the dispossessed, and of the darkness that necessarily accompanies the light" (ibid., p. 104). Non-cinema asks us not to be detached observers of the world, but to become participants therewith, also suggesting that there is more reality than what cinema wants to show us.

Kate Dangerfield's documentary can thus be considered an example of non-cinema, one that is shot digitally and with minimum budget by the un(der)-represented community of the deafblind, who show us a point of view/perspective of disability that suggests that there is more reality to it than what mainstream cinema has shown us. The film challenges people without disabilities to access this new reality. Needless to say, this documentary will also involve the integration of translation and accessibility into the filmmaking process, but at this point we are no longer referring only to a wider idea of access to content, but to a freer notion of access to creation.

Interestingly, the transition of accessibility from being a footnote at the end of film production concerning only deaf and blind audiences to being considered (1) an integral part of production concerning all audiences (access to content) and even (2) a proactive principle for creation (access to creation), as per the AFM model, is not happening only in film. Other arts such as painting and especially theatre illustrate this trend. In the theatre, perhaps more common than accessible theatre-making is the notion of integrated access, which, in Fryer's (2018) view, and as regards AD, is being used as an umbrella term to cover the following aspects:

> That it be non-neutral (creative and /or subjective); that it be collaborative so as to reflect the director's vision (auteur); that it is considered a priori; and, that it be open and inclusive, available to be heard by all.

Largely based on her collaboration with visually impaired actor, singer, musician, and circus aerialist Amelia Cavallo[3] and with Extant, UK's leading performing arts company of visually impaired people, Fryer (ibid.) points out that integrated theatre AD has its risks, for instance "sounding like stage directions without reflecting the full visual nuances of the final production". However, this can be mitigated by ensuring two-way communication between the describer(s) and the creative team. The final words of her article sum up the main advantages of integrated AD for theatre and can be largely applied to AFM:

> By being conceived from the start with the sanction and full participation of the originating artists, integrated AD demonstrates a commitment to access on the part of the creator(s). The advantage for the users is that AD is part of the weft of the piece and will be available at every performance. It is unlikely, for example, to be dropped if budgets shrink. It has the added advantage of

raising the profile of AD with the wider audience and the performers. The extent of integration may vary, but at the very least an integrated approach carries with it a seal of approval in the sense that the AD users know that the director, and possibly the actors too, have sanctioned what the describer says. Perhaps it is time for this form of accessible theatre-making to become the primary approach to AD, so that AD is thought about from the start, and is an integral part of every production.

An interesting example of accessible theatre-making or integrated access for theatre is that of *Club der Dickköpfe und Besserwisser*, a play that was made accessible from inception by the theatre group Theater Kirschrot with the help of students from the University of Hildesheim. It features deaf and hearing children, and the languages used on stage (by the actors and in the projected videos) are German in spoken and written form and German Sign Language. In the play, the surtitles used on stage are not only a means of translation (for German Sign Language or spoken German) that is needed by the entire audience (a wider notion of access) but also a character that interacts with the actors on stage or with the children in the videos, that is, an aesthetic element of the play. *Club der Dickköpfe und Besserwisser* is thus another example of accessible theatre-making as far as access to content is concerned, and the fact that it involves deaf children in the production also makes it an example of access to creation.

At this point, a further distinction must be made between disability art and disability in the arts. First coined in 1986, the term "disability art" referred originally to art made by people with disabilities that tackles the experience of disability (Sutherland, 2008). Following the Disability Discrimination Act of 1995 in the UK and the revised Disability Discrimination Act in 2004, it was recognised that society as a whole and not just people with disabilities needed to support the movement. In other words, disability art came to refer to art that takes on disability as its theme (i.e. exploring the conceptual ideas and physical realities of what is to be disabled) but that does not necessarily have to be made by people with disabilities. In contrast, "disability in the arts" refers to art that involves the active participation or representation of people with disabilities in the arts, whether or not the theme is disability. Currently, the growing visibility of disability and accessibility in the arts falls mainly within the category of disability art. In other words, these are films (*Joining the Dots*, *Notes on Blindness*) and film festivals (Superfest International Disability Film Festival in San Francisco, ReelAbilities in New York, Breaking Down Barriers Film Festival in Moscow, Look&Roll Film Festival in Basel) that may or may not involve artists with disabilities but which deal with disability as a theme. Although all these initiatives are a tremendous step forward and an inspiration for the work to come, there is still a clear need for more disability in the arts, that is, for the normalised participation of people with disabilities in the creation of art that does not necessarily deal with disability as a theme. This is the case of Vital Xposure, a theatre company led by the disabled artist Julie McNamara that makes productions geared towards social engagement

while ensuring quality training, work experiences for talented artists with disabilities and integrated access. They do not necessarily deal with disability as a theme, and can thus be considered as an example of disability in the arts.

Unfortunately, the film industry is lagging behind. Research by the Office of National Statistics (BFI, 2015) in the UK shows that 14% of employed people aged 16–64 considered themselves disabled, and yet according to the 2012 Creative Skillset employment census, only 0.3% of the total film workforce is disabled (2% in production, 0.1% in exhibition and none in distribution). This also applies to other underrepresented groups. As shown by a study conducted in 2012 (BFI, 2015), professionals from Black, Asian and minority ethnic backgrounds only made up 5.3% of the film production workforce, 3.4% of the film distribution workforce and 4.5% of the film exhibition workforce. In order to tackle this disparity, the BFI has made one of its key priorities the development of a new agenda on diversity. Just as accessibility has gone in the area of MA from referring to people who are deaf or blind to including the fully sighted and hearing users of translation, and then even the more general view of universal access provided by the field that Greco (2018) calls "accessibility studies", the BFI has replaced its focus on accessibility for one on diversity, thus including a wider range of underrepresented groups, with a focus on disability, gender, race, age, sexual orientation and socioeconomic condition. The BFI regards diversity as the recognition and acknowledgement of the quality and value of difference and seeks to reflect the public in the films they fund, the programmes they support, the audiences who watch them, and the filmmakers, actors and crews who make them (BFI, 2016). Applicants for funding to the BFI are asked to demonstrate how their project will contribute to reducing underrepresentation in relation to at least one of the four themes in the BFI Diversity Standards: (1) on-screen representation (diversity in the story), (2) project leadership and creative practitioners (diversity in the creative team), (3) industry access and opportunities (work experience and development opportunities) and (4) audience development (reaching a more diverse audience). Of the four themes, and as far as disability is concerned, the last one is directly related to the access-to-content dimension of AFM, and the first two may be included within the access-to-creation dimension. Furthermore, diversity in the story would be linked to disability art and diversity in the creative team to disability in the arts. The BFI's new focus on diversity thus seems to be in line with the wide notion of access proposed in this book.

2.1.4 Concluding thoughts on a wide notion of accessibility and translation

Neither the current and prevailing narrow consideration of MA as concerning only people with sensory impairments nor one that extends its scope to foreign audiences seems to be a true reflection of who is using these access services or who is addressed by the new legislation in this area. Based on the idea of accessibility as an instrument for the human rights of all, the case made in this book supports

a wider view of MA, one that encompasses both people with disabilities and people without disabilities who may need access to audiovisual content. This shift involves not only epistemological (is MA part of AVT or vice versa?) and terminological considerations (is it accurate to refer to SDH when this service is mainly consumed by hearing viewers?) that merit their own separate discussions, but it can also help to unleash the enormous potential that MA has for social change.

The wide notion of access to content presented here is also at the core of AFM, which envisages the integration of translation and accessibility into the filmmaking process. AFM can help to bridge the long-standing gap between film and AVT/MA and to increase the visibility of the latter within the former. This has been illustrated here with regard to two key groups of viewers: persons with sensory disabilities and foreign viewers. By joining forces with the deaf and blind communities, foreign-language audiences benefit from the social impact of MA, its presence in legislation, etc., whereas persons with sensory disabilities obtain from the foreign-language users the strength in numbers that can turn what has traditionally been a minority group into a majority.

However, widening the scope of MA also means going beyond providing access to content that is typically made by people without disabilities and expanding this to access to creation. Some of the most innovative projects that are adopting the AFM model are using this approach as a platform to enable participants with sensory impairments to take responsibility for the creation of audiovisual products. In some of these cases, the resulting films are both innovative and unique, and fall within the emerging trend of so-called non-cinema (Brown, 2018). They are films that defy traditional production and distribution routes and that challenge us to engage with the un- or underrepresented and with a reality that has so far been absent from cinema or shown only secondhand by filmmakers without disabilities.

In this battle to obtain access to creation, persons with disabilities may want to adopt an even wider approach to MA and adhere to the idea of diversity promoted by other underrepresented groups, such as Black, Asian and minority ethnic backgrounds, the LGBT+ community and women. As shown by Kate Dangerfield's project, the above-mentioned figures from the Creative Skillset and a recent article published on *The Guardian* website entitled "Isn't It Time Disabled Actors and Directors Were Allowed to Make Their Own Films?" (Edgar, 2018), this fight for access to creation is likely to be long and full of obstacles to overcome, namely access to (assistive) technology, access to funding and access to the professional market, which in itself requires a profound change in attitudes and perhaps also a set of proactive policies. Finally, it is important to bear in mind that even if access to creation is obtained, the ultimate goal should go a bit further and ensure that artists with disabilities are not only able to make films about their group/plight (disability art), but about any other topic they choose to tackle (normalised disability in the arts). And these films should not necessarily be non-cinema, but also mainstream cinema should these artists wish to adopt a more commercial approach.

To conclude, the famous film critic Roger Ebert once said that "movies are like a machine that generates empathy" (2005). As is the case with many other

statements about film, these words refer to original films and original audiences. Translated or accessible versions produced over three days for little remuneration and without access to the creative team cannot always manage to convey the original vision of the filmmaker or indeed the same degree of empathy. The wider notion of MA presented and supported in this section may just be one of the missing elements that can help movies unleash their potential for empathy not only for original viewers but also for those of the translated and accessible versions. It should also go some way towards bridging the gap between MA/AVT and film studies/filmmaking, although for that to happen a different and more translation-oriented notion of film studies may be needed.

2.2 In support of a translation- and accessibility-oriented notion of film studies

As mentioned earlier, despite more than a century of prolific and interdisciplinary work, film studies has largely failed to engage thoroughly and consistently with translation and accessibility. The aim of this chapter is to deal with the exception to this rule, namely the few scholars who have explored what happens when films are translated/made accessible and have analysed the experiences of foreign and sensory-impaired viewers. A case will be made for a wider, more translation-related notion of film studies that is operationalised in filmmaking practice through the notion of AFM.

2.2.1 The invisibility of translation and accessibility within film studies

The few film scholars who have engaged with translation often start by expressing their surprise at how little attention has been paid to this topic despite being the main means of access to foreign cinema (Flynn, 2016 p. 1) and despite its fundamental role in mediating the foreign (Nornes, 2007 p. 4). As noted by Dwyer (Longo, 2017), film has been surrounded by translation since its very origin, and not only for geographical reasons. Fiction films often involve the translation of words on a script into on-screen images, whereas, to name but one example, ethnographic documentaries may require a triple case of translation (Barbash & Taylor, 1997), rendering aspects of one culture intelligible to another, transforming cultural elements into the film medium and transferring meaning from one language into another. At least three different explanations may be considered as to why the practicalities and risks posed by translation have been largely ignored in film. Firstly, despite the film-as-language metaphor often used in this area (M. Nornes, 2007, p. 18), Dwyer (Longo, 2017) notes that there is still a "primacy of the visual", which may be linked to an ocularcentric view of film and a "misguided notion of film as Esperanto". In other words, the (questionable) belief that what really matters in film is the image, since it is what made film a universal language in the silent era, before the introduction of sound. Secondly, the apparatus theory, a dominant school of thought within cinema studies during the 1970s, was based

on the denial of difference (Baudry & Williams, 1974), and difference is precisely what translation provides to film. Foreign audiences may have a very different experience to that of the original audience or even to that of foreign audiences from other countries depending on whether a film is shown with different types of subtitles, dubbed or with a voice-over narration. Eleftheriotis (2010, p. 187) notes, for example, that subtitles must have been an integral part of the filmic experience of the French theorists who analysed this apparatus so thoroughly. Yet, they never acknowledged (let alone analysed) the presence of subtitles, which would have posed a threat to the perceived objectivity and universality of their claims. For Eleftheriotis (ibid., p. 187), this has two implications:

> The first is a logical extension of the apparatus theory rationale and suggests that films operate by constructing universal positions that transcend differ-ence, in other words, that the cinematic apparatus and its effects are univer-sal and immune to national/cultural variations. The second is the apparatus theorists' inability to acknowledge the specificity of their own position as one of necessarily partial and limited understanding rather than perfect mas-tery over the "foreign" text. Ultimately, such a position resides in the realm of a politically suspect fantasy and typifies modern sensibilities [. . .] that value the possibility and desirability of universal knowledge that transcends national and cultural specificity. It is profoundly elitist as it elevates the the-orist to a level of immense cultural and epistemological power.

This book goes in the opposite direction. The intention here is to tackle head on (and even embrace) the difference brought about by translation, which includes (1) acknowledging the difference between original and translated/ accessible film versions, (2) identifying the effect it may have on the viewers' experience, (3) promoting a notion of film studies that can account for this difference in the analysis of film and especially (4) introducing a new collabora-tive filmmaking model that can consider translation early in the process in an attempt to bridge the gap between the experience of the different audiences. Finally, the third reason to explain the invisibility of translation within film studies is precisely translation's long-standing vocation for invisibility; in other words, the traditional notion that the translation of a film is good when it is not noticed. Nornes (2007, p. 155) criticises the cultural appropriation involved in what he considers a corrupt and colonial approach that "domesticates all other-ness while it pretends to bring the audience to an experience of the foreign". As an alternative to this "corrupt subtitling" that separates spectators from "the beauty of the original" (ibid., p. 19), Nornes (1999, p. 32) introduces the notion of "abusive subtitling":

> Just as the spectator approaches films from faraway places to enjoy an expe-rience of the foreign, the abusive translator attempts to locate his or her subtitles in the place of the other. Rather than smothering the film under the regulations of the corrupt subtitle, rather than smoothing the rough edges of

foreignness, rather than converting everything into easily consumable mean-
ing, the abusive subtitles always direct spectators back to the original text.

Nornes' stance is very useful to denounce the cultural and political implications
of "invisible" approaches to translation and to highlight the creative potential of
subtitles. However, the aim of this book is to increase the visibility of translation
in film studies and in the film industry by making it part of film discourse and the
production process, respectively. Whether or not actual translations are more
or less domesticating or foreignising (or corrupt or abusive) will be determined
by the newly established collaboration between filmmakers and translators. At
any rate, there is little doubt that the invisibility of translation (and accessibil-
ity) within film studies is a reflection of the place it occupies in the industry
as an afterthought or necessary evil (Serban, 2012, p. 49) that is "added post-
filmically and without aesthetic intention" (Flynn, 2016, p. 22). In this indus-
trialised model, translators are "relegated to a sub-species below the tea assistant
within the filmmaking hierarchy" (Fozooni, 2006, p. 194) and, as is the case with
football referees, they are normally never praised, and only noticed when an error
occurs. As pointed out by Crow (2005b), this results in translation and MA being
shoe-horned into existing templates that bear no relation to the film, which may
undermine not only its aesthetics but also the vision that the filmmaker has
worked so hard to create and communicate. This makes the absence of literature
on translation within film studies more glaring and the few contributions avail-
able (discussed in the next section) all the more compelling.

2.2.2 Translation and accessibility as seen by film scholars

Those film scholars who have discussed translation and accessibility have often
done so from the perspective of world, slow, transnational, ethnographic or mul-
tilingual cinema. Eleftheriotis (2010, p. 179) describes world cinema as a "discur-
sive space occupied de facto by foreigners, foreign films and foreign spectators",
whose encounters are made possible by dubbing or by subtitles, which are "the
most widely shared characteristic of world cinema". The same goes for slow cin-
ema, which normally targets foreign-language audiences and where subtitles are
de rigueur (Dwyer, Tessa, & Perkins, 2018). As for transnational, ethnographic
and multilingual cinema, they share the peculiarity that there is no unsubtitled
version of the film, as the original audience need access to the foreign language(s)
included in the original version of the film. Here, subtitles are often a deliberate
artistic choice by the filmmaker, as long as the producers agree to include several
languages in the original version.

Three main common points may be gleaned from the contributions by film
scholars discussing translation, and more specifically subtitling, in film: (1) subti-
tles are integral to the film (and to its analysis), (2) they must be analysed beyond
their linguistic dimension and (3) they trigger a different viewing experience to

that of the viewers of the original version. The notion of subtitles as an integral component of film calls for serious reconsideration of how translated cinema has been analysed in film studies to date. Subtitles advance the plot and thus fulfil a narrative role. They contribute to further the characterisation of the participants in the film and help filmmakers to recontextualise, focus or narrow their ideas. Subtitles are a "stamp of possession" (MacDougall, 1998, p. 174), the "textual eyes" (Zhang, 2012, p. 447) that allow filmmakers to project their particular interpretation and to speak to the audience while the participants in the film are speaking to each other. In light of this, film scholars have embraced a cultural rather than linguistic approach to translation. Egoyan and Balfour (2004, p. 25) note that subtitles trigger questions of "otherness, representation, national identities and the tasks of cultural interpretation", whereas Eleftheriotis (2010, p. 179) views them as cultural imprints or a "visual testimony (like visa stamps on a passport)" of the film's journey. The focus is no longer placed on subtitles as signifiers of linguistic meaning or as external elements that come "from the outside to make sense of the inside" (Sinha, 2004, p. 173), but on the "affective force of subtitled film viewing" (Flynn, 2016, p. 5) and on the role of subtitles as "affective bodily expressions" (ibid., p. 16) that have the potential to transform filmic experiences.

The latter is a particularly recurrent point made by film scholars looking at subtitles, some of whom suggest that the dramatic impact that subtitles have on the viewers' film experience (Bergfelder, 2005) may warrant the consideration of the foreign spectator as a "theoretically productive conceptual category" (Eleftheriotis, 2010, p. 179). From a perceptual viewpoint, Shochat and Stam (1985, p. 41) note that the experience of the foreign viewer watching a subtitled film is bifurcated as they hear a foreign language and read their own, while trying not to miss the images and forge a synthetic unity that can help them make sense of the film. As a result of this process, subtitles impact on the rhythm of film or, at the very least, on the rhythm at which film is viewed. This has been noted by MacDougall (1998), Eisenschitz (2013) and Cuarón (Aguilar, 2019) based on the films which they have made or translated and by Dwyer, Tessa and Perkins (2018) based on recent eye-tracking research. In their analysis of viewers' eye movements watching slow cinema, Dwyer and Perkins (2018, p. 123) found that the visual momentum (the rhythm at which the film is viewed) is increased by the presence of subtitles, which trigger a more visually intense experience, promote active and critical engagement and "are central to the affective experience that filmmakers intend all along". The perceptual and affective dimension are thus combined, as subtitles "set us on a course for an affective encounter that is distinct from the original, untranslated film experience" (Flynn, 2016, p. 12). For Eleftheriotis (2010, p. 185) foreign spectators are required to oscillate "between the narrative depth of the film and its surface where the subtitles reside", undertaking "complex and often unpredictable negotiations between what is familiar and what is strange". This line of thought enables Eleftheriotis (ibid., p. 188) to put forward a consideration of subtitling

(and, by extension, film translation), which may be regarded as the theoretical film studies equivalent of the notion of AFM presented in this book:

> An embracement of incompleteness, imperfection, limits and limitations, but not of impossibility in the encounter between spectators and "foreign" texts. This position is marked by awareness of one's own relation to the foreign text/culture and of the limitations and imperfect understandings that it entails. It is also characterised by an active reading both of the subtitles and of the formal codes of the film and by a constant oscillation between familiar and strange that cuts across the domestic/foreign binary. It is a form of engagement that accepts gaps and lacunae in the experience while at the same time strives to overcome cultural and linguistic barriers by a semiotic reading of the filmic text alongside the literal reading of the subtitles. A cross-cultural critical practice that corresponds to such model would be one of modest and limited claims, acute awareness of the position from which the critic analyses and speaks, openness to the possibility of errors and misunderstandings, painstaking attention to textual and contextual detail but also a determination in the pursuit and acknowledgement of the value of such partial knowledge.

Just as AFM requires filmmakers to consider from inception (and in collaboration with translators) the impact that translation and accessibility may have on the nature and reception of their films, it also requires film scholars, film analysists and film reviewers to acknowledge the specificities involved in watching the foreign version of a film as opposed to the original version. Yet, in order to acknowledge these specificities, it may also be necessary to refer to a global version, one that encompasses the original and its translated and accessible versions.

2.2.3 The global version

> How does the risk of translation affect the medium? How does it affect its global address? How does translation as risk, as failure, as dysfunction allow us to reconceive the global currency and globalizing nature of screen media? This risk involves mismatch, error, cultural asymmetries, appropriation, censorship, gatekeeping, etc. It also involves renewal and revitalization, activity, mobility, activation, accessibility. Cinema and screen media are situated within and amongst these forces and flows – which need to be acknowledged and unpacked.
>
> (Dwyer in Longo, 2017)

In the classic book *Hitchcock* (Truffaut, 1966), recently adapted into a feature-length documentary (K. Jones, 2015) and widely regarded as one of the most influential books on film studies ever published, Hitchcock and Truffaut discuss at length many of Hitchcock's films. They cover every aspect involved in filmmaking, from

planning and scriptwriting to shooting, acting, editing and even the reception of the films. Everything except for translation. There is not one single mention of translation or the foreign audience. For all the readers know, both filmmakers seem to have watched, and be referring to, the same versions of the films. We know that Truffaut, who conducts the interview in French with a liaison interpreter in order to communicate with Hitchcock, watched the French version with subtitles, but there is no acknowledgement of potential "gaps and lacunae in the experience" by Truffaut or signs of "acute awareness of the position" from which he analyses the films as he "strives to overcome cultural and linguistic barriers" (Eleftheriotis, 2010, p. 185). If, as explained in the previous section, translation (and more specifically subtitling) has such a dramatic impact on the viewers' experience that it can change the rhythm at which the film is watched and trigger a different affective response to the original version, to what extent can both filmmakers discuss the films (including aspects of rhythm and editing) as if they had watched the same version?

Take for example *Mogambo* (Ford, 1953), which is included in the Eddie Mannix Ledger as a worldwide success in the history of cinema. When Monaco (1992) praises the subtle script about a love triangle involving the white safari leader Clark Gable, the showgirl Ava Gardner and the cool and married Grace Kelly, or when he recalls Ford's words about why he made the film ("I liked the script and the story. . . – so I just did it"), he is referring to the original film, albeit the underlying idea is that this normally applies to foreign versions of the film, too. However, the Spanish dubbed version was very different. In order to eliminate adultery, Francoist censors changed the relationship of the characters played by Grace Kelly and Donald Sinden from wife and husband to sister and brother, which required the removal of a bedroom scene in which only one bed is present and which, as noted by Galán (1981), replaced adultery with incest. This heavily modified Spanish version is far from the subtle script praised by Monaco and from the story about adultery that persuaded Ford to make the film in the first place. When talking about this film, it thus becomes necessary to specify which version is being referred to. Monaco and Ford's words apply only to the original version; Galán's, to the Spanish dubbed version; and the Eddie Mannix Ledger's description of *Mogambo* as a worldwide success is referring to what can be described as the *global version*, that is, one that encompasses the original version and all or some of its translated/accessible versions.

Casablanca (Curtiz, 1942) is another interesting example of the need to make a distinction between versions. Much has been written about its iconic script, which includes more lines in the American Film Institute book *AFI's 100 Years . . . 100 Movie Quotes* than any other film in history. Number one amongst these is the famous toast "Here's looking at you, kid", a subtle "I love you" that is placed strategically four times throughout the film. It is the last line spoken between the main characters and is now part of everyday culture. It has been used in other films (*Play It Again*, Allen, 1972), songs (Bertie Higgins' 1981 "Key Largo"), album titles (Sammy Davis Jr's 1956 *Here's Looking at You*), series (the title of

episode 5 of the first season of *Frasier*), books (McFarlane, 2013), etc. However, this applies once again to the original version and not necessarily to its translations. In the Spanish dubbed version, the four occurrences of "Here's looking at you, kid" are translated, respectively, as "Entonces, por nosotros" ("So here's to us"), "Toda la suerte, Ilsa" ("All the best, Ilsa"), "Por todos nosotros" ("Here's to all of us") and, in the farewell scene, "Vamos, ve con él, Ilsa" ("Go with him, Ilsa"). There is no subtle and recurrent "I love you" in the Spanish *Casablanca*, which thus deprived millions of Spanish viewers from accessing the most famous line of the most quoted film in history, of the intertextuality involved in its everyday use and of the place it occupies in the (original) cinemagoers' collective memory. Once again, a difference must be made between the original version, its translations (in this case into Spanish) and the global version of the film, which enjoyed worldwide success.

A more modern example is that of *Munich* (Spielberg, 2005), which tells the story of the terrorist attack orchestrated by the Palestinian group Black September to kill several members of the Israeli Olympic team at the 1972 Munich Olympics, and especially of the secret retaliation organised by the Israeli government. Spielberg, himself a Jew, was very aware that the focus would be placed on his political stance and whether the film may be seen as "condoning or condemning Israel's action" (Morris, 2007, p. 360). In this sense, one of the key lines of the film, included in the trailer, is said by Israeli Prime Minister Golda Meir, who justifies the retaliation by saying that "every civilization finds it necessary to negotiate compromises with its own values". In the Spanish dubbed version, she says "cada civilización se ve obligada a llegar a un compromiso con sus propios valores" ("every civilization finds it necessary to commit to its own values"). In other words, whereas in the original version, Meir says that Israel is not a violent country, but it may have to be this time round, in the Spanish version, Israel is going to retaliate because it is a violent country. This example illustrates once again the need for analysts to make a distinction between original and translated versions but also the need for filmmakers to supervise the global version, thus ensuring a degree of consistency across translated and accessible versions. The AFM model presented in this book aims to make this possible by promoting and articulating the collaboration between filmmakers and translators. And while it may be difficult for a filmmaker to have complete control/knowledge of every aspect of every translated version, it is reasonable to expect the filmmaker to supervise the content regarding a line as important as this one, which is a key part of the film, of the trailer and of Spielberg's stance on the political conflict between Israel and Palestine.

This need to distinguish between original, translated and global versions is not only justified by, and does not only apply to, cases of mistranslation. As mentioned above and as will be shown in Chapter 3, films with subtitles are often viewed so differently that in some aspects they may sometimes become a different film altogether. The case of dubbing, where all actors' voices are replaced by those of new actors in a different language, is even clearer. *There Will Be Blood*

(Thomas Anderson, 2007) was highly praised for its direction, cinematography, editing and, especially, acting, with Daniel Day-Lewis winning an Oscar, a Bafta, a Golden Globe and many other accolades. Much of the praise towards his acting was focused on his speech, which was allegedly modelled on actor-director John Huston's voice and which for several dialect experts is an uncanny reproduction of vintage, early American Californian accent, built around the oral posture, "with his tongue stuck in the middle of his mouth, bracing against the molars, leaving his cheeks loose" (Singer, 2016). This is very different from the vocal work involved in his also revered performance as William Cutting in *Gangs of New York* (Scorsese, 2002), where, according to Singer (2016), he mirrors 19th-century New York accent to perfection by having the tip of his tongue hit his teeth while producing a colourful tone with a great deal of nasality.

In Spain, *There Will Be Blood* was met with very positive reviews but Daniel Day-Lewis' performance divided critics. In *El País*, Spanish critic Carlos Boyero (2007) showed his surprise at the praise he received for his performance, which, for him, is too similar to his role as William Cutting in *Gangs of New York*. In the Spanish versions of these films, Daniel Day Lewis is dubbed by the Catalan dubbing actor Jordi Brau, who uses the same voice and accent for both films. While this is understandable, given the very little preparation time available for dubbing actors, it begs the question of to what extent a Spanish reviewer can rate an original performance based on a dubbed film.

An extreme case is that of non-visible performances, such as the supporting characters in *Buried* (Cortés, 2010), a film set entirely inside a coffin. Only the main character is seen, alive inside his coffin, while the others are heard through the phone. The millions of viewers who watched the dubbed version in Spain, France, Italy or Germany did not have any access whatsoever to the key performances of Samantha Mathis as the main character's wife or that of Robert Paterson as Dan Brenner, a colleague trying to rescue the protagonist. Instead, in the case of Spain, they heard the voices of Victòria Pagès and Jordi Boixaderas, the dubbing actors. When Jordi Costa (2010), film critic for *Fotogramas*, praises the supporting actors for the way they articulate their characters, is he referring to Samantha Mathis and Robert Paterson or to Victòria Pagès and Jordi Boixaderas? His remark can certainly not apply to all four and neither Victòria Pagès nor Jordi Boixaderas are mentioned in the review. It thus seems that he is praising Samantha Mathis' and Robert Paterson's performances, which is only possible if he has seen the subtitled version, not the dubbed one.

At the very least, reviewers should specify whether they are referring to the subtitled or the dubbed version. If the intention of the Spanish critics is to assess the performances by Daniel Day Lewis, Samantha Mathis or Robert Paterson, for instance, to consider whether they are worthy of an Academy Award, then it would make sense to watch either the original or the subtitled versions. If the critics only have access to the dubbed version, comments on the quality of the acting should refer both to Daniel Day Lewis' visual performance and Jordi Grau's vocal performance in the case of *There Will Be Blood* and *Gangs of New York* and

only to Victòria Pagès and Jordi Boixaderas in the case of *Buried*. In a way, assessing foreign performances based on dubbed films is no less questionable than rating the performance of a lead singer in a musical where their voice is prerecorded (and here at least it would be their own voice, and not that of another singer). Finally, if a reference is made on a website such as IMBD to the global versions of *There Will Be Blood*, *Gangs of New York* or *Buried*, highlighting for example the awards received by their original and translated versions worldwide, information about their cast should also include the dubbing professionals working in the different language versions. After all, they make up for at least 50% of the acting in the film (or almost 100% in the case of *Buried* and most animation films) as received by millions of viewers.

As shown by the above examples, there seems to be a widespread neglect and denial of translation. Filmmakers and film scholars, who control and/or analyse respectively every aspect of film, tend not to consider how the nature and reception of films may be impacted upon by translation, just as foreign scholars and reviewers deny translation by pretending they are accessing the original version even if they are not. In Eleftheriotis's words (2010, p. 183), this is "an act of violence, a powerful, imperialistic closing-down of possibilities that ignores the extensive transnational life of filmic texts". And, it could be argued, it is one that has contributed to silence differences, heterogeneity, manipulations through censorship and the work of many people (translators and perhaps more specifically dubbing artists) without which cinema would not be able to travel.

The consideration of (and the distinction between) original, translated and global versions may contribute to a fairer and more precise analysis by scholars and to a greater visibility and appreciation of the work carried out by the translation teams. It may also prompt filmmakers to take an interest in, and keep certain degree of control over, the global version of their films, ensuring consistency in the nature and reception of their films across cultures and languages. AFM provides them with a model to put this into practice.

2.3 A new model: AFM

2.3.1 The pioneers of integrated translation

The integration of AVT into the filmmaking process is not new. It goes back to the early days of cinema, before the introduction of sound. Silent films required the translation of the intertitles used by the filmmakers to convey dialogue or narration, which were "removed, translated, drawn or printed on paper, filmed and inserted again in the film" (Ivarsson, 1992, p. 15). This translation was often not outsourced, but rather done in the studios, as part of the post-production process of the film (Izard, 2001, p. 190). Translation in the silent era also involved other practices, including plot modifications at the pre-production stage and the use of alternate takes at the production stage to cater for foreign markets or to meet censorship requirements (Vasey, 1997, pp. 54–64). As summed up by Dwyer

(2005, p. 302), "translation formed an integral part of the industry as a whole". The introduction of partial or full audible dialogue in films such as *The Jazz Singer* (Crosland, 1927) and *The Lights of New York* (Foy, 1928) brought about a new scenario and the need for a different type of translation. Some of these films (known as part-talkies and talkies) used intertitles in the target language to translate the original audible dialogue, while others prompted the first (and largely unsuccessful) attempts at dubbing and subtitling in French, German and Spanish (Izard, 2001, pp. 196–198). These three translation modes were part of the post-production process of the films.

In view of negative audience reactions to these translations, the film industry opted for a different solution in the form of "multiple-language versions" (Vincendeau, 1999), also known as "multilinguals" or "foreign language versions" (Ďurovičová, 1992). Films were made and remade in 2 or 3 languages by the same director and sometimes in up to 14 languages with a different director for each language version. The cast could remain the same or change depending on the films and the number of versions to be produced (Vincendeau, 1999, pp. 208–209). The Joinville Studio, founded by Paramount in Paris in 1930, made multiple versions in up to 12 languages, which usually accounted for 30% of a film's total budget. They even had a literary committee to supervise the quality of the translated versions (Izard, 2001, pp. 201–202). This may be regarded as an extreme form of AFM, where the need to make films accessible to foreign audiences was not just an element of post-production, as was the case until then, but rather a structuring principle of film production. The cost was, however, too high. As soon as dubbing and subtitling were fine-tuned, the studios opted for these modes, which helped reduce the cost of translations to around 10% of the film budget. Increasingly outsourced and unsupervised by filmmakers, translations lost their status as part of the filmmaking process and were relegated to the distribution process, as is still normally the case now.

An exception to this rule is that of ethnographic documentary filmmakers, whose work, largely overlooked in AVT, provides a key contribution to our understanding of the relationship between film and translation and one of the first examples of AFM from the point of view of research and practice. As mentioned in Section 2.2.1, ethnographic documentaries involve a triple case of translation: rendering aspects of one culture intelligible to another, transforming cultural elements into the film medium and transferring meaning from one language into another (Barbash & Taylor, 1997, p. 420). In this type of cross-cultural filmmaking, filmmakers are brokers of meaning and translation is a cultural act involving interpretation, negotiation and, inevitably, compromise:

> As cross-cultural film makers, we have to ask ourselves: How much do we feel compelled to translate, allowing that some meaning will always be lost? How can we fill in the gaps of understanding? And how, if at all, can we reveal to the spectators our role in translation and interpretation for what it is?
>
> (ibid., p. 421)

Up until the early 1960s, ethnographic documentaries such as those made by Jean Rouch had normally resorted to dubbing and especially voice-over for translation. Filmmakers valued that the viewing experience remained "one of looking and listening" (ibid., p. 425), and that this mode allowed the translation of several voices at the same time. However, they found this translation mode problematic in transferring the authenticity, rhythm, inflections, nuances and background information of the participants in the film. The pioneering use of subtitles by filmmakers John Marshall and Tim Asch in their documentaries at the beginning of that decade is regarded as a landmark in documentary filmmaking (P. Henley, 2010). It helped filmmakers to construct a closer relationship with their participants, and it is also key for AVT studies, since it triggered some of the first theoretical reflections on the role played by translation in film and the political and ethical reasons for the use of subtitles:

> What we wanted to replace was not a narrative view of life, but the word-dominated structures of the illustrated lecture film and the all-knowing eye of Hollywood. This resulted in part from our having watched foreign feature films. The people in these films spoke other languages and came from other cultures, but they were still portrayed as individuals. There was no voice on the soundtrack telling you what to think about them. We read their conversations in subtitles and, guided by the filmmaker, we made an analysis of their motivations and actions.
>
> (MacDougall, 2001, p. 88)

Unlike in fiction films, subtitles in ethnographic films were regarded from the beginning as one of the creative ingredients of the filmmaking process, a "dramatic component of visual anthropology" (Ruoff, 1994) that required to be tackled collaboratively, often by filmmakers and non-professional translators (Lewis, 2004), and from the editing stage (Paul Henley, 1996). All these elements, as well as the consideration by these filmmakers and scholars of the effect of subtitles upon the audience account for the pioneering role played by ethnographic film studies in the research and practice of AFM. Subtitling is considered here as a linguistic, cultural and technical challenge, but one that encourages the creativity of the filmmakers and that allows them to develop new meanings and interpretations for their films (Zhang, 2012). For MacDougall (1998), the main disadvantage in the use of subtitles is that the dialogue is packaged and acquires a somewhat prophetic nature, viewers lose freedom and become word-focused and filmmakers have to go against the "show, don't tell" formula that is traditionally recommended to enhance the visual nature of film. Yet, he points out that subtitles also present a great deal of benefits to filmmakers, as they can contribute to further the characterisation of the participants in the film and can help filmmakers to recontextualise, focus or narrow down their ideas, as well as to project their particular interpretation and to speak to the audience while the participants in the film are speaking to each other.

More specifically, many of these scholars reflect on the impact subtitling has on the filmmaking process. As far as production is concerned, and from a practical

point of view, subtitling requires key changes in framing that must be planned before shooting (Henley, 2010; Romero-Fresco, 2013), whereas from a more theoretical standpoint subtitles are thought to act on the verbal level as the camera acts on a visual level "to single out subjects and frame human relationships" (MacDougall, 1998, p. 169). As far as editing is concerned, MacDougall also stresses the key role played by subtitles on the rhythm, cadence and tempo of the film. Rhythm in film is for MacDougall not only determined by the pace of the editing, an aspect that has been researched exhaustively by film scholars, but also by the pace at which the viewers read the subtitles. This is in line with the above-mentioned eye-tracking-based findings by Dwyer, Tessa and Perkins (2018) and with Alfonso Cuarón's view that "subtitling is not only about translating, but also about creating a rhythm" (Aguilar, 2019). Thus, the density, speed, exposure time and complexity of the subtitles may be critical to determine the rhythm of a film, which may be different in its translated version. The following quote by MacDougal (1998, p. 168) sums up the role played by subtitling in ethnographic film:

> The writing and placing of subtitles involves considerable polishing and fine-tuning, but unlike the ex post-facto subtitling of a feature film, this remains part of the creative process, influencing the pacing and rhythm of the film as well as its intellectual and emotional content.

Finally, ethnographic filmmakers have also discussed the use and implications of non-subtitling, an issue that is nowadays commonly debated in AVT research in the light of the increasing production of multilingual films that have this option at their disposal (Krämer & Eppler, 2018). Non-subtitling is used in ethnographic films to enhance the visual nature of the viewing experience and to place the focus on people's physiognomy, non-verbal forms of interaction and the language of music, which "need not be reduced to the mere function of communicating meaning" (Trinh, 1992, p. 114). Then again, non-subtitling is also acknowledged as a controversial decision, and one that can be seen as self-indulgent, ethnocentric, abusive towards the film participants and orientalist (Barbash & Taylor, 1997, p. 429).

At any rate, it would seem that just as the emergence of ethnographic filmmaking helped to give a voice to silent communities around the world mainly through the use of subtitles, it also contributed to raising the visibility of translation amongst an admittedly small number of filmmakers and film scholars. Unfortunately, the obvious connection between ethnographic filmmaking and AVT studies has until now never materialised, as shown (to mention one example) by the absence of ethnographic filmmakers in AVT publications and conferences such as Media for All and Languages and the Media and by the fact that ethnographic conferences and panels such as the 2011 "Subtitling Ethnographic Films: Knowledge and Value in Translation" have so far fallen off the AVT radar. Given the current relevance of abusive (M. Nornes, 2007), creative (McClarty, 2012) and integrated (Fox, 2018) subtitling,[4] the use of, and reflection on, subtitling by ethnographic filmmakers is now more relevant than ever and it shows that it is possible to integrate AVT as a creative element within the filmmaking process

through the collaboration of filmmakers and translators. This, however, refers exclusively to translation and mostly through subtitles. Proposals for the integration of accessibility into the filmmaking process did not appear until the first decade of the 21st century.

2.3.2 The pioneers of integrated accessibility

The introduction of SDH in the US and Europe during the 1970s and 1980s did not change the industrial model that relegates translation to the distribution process in the film and TV industry. Accessibility services were regarded from the beginning as costly and catering to the needs of a very reduced and specific population (Stephanidis, 2001). In the case of SDH for TV, this marginalisation was also determined by the teletext-based technology used. The subtitles were conveyed as a separate signal created outside the production process of the programmes. The same applied to SDH for the cinema, produced by a third party and thus not supervised by (and often unknown to) the members of the original creative team.

The first proposal to change this model was inspired by the principles of universal design, a term coined by the architect Ronald L. Mace and applied to buildings, products and environments that are accessible to people both with and without disabilities (Mace, 1976). To abide by the principles of universal design theory, the design of a product needs to include as many potential users and uses as possible and to do so from conception. In their article "The Rogue Poster-Children of Universal Design: Closed Captioning and Audio Description" (2009), John-Patrick Udo and Deborah Fels apply the principles of universal design theory to SDH and AD in order to ascertain whether they may be regarded as examples of universal design. Very much in line with the wide notion of MA supported in this chapter, SDH is often described by these authors as an "electronic curb-cut", that is, a service that, just like ramps in pavements, benefits not only the target users (viewers with hearing loss) but also less predictable users; in this case, those who may be watching screens in noisy environments or who may need subtitles for language learning. Nevertheless, Udo and Fels find that neither SDH nor AD can be regarded as examples of universal design because they are designed after the fact and not at the beginning of the process and because the designer of the (audiovisual) product is not involved in the SDH/AD process at all:

> Whereas every other aspect [of the filmmaking process] is shaped to form part of an inextricable and greater whole, the CC [closed captions, American term for SDH] and AD exist on the outside, noticeably different parts that do not fit, as they have not been created by the same person with the same vision.
>
> (Udo & Fels, 2009, p. 27)

As the addition of SDH and AD is likely to affect the audience's interpretation of a film, Udo and Fels wonder to what extent a third party with no access to

the creative team can take it upon themselves to convey the director's vision. In order to tackle this problem, the authors propose an alternative model:

> We assert that audio describers and captionists should operate under a similar system [to the rest of the filmmaking crew], reporting to or, at least, consulting with a director of accessibility services. This team would then meet with the production's director to develop an accessibility strategy that re-interprets the "look and feel" of the production. The captioning and description team would then work together to develop prototypes that would, in turn, be approved by the director before being produced. The final product should receive similar attention.
>
> (ibid., p. 24)

Although the notion of universal design (and Udo and Fels' proposal) is a key inspiration for AFM and a very useful and widely recognised concept, it has draw-backs. First of all, in order to assess whether or not a given product may be con-sidered as an example of universal design, Udo and Fels feel compelled to apply the seven principles of universal design outlined by Connell et al. (1997). These principles were created for a different type of accessibility and, as Udo and Fels acknowledge, many of them are not relevant to MA "because they are not physi-cal entities" (2009, p. 20). More importantly, in their model of universal design, Udo and Fels only deal with access services (SDH and AD) but not with transla-tion. However, if a new production model is to be successful in the film industry, it must be as cost-effective and wide-reaching as possible. If it only applies to access services, it risks being considered costly and appearing to cater to the needs of a small, specific population (Stephanidis, 2001), even if this is not true. By integrating AVT and accessibility into the filmmaking process, AFM addresses all the elements that filmmakers must take into account in order to make their films accessible not only to viewers with hearing or visual loss, but also to viewers in other languages. We are thus no longer referring to a minority, but to a large share of the audience.

2.3.3 AFM: progress to date

Although the need to integrate translation and accessibility into the filmmaking process has been present in the theoretical and practical works of some of the authors included in the previous sections of this chapter, AFM was originated as a model in 2013 (Romero-Fresco, 2013). Since then, it has made considerable progress regarding training, research and professional practice.

2.3.3.1 Training

Given the current prominence of industrial subtitling (Pérez-González, 2012), carried out after the fact and with no communication with the creative team of

the film, AFM has so far been applied mainly at the grassroots level, and training has played a key role in its development. Film(making) courses have traditionally disregarded translation and accessibility issues and postgraduate programmes in AVT have not normally included film(making). This is beginning to change. Postgraduate courses in filmmaking such as the Master of Arts in Filmmaking at Kingston University (London), the Film Studies Masters at the University of Malta and the Master of Arts in Film Production at the ESCAC (Barcelona), the leading film school in Spain, have included classes on AVT and accessibility. The same goes for undergraduate and postgraduate film programmes at Universidad de Valladolid and the Central School of Speech and Drama (London). Likewise, AVT courses are beginning to open the door to film-related contents, as shown by the collaboration between the Universitat de Vic and the ESCAC, the Master of Arts in Accessibility at the University of Macerata and the Master of Arts in Multimedia Translation at the Universidade de Vigo.

In some cases, AFM is promoted not only through the exchange of contents and modules between programmes but also through the collaboration between film students and AVT students. This is the case of a project set up by five students from the Master of Arts in Translation at the University of Antwerp who produced SDH and Italian subtitles for the award-winning film *De weg van alle vlees* (2013) in collaboration with, and under the supervision of, the Belgian filmmaker Deben Van Dam (RITS Film School, Antwerp). The film was broadcast by VRT, the main public broadcaster in Belgium, on 7 December 2014 with the SDH produced by the students and with their names included as part of the credits. A similar project was set up at the University of Roehampton in 2014 to produce French subtitles for Alvaro Longoria's film *Hijos de las Nubes* (2012), produced by Javier Bardem. The subtitles were created in collaboration with the filmmaker and were broadcast by the French TV channel Arte in February 2014. Following this project, the University of Roehampton launched in 2013 the first Master of Arts in Accessibility and Filmmaking, where students learnt not only how to make films but also how to make them accessible to viewers in other languages and viewers with hearing and visual loss. The students graduating in this course are being employed both in the translation and the film industry, and their first films have adopted an AFM approach.

Furthermore, training in AFM has also been made available to professionals in the translation/MA and film industries through workshops and special courses. The workshops have taken place mainly at international conferences such as Languages and the Media (Berlin, 2018), Media for All (Dubrovnik, 2005, and Stockholm, 2019) and the American Translators Association Conference (Palms Springs, 2019), as well as film festivals such as the International Edinburgh Film Festival (2013), the Venice Film Festival (2012 and 2013), the Torino Film Festival (2018) and the III Encontro Alumiar de Cinema Acessível in Recife, Brasil (2018). As for the special courses, some examples are the first official course on AFM organised by POIESIS and the Apulia Film Commission in Lecce in 2015, another one run by Fondazione Carlo Molo, the Torino Film Commission and Museo Nazionale del Cinema in 2016 and 2018, and finally AFM lectures in Brasil

(Universidade Estadual de Campinas, Sao Paulo), Qatar (Hamad Bin Khalifa University, Doha), Perú (Universidad César Vallejo, Lima), Finland (University of Helsinki) or Russia (Moscow School of Audiovisual Translation). Finally, drawing on the proposal outlined in Romero-Fresco (2019), the author of this book has recently teamed up with the British Film Institute and the online education platform FutureLearn to develop the first online course on AFM, catering for both filmmakers and translators/MA experts who wish to be trained in this new area.

2.3.3.2 Research

Since the first article on AFM (Romero-Fresco, 2013), which has been translated into Spanish, Portuguese and Italian, AFM has gained visibility as an emerging area within AVT and film. It is now included in panels and presentations at international conferences such as Media for All or Languages and the Media, and it has been the subject of full chapters in books and anthologies on AVT such as *The Routledge Handbook of Audiovisual Translation* (Pérez-González, 2018), *Reception Studies and Audiovisual Translation* (Di Giovanni, Elena, & Gambier, 2018) and the inaugural issue of the *Journal of Audiovisual Translation*. AFM is or has been the subject for 22 Master of Arts dissertations, 5 PhD theses and several academic articles on AFM and documentaries (Cerezo Merchán, de Higes Andino, Galán, & Arnau Roselló, 2017; Romero-Fresco, 2017), AFM and eye tracking (Fox, 2018; Romero-Fresco, 2018a), AFM and creative subtitles (Fox, 2017) and training in AFM (Romero-Fresco, 2019). In its attempt to bridge the gap between film studies and AVT, AFM has also been the subject of two chapters included in the recent anthology on film and eye tracking *Seeing into Screens: Eye Tracking and the Moving Image* (Dwyer, Perkins, Redmon, & Sita, 2018).

AFM is also the key area studied by the Galician Observatory for Media Accessibility (GALMA), a research group based at Universidade de Vigo (Spain) that promotes research, training and knowledge transfer in the area of MA for the benefit of people who, for different reasons, cannot have access to original audiovisual media. The work carried out within GALMA is aligned with the wide notion of MA described in this chapter and focuses mostly on quality in MA and on the integration of MA as part of the audiovisual production process. GALMA is currently leading or involved in several research projects exploring different aspects of AFM, such as AFM and minority languages (EU-VOS), AFM in Spain (ITACA), the production of AFM guidelines for the industry (Romero-Fresco & Fryer, 2019) and the development of specialised software for the production of AFM-based subtitles.

2.3.3.3 Professional practice

Apart from the above-mentioned silent films and ethnographic documentaries, the history of cinema includes other examples of fiction filmmakers who have been known to keep some degree of control over the global versions of their films, either by producing the subtitles themselves, such as Eric Rohmer and the filmmaking duo Jean-Marie Straub and Danièle Huillet (Eisenschitz, 2013), or

by supervising them, such as Alfred Hitchcock, Federico Fellini, Stanley Kubrick and Martin Scorsese (M. Nornes, 2007). In recent years, partly due to the emergence of multilingual films, more and more filmmakers are beginning to engage with translation from the production process and/or to collaborate with translators, as is the case of Jim Jarmusch (*Mystery Train*, 1989; *Night on Earth*, 1991), John Sayles (*Lone Star*, 1996; *Men with Guns*, 1997), Charlie Kaufman (*Synecdoche, New York*, 2008), Danny Boyle (*Slumdog Millionaire*, 2008), James Cameron (*Avatar*, 2009), Wim Wenders and Juliano Ribeiro Salgado (*The Salt of the Earth*, 2014), Matt Ross (*Captain Fantastic*, 2016), Alfonso Cuarón (*Roma*, 2018) and, more notoriously, Quentin Tarantino (*Inglourious Basterds*, 2009) and Alejandro González Iñárritu (*Babel*, 2006; *The Revenant*, 2015), both of whom issued translation guidelines to their distributors in order to ensure that their vision for their films was maintained in the translated versions (Sanz Ortega, 2015). However, given the inflexible nature of industrial subtitling, where distributors have the power to decide against the translation wishes of recognised filmmakers such as Ken Loach and Quentin Tarantino (ibid.), independent filmmaking offers an ideal platform for AFM to be developed. This is shown by recent films that have engaged with translation before the distribution process, such as Michael Chanan's *Secret City* (2012), Enrica Colusso's *Home Sweet Home* (2012), Elisa Fuksas' *Nina* (2012), Deben Van Dam's *De weg van alle vlees* (2013), Álvaro Longoria's *Hijos de las Nubes* (2012) or the award-winning Spanish films *Matria* (Gago, 2017) and *Estiu 1993* (Simón, 2017).[5]

Whereas most of these films have (often unwittingly) applied elements of AFM in an attempt to maintain the filmmaker's vision across language versions, others have applied the model more systematically, including the presence of a director of accessibility and translation (DAT), which is similar to the supervisor of accessibility services proposed by Udo and Fels (2009) but including both translation and accessibility. This is the case of *Joining the Dots* (Romero-Fresco, 2012a), which has been used by Netflix and the United Nation's ITU Focus Group on Media Accessibility as an example of good practice; *The Progression of Love* (Rodgers, 2010) and *Acquario* (Puntoni, 2018), which have been the subject of a master's thesis and a PhD (Branson, 2017), and especially the Emmy award–winning *Notes on Blindness* (Middleton & Spinney, 2016). The latter developed, with the contribution of the British film industry, an international impact campaign on the need to adopt an AFM approach in modern filmmaking. These films will be referred to throughout this book as showcases of AFM, and testimonies from their directors are included in Chapter 5. In Uruguay, the company *Puerto USB: Uruguay Sin Barreras* has made accessible films such as *El candidato* (Daniel Hendler, 2016), *Mi Mundial* (Carlos Morelli, 2017), *Locura al aire* (Alicia Cano y Leticia Cuba, 2018) and *Mirador* (Antón Terni, 2018) applying the AFM model with a director of accessibility and translation and consultants with sensory impairments.

In some cases, the commitment of some of these filmmakers to the idea of AFM has turned them into activists and researchers, as they accompany their films with recommendations and reflections on how to ensure that the filmmaker's vision is maintained in translation and accessibility. In the UK, the visually impaired

filmmaker Raina Haig was the first one to include AD as part of the production process in her award-winning debut film *Drive* (Haig, 1999). Her website includes articles on disability and filmmaking and on how to integrate accessibility from production. In her view, in order to provide visually impaired audiences with "equitable commercial choices and artistic quality" the AD needs to be constructed "in consultation or even collaboration with the filmmaker", thus regarding "the job of audio description as a part of the film industry" (Haig, 2002). This requires training in film studies for the audio describers to "learn how to attune themselves to the filmmaker's vision" and in the basics of AD for filmmakers to be able to take decisions on how their film can be made accessible to a blind audience.

Also in the field of accessibility, filmmaker and artist Liz Crow founded in 2005 the production company Roaring Girl Productions, one of whose aims is

> to pioneer new approaches to film accessibility, working to make audio description, captioning and sign language (ACS) an integral part of the production process rather than an access "add-on". This is so that people with sensory impairments can participate fully as audience members and filmmakers' work can be accurately and sensitively conveyed.
>
> (Crow, 2005a)

In "Making Film Accessible" (Crow, 2005b) and "A New Approach to Film Accessibility" (Crow, 2005a), she provides detailed descriptions of how her films *Nectar* (Crow, 2005c), *Illumination* (Crow, 2007) and *Resistance* (Crow, 2008) were made accessible. For Crow, it is essential to avoid the prevailing template-based, one-size-fits-all approach to accessibility which results in AD and subtitles that are removed from the overall feel of the production:

> For the audience, the result is that the very methods designed to promote access can detract from the qualitative experience of the production. For the filmmaker, the access conventions available can misrepresent and undermine the vision they have worked so hard to create and communicate.
>
> (Crow, 2005a)

Crow's account of how accessibility was brought into the core of the creative process in the production of *Nectar* (Crow, 2005c) through experimentation with both aesthetic and technological solutions is particularly interesting and constitutes one of the first set of recommendations on AFM. The subtitles, produced in collaboration with a deaf consultant, were not only based on traditional technical guidelines, but also on aesthetic grounds. This helped to decide on the font, colour, speed and display mode of the subtitles on the basis of the visual identity, the mise en scène and the mood of the film. Reflecting on the whole process, Crow explains that this approach requires some extra time in post-production, which can be made possible by the inclusion of accessibility in the film budget and by its recognition as a budget line for funding bodies. Only in this way will filmmakers be able to keep control over the way in which their films are received by sensory-impaired

audiences, with a degree of subjectivity (and collaboration with the translator) that is not possible within the rigid margins of standard industrial subtitling.

In the field of ethnographic documentary, a good example of AFM is the filmography of award-winning director Alastair Cole. His latest film, *The Colours of the Alphabet* (2016), is a feature-length ethnographic documentary about multilingual education in Zambia in which he has used subtitles as "an intrinsic part of the filmmaking process that can be planned and engaged with from the start of production, and embraced as a powerful tool for emphasising perspective as well as forging characters and narratives" (Cole, 2015, p. 134). Figure 2.2 (ibid., p. 35) illustrates how subtitling was integrated in the filmmaking process.

Cole ensured that the subtitles were created before picture lock, which allowed them to "influence the pacing and emotional engagement of the film where necessary, and permitted the adjustment of any scene that would create significant problems in viewing with the subtitles" (ibid., p. 138). Cole worked with a "producer of language and accessibility" to create a guide document for subtitlers. This document included the full original transcript, the translation into English, the English subtitles, the Italian subtitles and a section with comments for subtitlers regarding potential translation difficulties. The subtitlers of the various foreign versions of the film had the opportunity to contact the filmmaker, liaising first with the producer of language and accessibility. In Cole's view, documentary filmmaking, and particularly ethnographic filmmaking (which has translation at its core), offers a unique context and a fruitful area of research to test new, creative and collaborative forms of translation and accessibility. Furthermore, he adds an essential ethical consideration to support the use of AFM in this genre that sets up the reflection included in the closing section of this chapter:

> The common, and often inevitable requirement to outsource the creation of various foreign language versions of films can result in removal of the director from any translation and subtitling debate, thus shifting ultimate responsibility for the translation and the representation of the characters involved in the film away from the person with whom the people in the film have entrusted their stories. Fully understanding the implications and procedures of subtitling, recognising the key role of the director in any debate, and understanding one's own ideological perspective within the creation of the subtitles and the film as a whole is, I suggest, critical to mitigating the obvious dangers and harm mistranslation, and misrepresentation can entail.
>
> (ibid., 148)

In general, the examples of accessible professional productions discussed here (and the content included in Chapter 5) show that AFM can present a feasible alternative to the industrial model of translation and accessibility that currently prevails in the film industry.

Figure 2.2 Subtitling production process in Cole's film *The Colours of the Alphabet* (2016).

2.4 AFM and the global version: a matter of responsibility

> Filmmakers must involve themselves in translation because the contribution
> of the translator is every bit as profound as that of the screenwriter, actor,
> or director. [. . .] Thus, it behooves artists to understand the process and get
> involved if they care at all about their work. After all, in an age when no film
> is complete until it crosses the frontier of language, it is the translator who has
> the last word. Global cinema is the translator's cinema.
>
> (M. Nornes, 2007, p. 243)

The relegation of translation and accessibility as a footnote in the distribution
process goes some way towards explaining their invisibility in both the film indus-
try and the theoretical area of film studies. The AFM model presented in this
book is an attempt to change this both from a theoretical and a practical point
of view. Whereas the practical side will be discussed in the next chapters of this
book, Chapter 2 has dealt with the new and wider notions of translation and film
studies that underlie AFM.

Firstly, a wider notion of MA is needed so as to develop the full potential
of an area that is rapidly becoming one of the key elements in society. This
involves (1) opening up the traditional scope of MA to include not only per-
sons with disabilities but also any other users who for whatever reason may
not have access to an original audiovisual production (which means that AVT
would be included here) and (2) making the most of the momentum gained by
pro-diversity movements to go beyond access to content into access to creation.
While this is fundamental if we are to unleash the full potential that MA has to
turn film into a properly inclusive and empathetic art, it also requires changes
in the area of film studies.

Different reasons have been put forward in this chapter to account for the little
attention received by translation (and accessibility) in film studies, not least the
preference by many translators and translation scholars to keep translation invis-
ible, the primacy of the visuals in the study of film and the questionable notion
of film as universal language, which privileges the original and denies or ignores
the difference involved in translation. Even though there is consensus (and now
also empirical evidence) that translation has a critical impact on the nature and
reception of film, filmmakers and film scholars tend to disregard translated versions,
while scholars and critics watching these translations often pretend they are access-
ing the original versions. AFM supports the opposite view, as it proposes to identify,
analyse and, if possible, minimise the difference between original and translated
versions, as well as to maintain the coherence of the global version that comprises
the former and the latter. This would require scholars and critics analysing trans-
lated/accessible versions to acknowledge the specificity of their position and film-
makers to take responsibility for the global version of their films and preserve its
coherence. By not doing so, most filmmakers seem to be abdicating responsibility

on translators who are neither trained nor paid to make decisions that are bound to change the nature and reception of the films they are working on, thus unnecessarily widening the gap between original and translated versions.[6]

The wider notions of MA and film studies presented here will hopefully serve as the theoretical framework to underpin the AFM model (presented in the next chapters) that can help filmmakers to take responsibility for the global version of their films and to ensure that their vision reaches all viewers.

Notes

1 An adapted version of this section may be found in Romero-Fresco (2018b).
2 This is partly related to the deaf translation norm (Stone, 2009), an idiosyncratic translation practice that results from the increasing presence of deaf translators and interpreters in several contexts, such as websites, public services, government literature and audiovisual media.
3 Amelia Cavallo is also the protagonist of "In Conversation with Amelia Cavallo" (Dangerfield & Neilson Smith, 2018), the first in an on-going series of interviews that have been made according to the AFM model.
4 Unlike Nornes (2007) and McClarty (2012), Fox (2018) avoids the term "subtitle" and refers instead to (integrated) titles, which highlights the fact that they are placed directly into the picture and not necessarily at the bottom of the screen.
5 Interestingly, AFM can also be regarded as part of a wider movement aiming to integrate translation and accessibility as part of the artistic creation process. The theatre is proving particularly active in this regard, with examples such as *The Gift*, a play produced by the professional Northern Irish children's touring theatre company Cahoots NI in 2015 (Maguire, 2015). With the help of the researcher Tom Maguire, the production of the play included aspects of universal design early on in the process and in collaboration with the creative team in order to ensure that spectators with visual impairment were as integrated into the play as sighted spectators.
6 In their recurrent battle to secure creative control of their films, the filmmakers involved in the Directors Guild of America estipulate that "in no case will any creative decision be made regarding the preparation, production, and post-production of a motion picture without the consultation of the Director" (DGA, 2014, p. 13). Yet, once again, this seems only concerned with the original versions. Unless these rights are extended to the distribution process, the directors will have no creative control over the translated versions, which is what a large (often the largest) part of the audience will watch.

Chapter 3

AVT and MA for filmmakers

As mentioned in the introduction, AFM requires collaboration between filmmakers and translators. This chapter aims to provide filmmakers (as well as film scholars, translators and translation scholars) with relevant and research-informed knowledge about what happens when their films are translated (through dubbing, voice-over or subtitling) or made accessible (through SDH and AD). This knowledge will allow filmmakers to have a meaningful discussion with translators about aspects that can have a dramatic impact on the nature and reception of their films and that have so far rested solely on the translators' shoulders.

3.1 General translational/accessibility issues

AVT and MA share many of the issues and challenges that are common to other types of translation, such as the impossibility of translating word for word, the difficulty of being faithful to both the content and the style of the original text or the complexity involved in translating humour and culture. In the case of AVT and MA, this is further complicated by the need to deal with both images and sound. A case in point can be found in Figure 3.1, from the Marx Brothers' *Horse Feathers* (McLeod, 1932). When a stamp is needed to sign a document ("Where's the seal?"), Harpo produces a live seal.

Most translators (whose languages are unlikely to include the polysemy of "seal" meaning both stamp and marine mammals) would need to find a creative solution in the translated script knowing that the image of a seal is the one thing that they cannot change in this scene. Even more challenging is the sketch from *The One Ronnie* broadcast by BBC One on Christmas Day 2010 (see Figure 3.2), which begs the question of whether certain films or scenes can be translated at all.

Located in a grocery store, the sketch features a customer complaining about the state of the fruit he has bought. It is based on a series of plays on words involving fruit and technology and includes phrases such as "my blackberry is not working", "it's completely frozen", "let's try it on orange", "launch the blackberry from the desktop" and "I've already tried that a few times. I mean, all it did was mess up windows". Since most languages use the original English names to refer

Figure 3.1 Still from the Marx Brothers' *Horse Feathers* (McLeod, 1932)

Figure 3.2 *The One Ronnie* (BBC One, 2010)

to these companies, there is little hope for a translation to convey the humour of the original dialogue.

Fortunately, translation is often much more feasible than this. The following sections will focus on the different AVT/accessibility modalities, the implications of choosing one over another and the elements that filmmakers and translators

should bear in mind to ensure that the experience of watching the translated/accessible film is as similar as possible to that of viewers of the original version.

3.2 Dubbing

Dubbing consists of replacing the original dialogue track of a film (or any audiovisual text) with another track on which translated dialogue has been recorded in a target language (Chaume, 2013). It is not unlike ADR (additional dialogue replacement or additional dialogue recording), in which the original actors re-record and synchronise audio segments for the original film. In foreign-language dubbing, the translated track is synchronised with the original images so as to make it look like the original actors are speaking the foreign language. Dubbing is used as the preferred mode of film translation in several European countries such as Austria, France, Germany, Hungary, Italy, Czech Republic, Slovakia, Spain, Turkey and Ukraine. It is also used regularly, along with subtitling, in China, Hong Kong, Japan, Indonesia and most countries in South America. More importantly, it is used all over the world to translate cartoons, even in countries that usually prefer subtitling. Dubbing was introduced with the first sound films, at the end of the 1920s. The quality of these first tests was still very low, which led to the adoption of the so-called multiple-language films (see Chapter 2). As soon as the technique was refined in the 1930s, dubbing became one of the two major forms of film translation, along with subtitling. Despite being criticised for not allowing the viewers to hear the original actors' voices, dubbing is still the preferred mode of film translation for millions of people around the world.

3.2.1 The impact of dubbing on the film

The invisibility involved in dubbing, the need to abide by a series of synchronies, the use of dubbese and the difficulty involved in dubbing multilingual films are some of the aspects that account for the impact that this translation modality can have on a film.

From the point of view of filmmaking, one of the interesting aspects about dubbing is its *invisibility*, which can be used to alter the nature (and reception) of a film. Although dubbing was not created as a fascist tool, it was adopted by Mussolini, Hitler and Franco with laws that enforced the dubbing of all foreign films in Italy, Germany and Spain, respectively, as a way to protect the national language and identity against the threat of foreign cinema (Mereu, 2016). Unlike subtitling, dubbing viewers do not normally have access to the original dialogue, which, provided that the synchrony between the images and the translated dialogue is successful, can turn this translation modality into a particularly effective and invisible tool for censorship and manipulation. An example of this was provided in Chapter 2, which described how in *Mogambo* (Ford, 1953) the Francoist censors changed the relationship of the characters played by Grace Kelly and Donald Sinden from wife and husband to sister and brother in the Spanish

dubbed version. The aim was to hide adultery but the inadvertent result presented the dubbing viewers with a case of incest that was never part of the original script. Another example of ideological manipulation can be found in *Casablanca* (Curtiz, 1942). In the original version, Rick's (Humphrey Bogart) track record of supporting the underdogs includes running guns to Ethiopia and fighting for the Republican side in the Spanish Civil War against the fascists. However, for many years the Spanish viewers were unaware of this fact, as the official dubbing translation changed his participation in the Spanish Civil War for his intervention in the Anschluss (annexation of Austria into Nazi Germany). The invisibility of dubbing has also been used to manipulate and censor content in democratic regimes. In an episode from the American TV series *Dynasty* (Moore, 1981) in which Steven Carrington's character confesses to his father that he is gay, the French dubbed version uses the word *malade*, thus telling French viewers that he is ill, rather than gay.

Nowadays, the dubbing industry has a series of mechanisms in place to guarantee quality and avoid such extreme examples of manipulation, from the translator, to the dialogue writer (who adapts the translation to fit in the actors' lips), the dubbing actors and the dubbing director. However, research shows that different degrees of censorship can still be found at many levels, such as a general tendency to tone down swearwords and taboo words and to correct grammar mistakes (Fong, 2009). This has a significant impact on dialogue exchanges, character profile, storylines and the overall authorial process and is caused by either ideological pressure in the target culture (Fawcett, 2003) or commercial factors (Gambier, 2002). Almost invariably, filmmakers are unaware of the changes that their films have undergone when they are received by the large dubbing audience.

The alteration of the original film in dubbing depends on a combination of factors related to cinematography (and more specifically shot scales) and *synchrony*. In dubbing, the two most important synchronies at play are isochrony and lip synchrony (Chaume, 2004). These constrain the translator's job considerably, making it difficult to maintain both the content and style of the original dialogue. Isochrony involves matching the translated text with the time in which the screen characters have their mouths open. This must be achieved at all times, except for shots where the characters' mouths are not visible. In contrast, lip synchrony applies only in close-ups and extreme close-ups. It requires adapting the translation to the lip movements of the on-screen characters, particularly in the case of bilabial (m, p, b) and labio-dental consonants (f, v) and open and closed vowels. This does not mean that if an original utterance has an "f" the translation must have an "f", too, but it does mean that if the on-screen character uses two bilabials and one open vowel (as in "*put it back*"), the translation should also feature two bilabials and an open vowel at the end.

In cinematographic terms, this means that long shots and shots where the on-screen characters' mouths are not visible bring about rare instances of unconstrained leeway where translators are free to find equivalents that can faithfully transfer the content and style of the original dialogue. Needless to say, they also

offer a great deal of freedom for translators to alter or manipulate the content of the original film in a way that can go unnoticed by the viewers. In contrast, close-ups pose a real challenge for translators and make it very difficult to provide an accurate rendition of the original dialogue. Often, either part of the content or the style may have to be lost to abide by lip synchrony. Recent research shows an increase in the use of close-ups (and extreme close-ups) in modern filmmaking (Bordwell, 2002), so much so that it has become the most common shot in contemporary cinema (Redfern, 2010). As found by the researchers of the scientific database *Cinemetrics*, in many recent films 50% of the shots are close-ups or extreme close-ups, a percentage that can sometimes increase to 70% or 75% in the case of TV series such as *EastEnders*. As part of their discussions with translators, filmmakers may want to pay special attention to specific close-ups in their films where the dialogue may be particularly important, so as to ensure that the translation manages to convey the content and spirit of the original script despite the strict dubbing constraints.

As well as the invisibility of dubbing and its relation to cinematography and synchrony, other factors that can have an impact on the nature of the translated film and its reception are the use of dubbese and the presence of songs and language variation in the original film.

Dubbese is the language used in dubbing (Romero-Fresco, 2006), a culture-specific register used in dubbed films that is characterised by being halfway between written and oral language and by the presence of recurrent and outdated or formal translation solutions and a tense and emphatic pronunciation (Pavesi, 2006). Dubbese sounds unlike original film dialogue or spontaneous dialogue, and it can be instantly recognised by dubbing viewers, who accept it as part of the suspension of (linguistic) disbelief (Romero-Fresco, 2009) that allows them not to question the incongruences of a dubbed film. Although in itself not a problem for the reception of the translated film, in some cases dubbese has been found to create a certain distance between the dubbing audience and the on-screen characters that was not present in the original film (Romero-Fresco, 2006). Likewise, the language used in dubbing is also determined by the voices of the dubbing actors, who are normally carefully chosen by the dubbing director. However, important issues can also occur here, for instance with the common use of female adult actresses dubbing child characters. This is normal practice, given the difficulty involved in finding young dubbing actors, but it can have a negative impact on the dubbed film. A recent case in point was *Beasts of the Southern Wild* (Zeitlin, 2012), whose Italian and Spanish dubbed versions were met with heavy criticism (and financial losses) due to the use of adult actresses voicing the young Hushpuppy, the charismatic protagonist of the film. The use of dubbese and the choice of voices in cases like this one may be another interesting point of discussion between translators and filmmakers, who may want to have a say in how dubbing can be approached or indeed in whether dubbing is the most appropriate form of translation for such films.

A similar situation is brought about by the presence of *songs* in a film. Until recently, songs in musicals used to be dubbed and interpreted by singers in the

target language. This is still the case in large Disney blockbusters such as *Frozen* (Buck & Lee, 2013). In general, however, this practice is regarded as too costly (or not desirable, in cases where the audience would like to hear the original actors singing) and nowadays musicals combine dubbed dialogue with subtitled songs. As a result, in the same film, dubbing viewers hear two voices for each character: the original English (or American) voices when they are singing and the voices of the dubbing actors when they are having a conversation. This practice poses a challenge to the viewers' suspension of disbelief and has been met with criticism in recent musicals such as *La La Land* (Chazelle, 2016) and especially *Les Miserables* (Hooper, 2012), whose dubbed version was made up of 90% subtitled songs and 10% dubbed dialogue. Once again, filmmakers may find it useful to consider the different options available (i.e. subtitling), their implications and the convenience of opting (or at least pushing) for dubbing or subtitling depending on the film.

Finally, another important issue that filmmakers should take into account when distributing their films in a dubbing country is *language variation*, which involves the use of geographical, temporal, social or individual dialects and the use of different registers (i.e. formal, informal, colloquial, etc.). All of these pose significant challenges for dubbing and require important decisions that the filmmakers may want to be part of since they have a decisive impact on the translated film and its reception by the viewers. How can the French film *Bienvenue chez les Ch'tis* (Boon, 2008), which builds much of its humour on the contrast between the northern and southern accents of the characters, be dubbed into Spanish? Should *Silence* (2016), Scorsese's historical film about two 17th-century Portuguese missionaries, be dubbed using 17th-century Spanish? What equivalent can be found to dub into German the social dialect used by the drug dealers in the TV series *The Wire* (Simon, 2002) or the idiosyncratic way in which Heath Ledger's Joker speaks in *The Dark Knight* (Nolan, 2008)? In the past, the use of "equivalent dialects" in dubbing was common, such as in the case of the Black Vernacular English spoken by Mammy, the house servant in *Gone with the Wind* (Fleming, 1939), which was translated with a Cuban accent in the Spanish dubbed version. This is now considered ideologically and linguistically questionable. Current practice in dubbing tends to opt for the opposite solution: to eliminate language variation, standardise dialects and correct the grammar errors of the original dialogue in translation (Díaz Cintas & Remael, 2008, p. 192). There are, however, many different possibilities in between that the filmmaker may want to discuss with the translator, given the importance that the use of linguistic variation has on the reception of the film by the dubbing audience.

An extreme form of linguistic variation, and one that is as common in contemporary cinema as it is difficult to translate, is *multilingualism*, or the presence of several languages in original films, as is the case in *Babel* (González Iñárritu, 2006) and *L'Auberge Espagnole* (Klapisch, 2002). If the first language (L1) is the main language of the original film and the second language (L2) is the dubbing

language, the question is, what can/should be done in translation with the other language(s) used in the original film (L3)?

In a scene from Ken Loach's *It's a Free World* (2007), Angie, the British protagonist, speaks to her Polish workers with the help of an interpreter. As Loach found out during the premiere of his film in Spain, Spanish viewers watched a somewhat different scene, one in which all characters were dubbed into Spanish and in which the storyline changed from a scene about translation to a group conversation. Loach's anger at this type of alteration (de Higes, 2014) is very revealing of both how unaware filmmakers are about what happens to their films in dubbing and also how powerless they are to change the decisions of the distributors, who often refuse to introduce subtitles for the L3 (in this case, Polish) in a dubbed film. In an interview about multilingualism in film translation conducted by Irene de Higes (2014), scriptwriter Paul Laverty and Ken Loach explained that dubbing is for them very problematic because it loses too much of the original performance, thus breaking the whole trust between filmmakers and the audience and undoing the fabric of the film. Laverty adds that they normally have no control over the distributors' decision to dub the film, and that he and Ken Loach are never consulted or talked to, so they know nothing about the dubbed version. Anticipating this problem in his multilingual film *Inglourious Basterds* (2009), Quentin Tarantino explicitly asked the Spanish distribution company to combine dubbing with subtitles in parts such as the pub scene, which is built around the use of languages (Sanz Ortega, 2015). The distribution company refused, arguing that the Spanish audience would not welcome the use of subtitles in a dubbed film. The resulting scene, fully dubbed into Spanish using different accents, bears little resemblance to the original. The millions of Spanish viewers who watched this scene on TV or in the cinema were effectively watching a different film.

When discussing the translation of multilingualism in film, translation scholars often advise translators to decide, first of all, the role and importance that multilingualism has in a particular film (De Higes-Andino, 2014). From the perspective of AFM, multilingualism is an ideal candidate for discussion between filmmakers and translators, who should not be burdened with the responsibility of having to take this decision themselves. As research in AVT has recently shown (Chaume, 2013), filmmakers and translators have several options at their disposal to deal with multilingual scenes in dubbing:

- *Dubbing L3 dialogue lines into standard L2*: Multilingualism is whitewashed in the translated film; that is, all characters speak Spanish in the dubbed version of *It's a Free World* (Loach, 2007).
- *Dubbing L3 dialogue lines into non-standard L2*: Multilingualism is marked only with a foreign accent; that is, Polish characters speak Polish-accented Spanish in the dubbed version of *It's a Free World* (2007).
- *Subtitling L3 dialogue lines into standard L2*: Multilingualism is marked through subtitles; for instance, if the dubbed version of *It's a Free World* (2007)

combined dubbed Spanish for the main characters and Polish with Spanish subtitles for the Polish characters.

- *Subtitling L3 dialogue lines into non-standard L2*: Multilingualism is marked through errors in the language of the subtitles; for instance, if the dubbed version of *It's a Free World* (2007) combined dubbed Spanish for the main characters and Polish with Spanish subtitles that contain errors and non-standard forms for the Polish characters. The problem here is that unless these errors are marked (for example with italics) the viewers could think that they have been made by the translator.
- *Subtitling L3 dialogue lines into L3*: Multilingualism is marked through subtitles; for instance, if the dubbed version of *It's a Free World* (2007) combined dubbed Spanish for the main characters and Polish subtitles for the Polish characters.
- *Voice-over*[1] *L3 into L2*: An unusual solution for fiction films.
- *No translation*: Often done in dialogue exchanges whose content is unimportant or can be easily understood from their context.

To complicate matters further, it is not uncommon to find films where the multilingual characters speak the dubbing language, that is, where L2 and L3 are the same. In the original version of *Toy Story 3* (Unkrich, 2010), the robot Buzz Lightyear is reset and starts speaking Spanish instead of English, thus baffling his friends. In the Spanish dubbed version, what causes the surprise of his friends, who in this version obviously speak Spanish, is his strong flamenco (or Andalusian) accent. In other cases, dubbing translators facing the same L2 and L3 opt for changing the words of the original dialogue or even the language, as in *The Devil's Advocate* (Hackford, 1997). In the original version, the character played by Al Pacino meets a gang of Latin criminals and speaks to them in Spanish, which in the Spanish dubbed version becomes Portuguese. Most of these solutions test the viewers' suspension of disbelief and can only work when there are no visual signs of the multilingual character's origin. The worst case scenario happens when the presence of the dubbed language in the original film is critical to the story plot or leads to misunderstandings between the characters. This is the case of *Spanglish* (Brooks, 2004), where the character played by Paz Vega teaches Spanish to Deborah (Téa Leoni) and they struggle to understand each other. In the Spanish dubbed version, Deborah speaks perfect Spanish for the entire film but in this scene, she uses a strange accent that makes her look as though she cannot speak Spanish, the only language that she seems to have.

The latter scene is an extreme example of the complexity involved in the translation of multilingual films and of the impossibility of finding a solution that can be true to the original film. Yet, a filmmaker may want to discuss with the translator the different options available for dubbing or, indeed, if there is any point in dubbing the film at all, instead of having it only subtitled. Admittedly, this decision is normally made by the distribution company, which in a way resembles the struggle for creative control often found in Hollywood between

filmmakers and studios (Harris, 2013). The difference is that, in the case of dubbing, most filmmakers are not aware of what is at stake and the extent to which their films may be altered in the dubbing process. As mentioned in Chapter 2, the Directors Guild of America states that "in no case will any creative decision be made regarding the preparation, production, and post-production of a motion picture without the consultation of the Director" (DGA, 2014, p. 202). The extent to which the filmmakers' voices are heard depends largely on their stature, but it is interesting to note here that the struggle for creative control leaves distribution (and thus translation) out of the equation. One cannot help but think that it is precisely the filmmakers' lack of awareness about the role played by translation in the nature and reception of their films that explains why distribution companies are calling the shots.

3.2.2 The impact of dubbing on the viewing experience

The issues discussed in the previous section (invisibility, synchronies, dubbese, multilingualism, etc.) are not always present in dubbing and, if they are, they do not always have a negative impact on the reception of the dubbed film. Indeed, despite being probably the most criticised (and even vilified) AVT mode for replacing the original actors' voices for other voices in another language, dubbing is the preferred choice for millions of viewers in countries such as Spain, Italy, France and Germany. Its success is not only commercial, as recent research shows that dubbing is also a very effective translation mode from a cognitive point of view (Perego, Orrego-Carmona, & Bottiroli, 2016; Wissmath, Weibel, & Groner, 2009) and it seems that (habitual) dubbing viewers still manage to suspend disbelief and become immersed in the fiction of film (Palencia Villa, 2002). Part of this success is due to the work carried out by the professionals in the dubbing industry, such as translators, dialogue writers, actors and directors, all of whom contribute to make dubbing work. This has been documented by Ávila (1997), Chaume (2004), Pavesi (2006), Sánchez Mompeán (2017) and Spiteri Miggiani (2019), amongst others. What remains to be seen is how viewers make dubbing work. How do we watch a dubbed film? How do we manage to suspend disbelief without being distracted by its artificial nature and by the mismatch between audio and visual elements? In short, what mechanisms do we activate to make dubbing work? This section sums up a recent study (Romero-Fresco, 2020) that for the first time provides empirical eye-tracking-based data on the reception of dubbed films. This is particularly relevant to AFM, as it shows evidence of how translation (in this case dubbing) can alter the viewers' experience, as predicted by some of the authors mentioned in Chapter 2.

3.2.2.1 Habituation, the suspension of disbelief and
the McGurk effect

Dubbing and subtitling are often said to be "a question of national habit and taste" (Zabalbeascoa, 1993, p. 248). Research shows that audiences seem to

prefer the translation method they are most familiar with (Bruls & Kerkman, 1989; Kilborn, 1993; Koolstra, Peeters, & Spinhof, 2002; Krämer & Eppler, 2018; Luyken, Herbst, Langham-Brown, Reid, & Spinhof, 1991). This may also explain the harsh criticism directed to dubbing by scholars and professionals who have not been brought up with this modality, which has been described as "a kind of cinematic netherworld filled with phantom actors who speak through the mouths of others" (Rowe, 1960, p. 116), "a stepchild of translation at best and no true son of literature at all" (ibid., p. 117), "the wedding of the phonetic beast to the literary beauty" (ibid., p. 117) and "a monster which combines the splendid features of Greta Garbo with the voice of Aldonza Lorenzo" (Borges, 1945). However, important as it may be, the notion of habit has often been used as a blanket argument that prevents us from having a more in-depth knowledge of the factors that account for the dubbing viewers' acceptance of this type of translation.

A useful concept in this regard is Gunning's idea of *habituation* (2003). Referring to the first exposure to new technologies, and thus applicable to film, Gunning explains that audiences go from wonder to knowledge to habituation and automatism, with the outcome of this habituation being "to render us unconscious of our experience" (ibid., p. 44). Wonder, "the first of all passions" (ibid., p. 15), draws our attention to the new technology as something that astounds us by performing in a way that seemed unlikely or magical before. This gives way to curiosity to understand how it works (knowledge), habituation after frequent usage and finally unconscious automatism. The case of film may be slightly different.

If consumed from a very early age, the sense of wonder (illustrated by Figure 3.3, from the Spanish film *El espíritu de la colmena*) is not necessarily followed by knowledge. When they are first exposed to film, children normally have no knowledge of the artifice involved in cinematic fiction, which means that they go straight from wonder into habituation and automatism. When interviewing young actress Ana Torrent

Figure 3.3 Shot from *El espíritu de la colmena* (Erice, 1973) showing young Ana, played by the child actor Ana Torrent, watching her first film in the cinema (*Frankenstein*)

during the casting of *El Espíritu de la colmena*, filmmaker Víctor Erice asked her if she had heard of Frankestein. Her reply ("Yes, but I've never met him") shows how the journey from wonder to habituation and automatism involved in film viewing does not need knowledge. By the time children learn about the prefabricated nature of cinema, film viewing has already settled as an unconscious experience whose enjoyment requires not questioning the reality of what they are seeing, that is, suspending disbelief. Crucially, dubbing audiences are exposed to both original and dubbed films from an early age. They are astounded by the magic of cinema (wonder), regardless of whether or not it is dubbed. The artifice of dubbing (the mismatch between audio and visuals, the inevitable lack of complete synchrony, etc.) is overlooked along with the artifice of cinematic fiction, as they go from wonder to habituation and unconscious automatism. By the time dubbing audiences learn about dubbing (just as when they learn about film), they have already internalised how to watch it without questioning it. In other words, getting used to dubbing, when it happens at an early age, is simply part of the (unconscious) process of getting used to film.

Closely linked to the notion of habit or habituation is that of tolerance. Even if a particular audience is used to dubbing, there is a tolerance threshold that must be respected with regard to at least two of the key dubbing constraints: synchrony and the naturalness of the dialogue. According to Rowe (1960, p. 117), this tolerance threshold may vary across countries:

> American and English audiences are the least tolerant, followed closely by the Germans. [. . .] The French, staunch defenders of their belle langue and accustomed to the dubbing process since those early days when rudimentary techniques made synchronization a somewhat haphazard achievement, are far more annoyed by slipshod dialogue than imperfect labial illusions. To the Italians, the play's the thing and techniques take the hindmost, as artistically they should.

A more updated take is provided by Chaume, who refers to a "threshold of acceptability" (2013, p. 15) that should not be overstepped, for which it is necessary to adhere to a series of quality standards (Chaume, 2007): compliance with synchronisation norms, the writing of credible and realistic dialogue, coherence between what is heard and what is seen, fidelity to the source text, technical adequacy of sound recording and appropriate performance and dramatisation of the dialogue. If these quality standards are met, the illusion of authenticity, or the illusion of an illusion involved in dubbing (Caillé, 1960, p. 108), can still be maintained, thus allowing the dubbing audience to suspend disbelief and become immersed in the fiction.

As for the notion of *suspension of disbelief*, it was originally coined in 1817 by the poet and aesthetic philosopher Samuel Taylor Coleridge, who suggested that if a writer could provide a fantastic tale with a "human interest and a semblance of truth", the reader would suspend judgement concerning the implausibility of the narrative. This term has since been used for film (Allison, Wilcox, & Kazimi, 2013) and AVT (Bucaria, 2008). Pedersen (2011, p. 22) applies it to subtitling, calling it a "contract of illusion" or tacit agreement between the subtitler and the viewers where the latter agree to believe "that the subtitles *are* the dialogue,

that what you read is actually what people say". In his definition of suspension of disbelief, Chaume (2013, p. 187) makes explicit reference to dubbing:

> a term referring to the reader/viewer's ability or desire (or both) to ignore, distort or underplay realism in order to feel more involved with a videogame, a film, or a book. It might be used to refer to the willingness of the audience to overlook the limitations of the medium (for example, that a film is dubbed), so that these do not interfere with the acceptance of those premises.

Closely related and also applied to dubbing are the notions of suspension of linguistic disbelief, that is, "the process that allows the dubbing audience to turn a deaf ear to the possible unnaturalness of the dubbed script while enjoying the cinematic experience" (Romero-Fresco, 2009, pp. 68–69), and that of suspension of paralinguistic disbelief (Sánchez Mompeán, 2017), the same process applied to the unnatural intonation sometimes found in dubbed films. According to these views, then, the suspension of disbelief works at different levels to allow viewers to be immersed in the dubbed fiction without being distracted by its prefabricated nature or by the potential lack of naturalness of its language or intonation.

From a psychological standpoint, the notion of suspension of disbelief is normally tackled as one more factor in a complex set of elements used to describe our involvement in different kinds of narratives. Drawing on Busselle and Bilandzic (2008), Fresno (2017) explains that in order to engage with a story, viewers must understand it and get immersed in it (see Figure 3.4). In turn, this requires two prerequisites or necessary conditions: interest in the filmic experience and suspension of disbelief or willingness to participate in it. Comprehension does not involve understanding every element in a film plot but just enough for the viewers to create and update mental representations of the fictional world, which, as per Johnson-Laird's mental model theory (1983), leads to comprehension. The immersion or psychological involvement with the narrative is facilitated by feelings of flow (Csikszentmihalyi, 1990), when the viewer is absorbed in the act of watching fiction, transportation (Green & Brock, 2000, p. 701), when "all mental systems and capacities become focused on events occurring in the narrative", presence (Biocca, 1997), the feeling of being in a mediated space different to where your body is located, and finally the viewers' disposition towards the characters (Raney, 2004; Zillmann, 1994). While it is harder to argue, as per identification theories (Cohen, 2001), that viewers experience the events on screen as if they were characters (which would mean that we may be urged to phone the police if a character is in danger), disposition theories explain how viewers develop affective dispositions towards the characters, depending on whether they like them more or less or feel closer or further from them.

In sum, it would thus seem that, when first exposed to dubbed films at an early age, viewers may feel a sense of wonder that leads to habituation and to an automatic and unconscious engagement with the dubbed fiction, facilitated by their ability to suspend disbelief, their interest in the story, some degree of

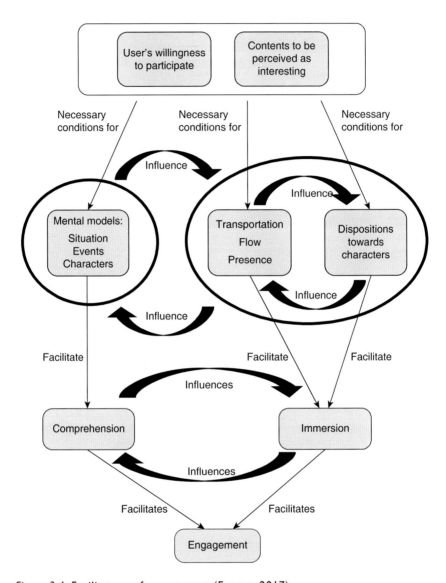

Figure 3.4 Facilitators of engagement (Fresno, 2017)

comprehension of the plot and a sense of immersion that involves feelings of flow, transportation and presence. This process of engagement is not affected by the discovery, years later, of the artifice involved in dubbing, since by then this path to engagement has already been unconsciously internalised as part and parcel of the process of watching film. However, the question remains as to whether this

process can explain why and how dubbing viewers do not seem to be put off by the inevitable lack of complete synchrony in the dubbing actors' lip movements and by the general discrepancy between audio and visuals. The McGurk effect, tackled in the next paragraph, would suggest otherwise.

The *McGurk effect* is generally regarded as one of the most powerful perceptual phenomena demonstrating the interaction between hearing and vision in speech perception. It is described by Smith et al. (2013) as "an auditory illusion that occurs when the perception of a phoneme's auditory identity is changed by a concurrently played video of a mouth articulating a different phoneme". A typical example would involve the audio of a given phoneme (such as /ba/) dubbed over a speaker whose mouth is visually articulating another phoneme (such as /ga/). Most subjects will report hearing /da/ even though the only sound that is heard is /ba/. Discovered by accident by Harry McGurk and John MacDonald in 1976, this phenomenon shows that speech perception is multimodal and that vision may sometimes be even more important than audio in the perception of sounds. From a neurological standpoint, the McGurk effect shows that information from the visual cortex instructs the auditory cortex which phoneme to "hear" before an auditory stimulus is received (Smith et al., 2013). This is generally regarded as a robust effect, that is, knowledge about it does not seem to eliminate its illusion. The effect has been shown to apply under very different conditions, including different viewers' profiles, audiovisual cross-dressing (combination of female faces and male voices), cross-cultural comparisons and even speakers standing on their heads (Massaro & Cohen, 1996). Partly due to this phenomenon and to the prevalence of vision in the perception of sound, Navarra (2003) shows that even full sentences are difficult to process when there is a mismatch between visuals and audio, given that the viewer's attention is unavoidably directed to the asynchronous lip movements.

This begs the question of how dubbing can possibly work for the viewers if (1) the McGurk effect is so robust that it works across cultures, languages and in the most varied contexts and (2) the mismatch between visuals and audio in on-screen faces draws the viewers' attention to the asynchronous lips and makes it difficult to understand and process single words and even sentences. As suggested by Evan (2016), "experimental psychologists should investigate how viewers manage to switch off the lip-reading without even being aware of what they are missing". Could it be that dubbing viewers are amongst the few individuals who have managed to switch off the McGurk effect so as not to be distracted by the asynchronous combination of sound and image? Have they found a way to avoid being put off by the mismatch between lips and audio or do they simply not look at the lips? Should the latter be true, is this a conscious mechanism and can the above-mentioned early acquired habit of viewing dubbed films and the ability to suspend disbelief account for this? The answers to some of these questions may be found in the eye-tracking study presented in the next section.

3.2.2.2 Dubbing and eye tracking: the dubbing effect

There is ample scientific research showing how we normally look at faces and especially the viewers' distribution of attention between eyes and mouth. Both early studies (Buswell, 1935; Yarbus, 1967) and more recent research on face processing and the perception of gaze (see reviews by Langton et al., 2000; Birmingham & Kingstone, 2009) have shown that we tend to focus on faces and, more specifically, on eyes, when looking at other human beings. This may be partly explained by the visual saliency and social importance of eyes (A. Senju, Hasegawa, & Tojo, 2005; Atsushi Senju & Hasegawa, 2005). However, most of this research has focused on static images, rather than dynamic viewing. Recent research performed on dynamic face viewing suggests that this attention bias may be task dependent and not exclusive to the eyes (Buchan, Paré, & Munhall, 2007; Gosselin & Schyns, 2001). It seems that there is no such thing as a general bias to look at someone's eyes since, at least during dynamic face viewing, "gaze follows function" (Võ, Smith, Mital, & Henderson, 2012, p. 12). Thus, our gaze is often directed to the eyes when we are asked to perform emotion judgements and to the mouth when we are asked to recognise speech (Buchan et al., 2007). In other words, we seem to adjust our gaze allocation dynamically "for the purpose of seeking information on an event-to-event basis" (ibid., p. 11). When viewing speaking faces in close-ups, mouths seem to attract between 29% and 35% of the gaze allocation, whereas the remaining 71% to 65% is spent on the eyes (Foulsham & Sanderson, 2013; Võ et al., 2012). The percentage of time fixating the mouth has been shown to increase when there is background noise (Buchan et al., 2007), low linguistic competence (Robinson, Stadler, & Rassell, 2015) or poorly synched lips (Smith, Batten, & Bedford, 2014), which is not too dissimilar to what happens in dubbing.

To date, and despite a few applications of eye-tracking technology to dubbing (Elisa Perego et al., 2016; Vilaro & Smith, 2011), no research has yet analysed and compared how viewers watch faces in original and dubbed films. This is the aim of the experiment presented here, whose findings, along with the above-included discussions on habituation, suspension of disbelief and engagement, intend to provide a picture of how viewers receive dubbing and how they make it work. On the one hand, it may be logical to expect viewers to allocate an unusually high amount of attention (perhaps more than the above-mentioned 30%) to the characters' mouths, as suggested by (1) what has been learnt so far about the perception of speaking faces, (2) the mouth bias triggered by speaking faces with poorly synched audio and (3) the focus on lips caused by the McGurk effect in a situation of mismatch between image and audio. However, excessive focus on the characters' mouths may also put off dubbing viewers, making it difficult for them to suspend disbelief and engage with the film. As a result, the hypothesis for this study is that given our tendency to (1) lip read and be confused by asynchrony as per the McGurk effect and (2) look at both eyes and mouth in moving faces, we have taken an unconscious decision not to look at mouths in dubbing (because there is no useful information to be obtained from there) in an attempt, aided by an early acquired

and subconsciously internalised dubbing viewing habit, to suspend disbelief and be engaged with the dubbed fiction.

In this study (Romero-Fresco, 2020), the eye movements of a group of 20 native Spanish participants watching a 6-minute clip from *Casablanca* (Curtiz, 1942) dubbed into Spanish featuring close-ups was compared to (1) the eye movements of a group of 15 native English participants watching the same clip in English and (2) the eye movements of the Spanish participants watching an original clip in Spanish from *Todo sobre mi madre* (Almodóvar, 1999), which is comparable in terms of duration, speech rate, type-token ratio, lexical density, syntactical complexity, number and percentage of close-ups. This analysis on distribution of attention was complemented by data on the participants' comprehension, sense of presence and awareness/perception of eye movement when watching these clips. Although for ease of reading this section does not include statistical data, a full statistical analysis can be found in the original article (Romero-Fresco, 2020).

While the English participants watching the original version of *Casablanca* (see Figure 3.5) showed a very similar distribution of attention (76% on eyes vs. 34% on mouth) to the one obtained by Võ et al. (2012) (76% vs. 34%) and Foulsham and Sanderson (2013) (71% vs. 29%), the viewing patterns of the Spanish participants watching *Casablanca* dubbed into Spanish are significantly different: 95% on eyes and 5% on mouths (see Figure 3.6). This extreme focus on the eyes/

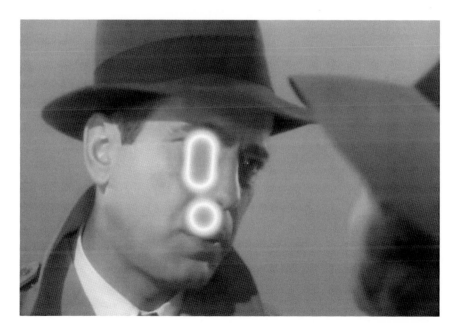

Figure 3.5 Distribution of attention between eyes and mouth by the English group watching an original clip from *Casablanca*

Figure 3.6 Distribution of attention between eyes and mouth by the Spanish group watching a dubbed clip from *Casablanca*

Figure 3.7 Distribution of attention between eyes and mouth by the Spanish group watching an original clip from *Todo sobre mi madre*

negative mouth bias is unlike anything found so far in the literature and very different to the way in which the Spanish participants view faces in the original Spanish film used in the experiment (see Figure 3.7), where, right after watching the dubbed clip, they show the same distribution (76% vs. 34%) found in the literature and in the English group watching the original version of *Casablanca*.[2]

This pattern changes in close-ups with no dialogue, where the eye movements of English and Spanish participants watching *Casablanca* finally converge. English participants move away from the mouth and focus more on the eyes (82.6% on eyes vs. 17.4% on mouth), which are likely to convey most of the meaning now that the mouth is not moving, whereas the Spanish participants finally look down to the mouth (85.8% vs. 14.2%). It is as though the dubbing viewers, aware of the mismatch between images and sound in dubbed close-ups with dialogue, refused to look at mouths, which does not apply to original films or to dubbed films when there is no dialogue. Interestingly, this intricate strategy seems to be unconscious, as there is no correlation between perceived and real distribution of attention between eyes and mouth. The Spanish viewers believe they spent 42% of their time looking at mouths in the dubbed version of *Casablanca* and 40% in the case of *Todo sobre mi madre*, while in fact they spent 5% and 23%, respectively. In the qualitative interviews after the study, many of them insisted that they had spent almost half of their time looking at the mouths in the dubbed clip of *Casablanca*, until they were confronted with the replay of their fixations. This means that (1) there is a significant discrepancy between where the participants think they are looking and where they are actually looking and (2) the strategy to avoid looking at mouths in dubbed close ups with dialogue but not in original films, known here as the *dubbing effect*, is an unconscious one.

Two more aspects may be worth discussing, even though the lack of statistical evidence means that they must remain as no more than anecdotal data or avenues for future research. Firstly, while most of the Spanish participants live in Spain and have regularly watched dubbed films throughout their lives, one of them, excluded from the analysis as an outlier, has lived in London for the past 20 years, a time during which she has not been exposed to dubbing. Her distribution of attention (55% on eyes vs. 45% on mouth) shows an unusually high focus on the characters' mouths, not only more than the other Spanish participants watching *Casablanca* but also than the English participants and than the evidence found so far in the literature. Her lack of regular exposure to dubbed films may be preventing her from ignoring the imperfectly synchronised lips and from becoming immersed in the film (her sense of presence is only 2.8/5, as compared to an average of 3.7/5 from all participants). Should this data be replicated and verified with other participants in the same situation, it could suggest that for dubbing to work (and for the dubbing effect to apply), it is necessary to have continuous exposure to dubbed products. Or, more accurately, prolonged lack of exposure to dubbing may cause viewers to lose the habit of focusing mainly on the characters' eyes, thus drawing their attention to the asynchronous mouths and having a negative impact on immersion and suspension of disbelief.

Secondly, it was observed that when Humphrey Bogart's character Rick says the line "Here's looking at you, kid", the English participants largely turn their attention to the character's mouth (65% on the mouth, as opposed to 24% in the rest of the clip). Again, more data would be needed to draw solid conclusions, but it may be that the recognition of the most famous line of the most quoted film in history, so often written and read in other contexts, has drawn the participants' attention to the signifier rather than the signified, to the physical form of the words and the place where they are uttered, the character's mouths, rather than to their meaning and the emotions they express, which are more often identified with the character's eyes. This pattern has not been found in the Spanish dubbed version, which may be explained by the fact that, as mentioned in Chapter 2, the Spanish translator opted for four different translations for the four key moments in which this line is said in the film, as a result of which there has never been an iconic equivalent in Spanish for "Here's looking at you, kid". In other words, there is no signifier to draw the viewers' attention to. At any rate, this mouth bias caused by iconic lines is at this stage no more than just an assumption that needs to be verified with further research.

To conclude this section on the impact of dubbing on the viewers' experience, although dubbing is regularly criticised for its artifice and its manipulation of film sound, it has proved to work and to be the preferred mode of AVT for millions of viewers. Research in this area has explored at length the way in which the professionals involved in dubbing (translators, dialogue writers, actors, etc.) make it work, often managing to strike a delicate balance between conveying the meaning and form of the original script and maintaining the illusion of synchrony. What has been overlooked so far is the process undergone by the viewers to make it work. It would seem that, when first exposed to dubbed films at an early age, viewers may feel a sense of wonder that leads to habituation and to an automatic and unconscious engagement with the dubbed fiction, facilitated by their ability to suspend disbelief, their interest in the story, some degree of comprehension of the plot and a sense of immersion that involves feelings of flow, transportation and presence. This process of engagement is not affected by the discovery, years later, of the prefabricated nature of dubbing, since by then this path to engagement has already been unconsciously internalised. Getting used to dubbing, when it happens at an early age, is simply part of the (unconscious) process of getting used to film. As for the question of how dubbing viewers manage to switch off the powerful McGurk effect and thus avoid being confused or distracted by the mismatch between lips and audio, a potential answer may lie in the results of the eye-tracking study presented here, which show that the Spanish participants watching a dubbed scene from *Casablanca* have an extreme negative mouth bias, with 95% of attention on the characters' eyes and only 5% on their mouths. This is in sharp contrast with their perception of how they watched this scene (58% on eyes vs. 42% on mouths), with their own viewing patterns watching a comparable scene in Spanish (76% vs. 34%), with the viewing patterns of the English participants watching the same scene from

Casablanca (76% vs. 34%) and with the data obtained so far in the literature for both film and real-life scenes.

Although in need of further research with larger and different samples, these results, similar to those obtained in Di Giovanni and Romero (2019) with Italian participants, point to the potential existence of a *dubbing effect*, an unconscious eye-movement strategy performed by dubbing viewers to avoid looking at mouths in dubbing, which prevails over the natural and idiosyncratic way in which they watch original films and real-life scenes, and which allows them to suspend disbelief and be transported into the fictional world. Although not conscious, this mechanism seems to be activated only with dubbed films and is then turned off when watching an original film, where the viewing pattern is aligned with eye movements in real life. From this point of view, there is a quasi-Darwinian quality to this effect, which enables viewers to adapt their viewing patterns in order to "survive" in the dubbing environment, that is, in order to overcome the danger of being put off by the asynchronous nature of dubbing, and thus achieve the ultimate goal of being engaged with the fictional story.

It is hoped that, at least as far as dubbing is concerned, the content of this section can provide filmmakers with the necessary tools to discuss the translation of their films with translators,[3] and, if need be, have a say in the way in which they should be distributed. Only then can there be a guarantee that the millions of dubbing viewers watching films around the world can have access to the film as originally conceived by the filmmakers.

3.3 Voice-over and the translation of documentaries

The term voice-over originated in film studies and has been used in many different contexts: from the lecturers (or *benshis*, in Japan) who used to provide live narrations for silent films, to narrations provided for fictional, educational, commercial and news content. In translation, *voice-over* refers to the revoicing of a film (often a documentary) in another language, delivered simultaneously and in synchrony with the original speech (Franco, Matamala, & Orero, 2000). Unlike dubbing, voice-over translation does not abide by lip synchrony and it does not eliminate the original dialogue, whose volume is lowered but which can often be heard at the beginning and sometimes also at the end of every translated utterance. Although in some East European countries, voice-over is used as the main translation modality in fictional programmes, in most West European, North American and Latin American countries voice-over is used for factual genres, such as news, documentaries, talk shows and political debates.

Voice-over is, along with subtitling, the main translation mode for documentaries, although dubbing has also been used for documentaries belonging to the so-called New Documentary wave that have been released in cinemas, such as *An Inconvenient Truth* (Guggenheim, 2006). The choice of one of these three modes

(voice-over, subtitling or dubbing) is bound to have an impact on how the film is received by the foreign audience. Dubbing places the documentary closer to fiction films and it will be subject to the constraints, dilemmas and issues described in the previous section. Perhaps because it does not delete the original dialogue, voice-over is seen as a trustworthy translation mode, one that contributes to the reality, truth and authenticity of factual programmes in order to prove that their arguments are right or believable. For this reason, voice-over is generally regarded as a faithful, literal, authentic and complete version of the original audio. This notion of legitimacy goes some way towards explaining why voice-over is used in non-fictional genres such as documentaries. However, voice-over presents a series of constraints that challenge this claim to faithfulness. First of all, except for a few seconds at the beginning and at the end of every utterance, the original audio cannot really be heard by most viewers, which means that there is certain leeway for manipulation of the content if this was the intention. Secondly, the pretended literalness of the translation is compromised by the need to achieve a series of synchronies. Although the translation does not have to match the speakers' lips, it does have to be voiced in the same amount of time as the original, or slightly less time so as to let the audience hear the original speech at the beginning and end of every utterance. Because of this, the translator is often forced to provide a reduced version of the original audio, unlike in dubbing and as in subtitling. Finally, a voice-over translation must also take into account the synchrony between sound and images. For instance, a natural translation into Spanish of "the criminals and the members of the violent gang were finally sent to prison by the judge" may start with "the judge" ("the judge finally sent to prison the criminals and the members of the violent gang"). However, if the documentary in question shows an image of the criminals over the audio "the criminals and the members of the violent gang" and an image of the judge over "were finally sent to prison by the judge", a less natural translation starting with "the criminals" may need to be used in the Spanish voice-over in order to keep the synchrony with the images.

Apart from adhering to these synchronies, voice-over translation tends to adopt a series of conventions, such as eliminating speakers' hesitations and accents. If filmmakers wish to maintain either of these elements in the translated versions of their films, they may need to point this out to translators. Furthermore, unlike in dubbing, emotions also tend to disappear in voice-over. The translated voice offers a steady and homogeneous delivery that is normally devoid of signs of happiness, fear, sadness, variations in volume and pace and, in general, any alteration of intonation. An exception for this can nowadays be found in reality shows such as *Geordie Shore* (Readwin, Regan, Reynolds, Taylor, & Wood, 2011), where voice-over actors are beginning to add emotion to their delivery in a way that is blurring the line between dubbing and voice-over. Although this may only be a temporary issue, the choice of this "emotional voice-over" for a documentary can potentially make it sound to the foreign audience as a reality show, a connotation that filmmakers may need to be aware of. Voice-over translation also has to

deal with some of the challenges faced by dubbing, such as the use of dubbese (unnatural language) and the translation of songs, language variation and multiple languages in the original script (see Section 3.2). All these elements are very likely to have an impact on the nature and reception of a documentary translated with voice-over and should be included in the discussion between filmmakers and translators.

Finally, filmmakers should also be aware that the choice of a translation modality (dubbing, voice-over, subtitling) also carries a significant political and ideological connotation, especially in the case of documentaries. As mentioned in Chapter 2, until the early 1960s, ethnographic documentaries such as those made by Jean Rouch had normally resorted to dubbing and especially voice-over for translation. Filmmakers appreciated this translation mode because it meant that viewers could look and listen, just as the original viewers, without having to read subtitles (Barbash & Taylor, 1997). Voice-over translation also allowed the translation of several voices at the same time, but it made it very difficult to convey the rhythm, inflections, nuances and background information of the participants in the film. In order to solve this issue, filmmakers John Marshall and Tim Asch started to use subtitles in their documentaries. This enabled them to build a closer relationship with their participants and to portray them as individuals, without the need for a "voice on the soundtrack telling you what to think about them" (MacDougall, 2001, p. 88).

Needless to say, no translation mode is perfect, and subtitling presents many challenges, as will be shown in the next section. Nowadays, dubbing countries tend to choose dubbing, voice-over and, to a much lesser degree, subtitling for the translation of documentaries, whereas subtitling countries opt for subtitles. For some scholars, this is not just a linguistic choice, but an ideological one. By having their film dubbed, filmmakers are choosing to "hide" the process of translation and to present the translated film almost as though it was the original version. The original documentary is domesticated and brought closer to the viewers, who do not need to make an effort to get familiarised with "the foreign", as the foreign is presented through the national language. While this method maintains the original viewing experience of looking and listening, it can also potentially contribute to an imperialistic view of culture. American or British viewers of a hypothetically dubbed version of *The Act of Killing* (Oppenheimer, 2012) would thus become familiarised with the horrors of the Indonesian genocide through their own English language, with no access to the original voices, intonations and emotions.

Whatever the choice of translation modality, which is not always up to the filmmakers, adopting an AFM approach seems particularly relevant and appropriate in documentary filmmaking. Unlike in fiction films, where translators deal with scripts that are usually prepared before production, documentary filmmakers often develop a direct and personal relationship with their participants. The ethical implications of potential mistranslations are thus amplified, as, for instance, the subtitles are an essential element in the accurate

representation of those on screen. This raises very important questions regarding the filmmakers' and translators' responsibility in the representation of the people in the film:

> The common, and often inevitable requirement to outsource the creation of various foreign language versions of films can result in removal of the director from any translation and subtitling debate, thus shifting ultimate responsibility for the translation and the representation of the characters involved in the film away from the person with whom the people in the film have entrusted their stories. Fully understanding the implications and procedures of subtitling, recognising the key role of the director in any debate, and understanding one's own ideological perspective within the creation of the subtitles and the film as a whole is, I suggest, critical to mitigating the obvious dangers and harm mistranslation, and misrepresentation can entail.
>
> (Cole, 2015, p. 148)

In other words, it could be argued that the inclusion of translation and accessibility in the production process is not only an issue of quality but also one of responsibility and trust for filmmakers towards their participants and their stories. From this point of view, relegating translation to the distribution process, as is normally the case nowadays, may be seen not so much as a delegation but an abdication of responsibility by filmmakers, who indirectly burden translators with a task for which they are not properly prepared nor duly remunerated.

3.4 Subtitling

Subtitling is a translation practice that consists of presenting a written text (normally at the bottom of the screen) that aims to recount the original dialogue of the speakers, discursive elements that appear in the image (letters, inserts, inscriptions, etc.) and the information that is contained on the soundtrack, such as songs, voices off, etc. (Díaz Cintas & Remael, 2008, p. 8). Subtitling was introduced along with dubbing at the end of the 1920s, with the arrival of sound films, and it may be regarded as an adaptation of the intertitles used in silent films. Since then, it has become the main translation modality in most countries around the world, and it is used in certain cinemas, on TV and on online platforms in dubbing countries as an alternative translation mode. Furthermore, it is the main form of access for viewers with hearing loss and/or learning disabilities.

Unlike dubbing, subtitling requires a certain level of literacy and is *visible*. The original dialogue is there for the viewers to hear, which often leads to complaints by those who can understand (totally or partially) the original language that the subtitles do not match what is said by the characters. Often, the reason for this may be found in the expectations and constraints inherent to subtitles.

They are supposed to be a synchronous and linguistically faithful account of the original dialogue but, at the same time, they must abide by strict time and space requirements in order to allow viewers to read the subtitles and look at the images on screen. Many of these requirements may be found in commonly used guidelines such as the "Code of Good Subtitling Practice" (Carroll & Ivarsson, 1998, pp. 157–159), "A Proposed Set of Subtitling Standards in Europe" (Karamitroglou, 1998), *Audiovisual Translation: Subtitling* (Díaz Cintas & Remael, 2008) and, in the case of SDH, the "BBC Subtitle Guidelines" (Ford Williams, 2009). As noted by Szarkowska (2016), subtitles are typically required to have no more than two lines (with a total of 37–42 characters per line) displayed over a maximum of 6 seconds, in other words, a maximum speed of 12–16 characters per second (cps) or 150–180 words per minute (wpm).[4] The fact that spontaneous and scripted speech is often faster than 180wpm and that overlapping dialogue can double up this figure explains why a reduction of around at least 20% of the original dialogue is a common occurrence in subtitled films (Gottlieb, 1990, p. 44).

Other constraints imposed on subtitling in order to allow the viewers enough time to read the subtitles and watch the images relate to (Díaz Cintas & Remael, 2008, pp. 81–98):

- The segmentation of the two subtitle lines, which must be done according to linguistic criteria, so that the eye can move smoothly from one line to the next.
- The gap between successive subtitles, which is normally at least 1 second for the eye to detect that there is a new subtitle on the screen.
- Shot changes. Whereas the absence of a gap between subtitles may prevent viewers from noticing that a new subtitle has been displayed, leaving a subtitle over a shot change tends to cause re-reading (the viewers scan the new shot and read the subtitle again), thus leaving less time to look at the images. Research (see Figure 3.8) shows that the average shot length in film has decreased dramatically over time, from an average of 10–12 seconds in 1930 to about 2.5 seconds today, with musicals or action films such as *Resident Evil 2* (Witt, 2004) or *Moulin Rouge* (Luhrmann, 2001) showing an average of 1.9 seconds and 1.6 seconds, respectively (Salt, 2009). Needless to say, it becomes almost impossible not to display subtitles over shot changes in these films, which means that, as is the case in any other type of film translation, subtitlers must find a compromise between the different and opposing constraints.

Take for example the following line said by Alan (Woody Allen) in *Annie Hall* (Allen, 1977):

Sylvia Plath, interesting poetess whose tragic suicide was misinterpreted as romantic by the college-girl mentality.

Figure 3.8 Evolution of average shot length in films through history (Salt, 2009, p. 378)

These are 116 characters uttered in 6 seconds, which results in a speed of 19cps. An English to Spanish translation with the usual reading speed limit of 15–16cps would only cover:

> Sylvia Plath, interesante poetisa, cuyo trágico suicidio fue malinterpretado como romántico. (Sylvia Plath, interesting poetess whose tragic suicide was misinterpreted as romantic).

Here, as on so many occasions, translators must decide what to leave out, thus risking criticism by viewers who are familiar with the original language but not with the constraints at play in subtitling. At any rate, it is important to remember that subtitles are meant to be viewed along with images (and the clues obtained from the soundtrack), which can help the translator. In the example above, if the camera shows the book with the author's name on the cover, the subtitler may not need to start the translation with "Sylvia Plath".

From the point of view of filmmaking, as well as understanding why subtitles often have to condense the original dialogue, what is perhaps particularly interesting to bear in mind is how subtitling can impact on the content of the film and on the way in which it is physically viewed by the spectators.

3.4.1 The impact of subtitling on the film's content

The impact on the content is not dissimilar to that of dubbing and relates to the particular language used in subtitling and the presence of songs, language variation and multilingualism.

Just as scripted dialogue is normally less natural than spontaneous dialogue, subtitled dialogue is usually less natural than scripted dialogue. This is explained both by the above-mentioned constraints and by the transformation of oral speech into writing. The constraints involve the reduction and therefore the common loss of discourse markers such as "well," "I mean," "you know" and other interpersonal elements (Hatim & Mason, 1997, p. 79). The transition from speech into writing means that certain oral features are omitted and that subtitling is seen as written language, more formal than speech. As a result, in *subtitlese* grammar and lexical errors tend to be cleaned up, whereas interactional features and intonation are only maintained to some extent (e.g. through word order, rhetorical questions, occasional interjections and incomplete sentences) (Díaz Cintas & Remael, 2008, p. 63).

The presence of *songs* in a film forces the subtitler to consider what must be translated and how, a decision that may be easier if it was informed by a discussion with the filmmaker. Normally, subtitlers work on the basis that if a song with lyrics has been included in a film, it is normally for a purpose, so it must be subtitled. Some exceptions may be cases in which the subtitling audience may be expected to know the song and understand it (especially when the lyrics do not contribute much to the story) or songs that overlap with speech or credits, which normally take precedence over the subtitles of the lyrics. Once the decision to translate lyrics has been taken, challenging issues of how to tackle content, rhythm and rhyme arise (Franzon, 2008). As for *language variation*, as explained in the section on dubbing, filmmakers using different registers (colloquial, informal, formal, etc.) and geographical, temporal, social or individual dialects should be aware that subtitling tends to neutralise some of these features (Ellender, 2015), while making occasional use of certain elements that hint at the fact that a different type of language may be used by one or some of the characters. One of the clearest examples of this difference between original film dialogue and subtitles can be found in swearwords, which are considered to have a stronger impact in writing than in oral speech and are thus often omitted (Mattsson, 2006) or toned down in translation (Han & Wang, 2014). Filmmakers wishing to maintain in the subtitles specific aspects of language variation used in their original films may have to discuss this with translators, so as to find potential ways in which this can be done.

Finally, the presence of *multilingualism* in the original film is also an issue in subtitled films (Bartoll, 2006; Zabalbeascoa Terran & Corrius, 2014). Although in the currently prevailing model of industrial subtitling it is normally subtitlers who decide the role and importance of multilingualism in a film, this should be part of the discussion between filmmakers and subtitlers implementing the AFM model. The first decision concerns whether or not the presence of one or more languages (L3) in the original film must be marked in the subtitles. These are some of the options available for filmmakers and translators (De Higes-Andino, 2014):

- *Subtitling L3 dialogue lines into standard L2 (no special typography)*, as in the English version of the award-winning Spanish film *Handia* (Garaño &

Arregui, 2017), which included standard English subtitles for the dialogue in Spanish and Basque. Following a conversation about AFM with the author of this book, the filmmakers realised that many English-speaking viewers did not notice that two languages were being spoken in the original version, which is an essential aspect of the protagonists' characterisation in the film. They then decided to change this version and opt for the use of a label in brackets to indicate change of language.

- *Indicating/naming the L3 in brackets*, as in the amended English version of *Handia* (2017). In this case, the multilingualism is maintained and the audience knows for sure what the L3 is.
- *Subtitling L3 dialogue lines into standard L2 with a different font or colours*. The latter device was used in *Biutiful* (González Iñárritu, 2010).
- *Subtitling L3 dialogue lines in L3*. This strategy is normally used when only some words are uttered in the L3. It is useful for language-learning purposes.
- *Subtitling dialogue lines into non-standard L2*. As in the case of dubbing, the problem here is that, unless these errors are marked (e.g. with italics), the viewers could think that they have been made by the translator.
- *No translation*. This is often done in dialogue exchanges whose content is unimportant or can be easily understood from the context. It can also be found in films that focus on issues of communication and incomprehensibility, such as *Bamako* (Sissako, 2006).

What is important to remember here is that subtitles are often used in the original version of many multilingual films in order to mark the presence of different languages. The absence of subtitles or the use of subtitles with a different strategy in the translated version would thus show a glaring contradiction between the film as received by the original viewers (and conceived by the filmmaker) and the film received by the foreign and deaf and hard-of-hearing audience.

3.4.2 The impact of subtitling on how we watch a film

The question of how viewers watch a film has concerned professionals and scholars since the very beginning of cinema. Filmmakers, cinematographers and editors often make educated guesses as to how the spectators will view a particular shot or scene, which may have an influence on their decisions. However, it was not until the introduction of eye-tracking technology that we began to have hard evidence about how viewers really watch film. The use of eye tracking, which is nowadays one of the most popular methods of studying film cognition through psychological investigation (Smith, 2015), seeks to quantify a viewer's experience of a film, analysing different viewing conditions and the way in which cinematic elements impact on where viewers look. This enables researchers to gain insight into how film works and how it is perceived by the audience, while

also serving as "a test bed for investigating complex aspects of real-world cognition that were often considered beyond the realms of experimentation" (ibid.). This section gathers some of the key eye-tracking-based findings obtained so far about how viewers watch original films and compares them with similar studies on subtitled films in order to see if and how the presence of subtitles may have an impact on the foreign and deaf audiences' viewing patterns.

3.4.2.1 Original films

Contrary to what may be thought, our eyes do not move smoothly across the page, the screen or whatever we are looking at. Instead, they focus on specific parts and then jump across words, images and objects. The pauses when the eyes remain still for about 0.25 seconds are known as *fixations* (the red dots in Figure 3.9), and it is only then that we manage to see something. The jumps between fixations are known as *saccades* (the lines in Figure 3.9), which take as little as 0.1 seconds and are the fastest movement the human being is capable of making (Rayner & Pollatsek, 1989). In other words, just like in film the quick

Figure 3.9 Eye-tracked shot showing a combination of dots (fixations) and lines (saccades) that represents how we view images

Figure 3.10 Example of viewers' focus on centrally positioned faces

succession of still pictures gives us the illusion of movement, our apparently continuous vision is in reality made up of quick stills obtained by our eyes. The fact that both film and our vision resort to the same device may go some way towards explaining how real and effective the illusion of cinema can be for the viewers.

The main findings from the analysis of original films so far show that the viewers' gaze is often focused on the central features of a traditionally composed film (see Figure 3.10), with a particular bias on faces (where eyes are favoured over mouths) and moving objects (Smith, 2013; Treuting, 2006). These movements are in line with the patterns found for facial and emotional recognition (Ekman & Friesen, 1971; Hernandez et al., 2009).

Eye movements in film viewing can be voluntary or involuntary. Voluntary or top-down movements are caused by the tasks we take on when we watch a film, for example to maintain our interest and to comprehend the story (Bordwell, 2011a). Our top-down hypotheses about what is going on and what will happen next inform what we look at, when and how we look at it. This is illustrated in an experiment conducted in 1965 by the Russian psychologist Alfred Yarbus, who asked participants to look at Ilya Repin's classic painting *They Did Not Expect Him* (aka *An Unexpected Visitor*, 1884; Figure 3.11).

Firstly, Yarbus let his subjects view the picture without any instructions and then asked them to look at it while assessing, amongst other aspects, the material

Figure 3.11 Ilya Repin's painting *They Did Not Expect Him* (1884)
Source: Courtesy of www.ilyarepin.org.

circumstances of the family, their age and the time the visitor has been away for (Figures 3.12–3.15).

As can be seen in the pictures, the viewers' eyes explore the image and mainly focus on faces when looking freely (Figure 3.12), focus on clothes when assessing material circumstances (Figure 3.13) and focus almost exclusively on faces to assess age (Figure 3.14). The journey back and forth between faces and especially the focus on the children is the key to guessing how long the man has been away (Figure 3.15): longer than the age of the girl, who does not seem to recognise him, but shorter than the age of the boy, who seems happy to see him.

This experiment shows that we vary our viewing patterns depending on the tasks we take on. In fact, we are sometimes so focused on these tasks that we

Figure 3.12 Look freely

tend to ignore other aspects. This leads to the so-called *inattentional blindness*, which shows that, when watching a film, we often miss what we are not looking for. This explains why the gorilla is missed in the famous experiment by Chabris and Simons (2010) and why so many continuity and technical inconsistencies in film go unnoticed by the viewers. Conversely, if a filmmaker wants the viewers to focus on an unexpected element placed outside the main point of attention, they should be aware that inattentional blindness will make it difficult to happen.

Involuntary eye movements are also key to understanding how we watch films. In fact, often what we think are voluntary movements are in reality involuntary ones. This is the *illusion of volition* (Bordwell, 2011b) that makes us believe that we are free to look where we want, when in reality our choice is manipulated by the cinematic tools used by the filmmaker, such as "sound, especially dialogue; camera movement, which is constantly redirecting our attention; and

Figure 3.13 Assess material circumstances

figure movement, which is a powerful eye-catcher" (ibid.). Other elements that inform our gaze patterns and fixations are characters' point of view and subjective experiences (Rassell et al., 2015), editing techniques (Smith & Mital, P. K., 2011) and the layout of the mise en scène (Marchant, Raybould, Renshaw, & Stevens, 2009).

The scene from *There Will Be Blood* (Thomas Anderson, 2007) analysed by David Bordwell (2011b) in his blog is a case in point. It also illustrates two phenomena that have been observed in eye-tracking studies on film cognition: *edit blindness* (Smith & Henderson, 2008), whereby the viewers miss many of the cuts in films edited according to the classical rules of continuity editing, and *attentional synchrony* (Smith & Mital, 2013), which shows that the viewers' gaze is often synchronised on the same areas of the screen. Indeed, the viewers' fixations at the beginning of a shot tend to be central and long, whereas there

Figure 3.14 Assess ages

seems to be greater exploration of the screen and less attentional synchrony as the shot duration increases (Mital, Smith, Hill, & Henderson, 2011). This is usually known as the *visual momentum* of the image: the pace at which visual information is acquired (Hochberg & Brooks, 1978). However, as shown in Figures 3.16 and 3.17, although there may be greater exploration of screen as the shot lingers, most viewers take in roughly no more than 3.8% of the total screen area during an average-length shot (Smith, 2013) and they show a clear tendency for viewing in detail only restricted parts of the overall image (Dorr, Martinetz, Gegenfurtner, & Barth, 2010).

Peripheral processing is at play, but it is "mostly reserved for selecting future saccade targets, tracking moving targets, and extracting gist about scene category, layout and vague object information" (Smith, 2013, p. 168). Filmmakers who wish to direct viewers' attention to peripheral areas of the screen may have

Figure 3.15 How long has he been away?

Figures 3.12–15. Ilya Repin's painting *They Did Not Expect Him* (1884) viewed by participants looking freely (3.12), assessing material circumstances (3.13), assessing ages (3.14) and ascertaining how long the visitor has been away (3.15)

to take this into account and, for example, extend the shot to allow the viewers to move from the central points of the shot to the margins.

The question now is: What happens in subtitling? How do these viewing patterns compare to those of a foreign viewer watching a subtitled version of the same film? And what about deaf and hard-of-hearing viewers? Recent research (Coutrot, Guyader, Ionescu, & Caplier, 2012; Rassell et al., 2015; Robinson et al., 2015) shows that the use of sound in film helps to concentrate the viewers' attention and increase attentional synchrony, whereas the absence of sound results in higher dispersion and more variability between observers' positions. Do deaf and hard-of-hearing viewers, who have limited or no access to the soundtrack, show a greater degree of dispersion when watching a film than hearing viewers, or

Figures 3.16 and 3.17 Original shot from *There Will Be Blood* and the same shot showing the viewers' focus

does perhaps the need to read subtitles help to mitigate this dispersion? The next section provides research-informed answers to some of these questions, which are key to understanding the differences involved in watching an original and a translated/accessible version of a film and how to mitigate them.

3.4.2.2 Subtitled films

As in original films, watching a subtitled film involves a combination of voluntary and involuntary eye movements. On the one hand, the viewers read the subtitles voluntarily as soon as the characters speak in order to understand what they

are saying. On the other, research shows that the appearance of text on screen (whether subtitles or another type of on-screen text) draws the viewers' attention to it automatically, whether or not the subtitles are needed (D'Ydewalle & De Bruycker, 2007) or even understood (Bisson, van Heuven, Conklin, & Tunney, 2014). This is also important for filmmakers using text on screen in their original films, who can take it for granted that the viewers' eyes will normally be fixated on the text when it is displayed, instead of on any other part of the screen. In the case of subtitling, experienced subtitle viewers seem to watch subtitled programmes almost effortlessly (D'Ydewalle & De Bruycker, 2007). As shown in Figure 3.18, viewers switch their attention from the image to the subtitles as soon as they hear the dialogue (Jensema, Sharkawy, Sarma Danturthi, Burch, & Hsu, 2000). The reaction time to focus on the subtitles is around 350 milliseconds (Romero-Fresco, 2015a). Once the subtitles have been read, visual attention is turned to the images (de Linde & Kay, 1999), while processing strategies are adapted according to the type of subtitled programme they are watching (Perego, del Missier, Porta, & Mosconi, 2010).

Some viewers show less smooth reading patterns, shifting their gaze between the image and the subtitles in what are known as "deflections" (de Linde & Kay, 1999), "back-and-forth shifts" (D'Ydewalle & De Bruycker, 2007) or regressions.

Figure 3.18 Viewers' focus on subtitles and images

Figure 3.19 Viewers' regressions from images to subtitles

Most viewers spend more time looking at the subtitles than at the images but the fixations on the images are longer (Perego et al., 2010). In other words, once they have finished reading the subtitles, the viewers of a subtitled film use their remaining time to focus on the key parts of the image (often faces, when they are present) for as long as possible. Like the viewers of the original film, they do not know how long each shot is going to last; unlike them, they have to spend part of their time reading the subtitle, which they do as fast as they can in order to grasp as much of the image as possible before it disappears. This explains why their focus is on the key and central part of the image and why they seem to explore the image (even) less than the viewers of the original film without subtitles.

The remaining part of this section is devoted to a series of key issues that determine how we watch a subtitled film: subtitling speed, subtitling as framing, visual momentum, subtitling legibility and especially subtitling blindness.

SUBTITLING SPEED

Subtitling speed is one of the most widely discussed issues in subtitling. In theory, a subtitle is expected to be on screen for as long as a character speaks, but since many characters speak faster than what the average viewer can read, condensation is needed, as is a maximum subtitling speed or an indication of how long a subtitle must be on screen so that it can be read by the average viewer. As explained above, subtitling speed is normally measured in characters per second or words per minute, and subtitlers are sometimes provided with figures such as those in Table 3.1 (Díaz Cintas & Remael, 2008, p. 99) that indicate the number

Table 3.1 Current professional recommendations for subtitling speed.

180 words per minute		Seconds: frames	Spaces	Seconds: frames	Spaces
		01:00	17	02:00	35
		01:04	20	02:04	37
		01:08	23	02:08	39
		01:12	26	02:12	43
		01:16	28	02:16	45
		01:20	30	02:20	49
Seconds: frames	Spaces	Seconds: frames	Spaces	Seconds: frames	Spaces
03:00	53	04:00	70	05:00	78
03:04	55	04:04	73	05:04	78
03:08	57	04:08	76	05:08	78
03:12	62	04:12	76	05:12	78
03:16	65	04:16	77	05:16	78
03:20	68	04:20	77	05:20	78

of characters (spaces) they can use in their subtitles depending on the number of seconds available.

The maximum subtitling speed allowed (180wpm or 15cps in Table 3.1) varies per country and has increased over the years, but it is normally somewhere between 12 and 16cps, or 150 and 180wpm (Szarkowska, 2016).

What is interesting here for filmmakers is the impact that subtitling speed may have on the viewers' experience. In general, the faster the subtitles and the more movement they present (e.g. scrolling, word-for-word subtitles as opposed to subtitles displayed in blocks), the more time is spent reading them and the less time is left to look at the images (Romero-Fresco, 2011). Figure 3.20 shows how a hard-of-hearing viewer watches scrolling subtitles displayed at 20cps, which leads her to spend 88% of her time looking at the subtitles and 12% of her time looking at the images.

From the point of view of AFM, the interest lies not so much on the speed at which subtitles are displayed (subtitling speed) or read (reading speed), but on the viewing speed (Romero-Fresco, 2015b), that is, the speed at which a given viewer watches a piece of audiovisual material, which in the case of subtitling includes accessing the subtitle, the accompanying images and the sound, if available. The results obtained in the EU-funded project DTV4ALL (Romero-Fresco, 2015a), which analysed 71,070 subtitles viewed by 103 deaf, hard-of-hearing and hearing viewers all over Europe, have made it possible to ascertain the average distribution of viewers' attention between text and image depending on the time that the text is left on screen (see Table 3.2).

These findings may be useful for filmmakers in a number of ways, not least when using text on screen in an original film (and not necessarily subtitles), which is becoming increasingly common as a way to portray with cinematic tools

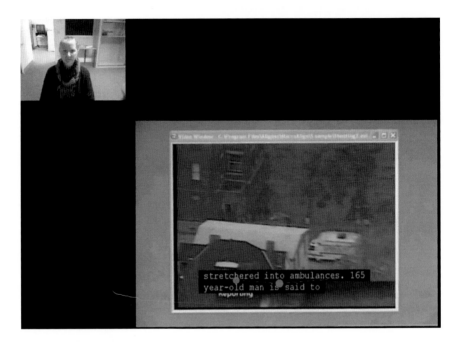

Figure 3.20 Viewer watching scrolling subtitles

Table 3.2 Time spent by the viewers on subtitles and images depending on the speed of the subtitles.

Viewing speed	Time on subtitles	Time on images
10cps	±40%	±60%
12–13cps	±50%	±50%
15–16cps	±60%–70%	±40%–30%
19–20cps	±80%	±20%

the ever-present text-based communication that characterises modern-day society (Figures 3.21 and 3.22).

As per the results of the above-mentioned study (Romero-Fresco, 2015a), it would make sense to allow at least 350 milliseconds for the viewers to find the text on screen (or slightly more, considering that this figure applies to subtitles that are always located at the bottom of the screen) and also to consider the table on viewing speed when deciding the duration of the text on screen. This table may also be useful for subtitlers. Nowadays, most subtitling software indicate the speed of every subtitle as it is being made. Drawing on the viewing-speed data, a subtitler can decide that for an important shot or a new scene,

Figures 3.21 and 3.22 Text on screen used in original versions of contemporary movies

that is, an image that has not been shown yet, it may be advisable to edit the content of the subtitle to 12–13 cps, thus allowing the viewers to spend roughly as much time reading the subtitles as looking at the new image. For subsequent subtitles displayed over this image, which the viewers have already seen, the subtitler may decide to render all the dialogue verbatim, without condensation, at a faster speed of 15–16cps, since 30% to 40% of the time may be enough to process an image with which the viewers are already familiar. This image-oriented approach to subtitling would be greatly facilitated by having access to occasional consultation with the filmmaker, and is thus in line with the principles of AFM.

SUBTITLING AS FRAMING: OVERLAPPING AND BACKGROUND DIALOGUE

Unlike dubbing, which can present overlapping voices in translation, subtitles can only present dialogue exchanges one after the other. When there is more than one person speaking at the same time, the subtitler normally decides whose utterance will be subtitled and whose will be omitted. An example of this can be seen in Figure 3.23, from the short documentary *Joining the Dots* (Romero-Fresco, 2012a). In order to illustrate the multiple conversations going on in the theatre between the actors, the audio describer and the audience before the play starts, the cinematographer opted for a long shot that includes 16 people, while the sound editor allowed for some of their voices to overlap. The image (especially the mise en scéne and the shot size used by the cinematographer) and the sound tell the same story.

However, when the scene is subtitled (see Figure 3.24) the translator must choose what to translate (in this case the off-screen narration), which leaves out five other conversations that are going on simultaneously in the scene. Even if the translator had chosen to subtitle two of those conversations, standard subtitles could only show them consecutively and not simultaneously.

Although displayed together, the film and the subtitle are clashing head-on and telling a different story. The film is in "long-shot mode" (overlapping voices by a group of people) and the subtitle is, as is normally the case, in "close-up mode" (one voice or two voices shown consecutively). Needless to say, both deaf and hearing viewers can still see the group of people, and hearing viewers can also hear the overlapping foreign voices. Yet, the fact remains that standard subtitles cannot help but single out subjects and are often the verbal equivalent of a visual close-up (MacDougall, 1998, p. 169), which may sometimes introduce

Figure 3.23 Long shot from *Joining the Dots*

Figure 3.24 Long shot from *Joining the Dots* with standard subtitles

an unintended and often undetected difference with the original version of the film. In scenes such as this one, and unless a different type of subtitle is used (see Section 3.6 on creative subtitles), subtitle viewers must live with a clash that does not exist for the original viewers.

In some cases, the role of overlapping dialogue, especially if used as a background, is to give context and life to a scene. The subtitler must decide whether this background dialogue is worth subtitling. Just as in group scenes subtitles frame the dialogue and show it as a close-up, subtitles for background dialogue bring it to the foreground in a way that is not conveyed in the original film. Once again, unless used creatively (see Section 3.6), subtitles cannot show different distances, and so in Figures 3.25 and 3.26 from *The Happening* (Night Shyamalan, 2008), the background dialogue competes for the viewers' attention at the same level as the images.

As is the case with most of the elements highlighted in this chapter, filmmakers are not part of the decision about which words will be subtitled and which will be omitted and, in most cases, they are not even aware that this decision must be made. This is therefore one more aspect to add to the discussion between filmmakers and translators as part of the AFM model.

VISUAL MOMENTUM

A more important aspect for filmmakers to bear in mind regarding the subtitled version of their films concerns the *visual momentum*, that is, the pace at which

Figures 3.25 and 3.26 Shots from *The Happening* (2008) with background dialogue in the subtitles

visual information is acquired (Hochberg & Brooks, 1978). This is directly related to the tempo of the film or, more specifically, the tempo of the film as experienced by the viewer. Up until now, filmmakers have focused on editing and on other elements such as the blocking of the actors or the music to manipulate and explore the sense of pace in film. Yet, in the case of subtitled films (or original films and series that use on-screen titles), the sense of pace is also determined by

the speed at which subtitles are displayed and read by the viewers, which has so far been largely ignored by filmmakers and by the film industry as a whole.

Subtitling decisions are therefore crucial to control the sense of pace in a film. For instance, the translator may have chosen to subtitle a scene with two-line subtitles but the filmmaker may decide that the scene requires an increase in pace, for which one-line subtitles (twice as many as two-line subtitles and therefore displayed twice as fast) may be better suited. In Figures 3.27–3.29 from *Slumdog Millionaire* (Boyle, 2008), two tourists mistakenly take Jamal, one of the protagonists, for a tourist guide and ask for his services, explaining that "Obviously we understand it costs more for just the two of us". This is shown across three fast shots with an approximate duration of 2 seconds each, which helps to highlight the sense the confusion. A conventional subtitled translation into Spanish abiding by the standard reading speed would be displayed across the three shots (see Figures 3.27–3.29).

If the subtitler (and the director) wished to increase the visual momentum or sense of pace for the subtitling viewers, they could split the subtitle into syntactically correct one-liners (one-line subtitles) instead of two-liners (Figures 3.30–3.32).

Recent research on this scene (Miquel Iriarte, 2017) has shown that whereas the viewers' comprehension of the scene was not altered by the variation of the subtitles, their eye movements differed significantly. With the standard two-line subtitles, the viewers read the subtitle during the first shot and then focused on the tourist couple in the second shot and on Jamal in the third shot, that is, one movement from subtitle to image and four areas of fixation in total (subtitle in shot 1 + image in shot 1 + image in shot 2 + image in shot 3). With the one-line subtitles, the viewers' eyes travelled from the subtitle to the image on every shot (three movements), thus covering six areas of fixation in total (subtitle in shot 1 + image in shot 1 + subtitle in shot 2 + image in shot 2 + subtitle in shot 3 + image in shot 3). In other words, the viewers of the second type of subtitles are forced to move their eyes twice as much (and twice as fast) as the viewers of the first type, which means that their visual momentum and the sense of pace has increased. For them, the scene is much faster than for the other viewers. Considering that subtitling viewers normally have to move their eyes more than viewers of original unsubtitled films, it is for filmmakers and subtitlers to decide whether in certain scenes the use of one-line or two-line subtitles may be a valuable tool to increase or decrease the sense of pace in a film. And, more generally, filmmakers and editors adopting an AFM approach (and thus with an interest in how subtitling viewers receive their films) may find it useful to consider how the transformation of dialogue into subtitles can alter the tempo of their films.

SUBTITLING LEGIBILITY

One of the most recurrent issues with subtitles, and one that can have a fundamental impact on the viewers' experience, is the (lack of) legibility of the subtitles. This is normally related to the mise en scène of a film (setting, costumes and

Figures 3.27–3.29 Shots from *Slumdog Millionaire* with a standard subtitle translation

Figures 3.30–3.32 Shots from *Slumdog Millionaire* subtitled with one-liners

makeup, lighting and staging). Normally neglected, this is an aspect that could be part of the discussion between filmmakers and translators in order to avoid errors such as those made in *Joining the Dots* (Romero-Fresco, 2012a), where the colour and pattern of Mags' outfit and Trevor's coffee table clash with the black and white letters of the subtitles (see Figures 3.33 and 3.34).

Another issue to be considered with regard to setting and costume is the potential use of colours in the subtitles, which is common practice in many countries in the case of subtitles for viewers with hearing loss (see Section 3.5). Given that

Figures 3.33 and 3.34 Clash between participants' outfits and settings in *Joining the Dots*

the colours are assigned according to the on-screen presence and importance of every character/participant, both the filmmaker and the cinematographer can often make an educated guess as to what colour will be used for each participant and bear it in mind during the shoot. In other cases, though, the importance of the participants will be decided during the editing process. In the shot from *A Grain of Sand* (Dangerfield & Avruscio, 2014) shown in Figure 3.35, subtitles would cause an obvious clash.

This is humorously tackled in *Austin Powers* (Roach, 1997), where one of the characters is forced to clear the objects on the desk so that the protagonist can read the subtitles (Figures 3.36 and 3.37).

In general, filmmakers who plan to use standard subtitles may be advised against using settings that are too cluttered at the bottom of the screen, as this will make it very difficult for the viewers to follow the dialogue.

SUBTITLING BLINDNESS

Finally, perhaps the most important aspect when it comes to AFM and subtitling is to avoid examples of what may be described as *subtitling blindness*, that is, instances in which reading a subtitle prevents viewers from watching an important part of the image on screen. Admittedly, the addition of subtitles to a film makes it more difficult to predict where the viewers will look. The idiosyncrasy of how each person reads text on screen is added to the specificity of how each person views images, but even so, research has shown some degree of attentional synchrony in subtitled viewing (Jensema et al., 2000). Even if habitual subtitling

Figure 3.35 Potential clash between subtitles and yellow background in *A Grain of Sand* (2014)

Figure 3.36 and 3.37 Fictional play with subtitles in *Austin Powers* (1997)

viewers have proved to be efficient and adept at processing images and subtitles (Perego et al., 2010), it stands to reason that some elements of the image may be missed when the viewers' eyes are set on the subtitles.

In some cases, this may not be for the worse. For instance, the presence of subtitles may increase edit blindness. In their study on edit blindness, Smith and Henderson (2008) show that viewers miss approximately one-third of the cuts in a classically edited film, even when they have been asked to identify these cuts. This illustrates the effectiveness of the rules of continuity editing in engaging and immersing the audience in a film as if the fictional story was continuous instead of fractured. A great deal of the subtitles in a film are likely to be displayed across cuts, especially as average shot lengths are reduced in contemporary filmmaking (Bordwell, 2002). Viewers are thus more likely to be busy reading a subtitle when the shot changes, which would theoretically mean that they are more likely to miss the cut. If this is true, one could argue that, contrary to the widespread view that subtitles draw viewers out of the fiction, they may actually help to enhance the viewers' sense of engagement and immersion in the film as a continuous story.

As for inattentional blindness ("the failure to notice a fully visible, but unexpected object because attention was engaged on another task, event, or object", Simons, 2007, p. 3244), the viewers of the subtitled version of a film are less likely than the viewers of the original version to find specific objects, unless the shot is long enough or the object is not entirely unexpected. In general, they are more likely to experience inattentional blindness.

However, subtitling blindness becomes a real problem in those instances where the presence of subtitles causes viewers to miss elements that are critical to the understanding of a film. Five such scenarios of subtitling blindness are particularly recurrent and important to consider:

1 Shots with dialogue/narration over on-screen text.
2 An important visual element at the beginning of a scene with dialogue/narration.
3 An important visual element in a scene with fast dialogue.
4 Shots where the subtitle covers important visual elements.
5 Short shots with dialogue/narration.

As an example of scenario 1, in the short documentary *Joining the Dots* (Romero-Fresco, 2012a), Figure 3.38 is accompanied by a narration from Trevor, the blind protagonist, where it becomes clear that he is not aware of the presence of a sign in his garden:

> Narration: "I don't want to wander into Mags's flowerbeds. She knows what she's got down there. I'm not sure."

The viewers of the original version can see the sign as they hear Trevor's words. In contrast, the viewers of the subtitled version are faced with a very different shot, which includes the translation of Trevor's narration at the bottom, the

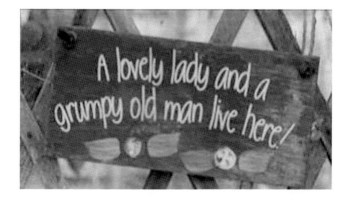

Figure 3.38 Combination of text on screen and narration in *Joining the Dots*

Figure 3.39 Spanish subtitled version of the shot from *Joining the Dots* shown in Figure 3.38

translation of the sign at the top and the sign itself, which the viewers are likely to miss (see Figure 3.39).

This cluttered and text-heavy subtitled shot is likely to increase the visual momentum and tempo for the viewers, is aesthetically very different from what the filmmaker had in mind and, perhaps more importantly, will make it very difficult for the viewers to see the sign, given the amount of reading they are being asked to do. This clash between subtitles and on-screen text is particularly relevant in documentaries, since the use of captions to name and describe participants in interviews is one of the defining features of this genre. Extra time should be allowed for this type of shot. In Figure 3.40 from the same film, Joan Greening's words, which could have been subtitled into two lines, have been edited down to one line so that the viewers can have enough time to read both the caption and the subtitle. Similarly, shot duration may need to be extended for blind and visually-impaired users so that audio describers can read out the name caption before the speech of the protagonist is heard.

Another example of subtitling blindness (scenario 2 above: an important visual element at the beginning of a scene with dialogue/narration) may be found on the BBC News broadcast on 17 August 2010. It concerns the following comment by news presenter Simon McCoy:

Now we'll have the weather forecast in a minute and of course it will be 100% accurate and provide all the detail you can possibly want. I've just seen Tom Schafernaker preparing for it.

This was followed by weatherman Tomasz Schafernaker raising his middle finger to McCoy for a split second and then moving his hand to his face in order to disguise it (see Figures 3.41 and 3.42).

Figure 3.40 Combination of caption and subtitles in *Joining the Dots*

Figures 3.41 and 3.42 BBC News weather broadcast on 17 August 2010 with Spanish subtitles

If this were subtitled into Spanish, the viewers would be reading the subtitle ("será tan completo como esperan. He visto a Tomasz Schafernaker") when Schafernaker raises his finger and would only have time to look at the image once they have read the end of the subtitle ("ya preparado"), by which time the weatherman already has his hand to his face. The viewers would have missed the key action that he is trying to disguise.

If this was a scripted scene instead of a live programme, the filmmaker may need to discuss with the translator different options available to ensure that the subtitling viewers are not prevented from seeing this crucial image, such as for example editing the content of the subtitle to make it shorter (which will allow more time on the visuals) or displaying the subtitle earlier, on the previous shot. Ideally, though, this situation is best tackled in (pre-)production (see Chapter 4), as the early involvement of the translator in the filmmaking process and the consideration of translation/accessibility issues by the filmmaker can help to flag this before it is filmed. As a general rule, filmmakers should be aware that any important visual element displayed only at the beginning of a scene/shot with dialogue/narration is very likely to be missed by the subtitling audience, who, as has been explained, start by reading the subtitle and then move to the image. If the important visual element is left on screen for long enough or is placed later on in the shot, the viewers are more likely to view it once the subtitle has been read.

However, it is worth mentioning that in scenes with very fast dialogue (scenario 3: an important visual element in a scene with fast dialogue), this subtitling blindness can also occur even if the important visual elements are placed later in the shots or are left on screen for longer. The reason for this is that, as mentioned above, the faster the subtitles, the less time there is for the viewers to look at the image. As per recent research (Romero-Fresco, 2015b), subtitles displayed at a normal conversational pace of 13–14cps will normally allow a distribution of 50%–60% of the time on the subtitles and 50%–40% on the images. However, fast conversations spoken at 19–20cps may provide the viewers with as little as 10%–20% of the time to look at the image. Given that subtitling viewers focus mainly on central elements of the shot before they start exploring the screen, filmmakers should be aware that any important element placed elsewhere during a shot with fast dialogue is very likely to be missed by the viewers.

The fourth scenario of subtitling blindness (scenario 4: shots where the subtitle covers important visual elements) concerns instances in which the viewers cannot see certain visual elements because they are covered by the subtitles. In standard subtitles, this applies to any key image displayed at the bottom of the screen while there is dialogue or narration, which is as obvious and recurrent as it is easy to solve. Yet, most filmmakers do not seem to take this into account. In the iconic shot from *Reservoir Dogs* (Tarantino, 1992) shown in Figure 3.43, which was used for posters, prints and artistic material, the original viewers' attention is drawn from Mr White (Harvey Keitel), who is standing ("You wanna shoot me, you piece of shit?"), to the main focus of the shot, Mr Pink (Steve Buscemi), who

Figure 3.43 Iconic shot from *Reservoir Dogs* (1992)

Figure 3.44 Iconic shot from *Reservoir Dogs* (1992) with Spanish subtitles

is lying on the floor ("You're acting like a first-year fucking thief. I'm acting like a professional!"). The journey of the viewers' gaze from one face to another is facilitated by the composition of the shot, as the characters' arms draw a straight line from one face to another.

What was perhaps overlooked by Tarantino was that the millions of hearing and deaf viewers watching the subtitled version of the film missed the focus of the shot, Mr Pink, which was obscured by the subtitle showing his words (see Figure 3.44).

If the viewers of the subtitled version had been factored in the production, an indication could have been made to the subtitlers to avoid standard subtitles for this shot and opt for a more flexible and creative position (see Figure 3.45). This

Actúas como un ladrón
de primer año.
¡Yo estoy actuando
como un profesional!

Figure 3.45 Iconic shot from *Reservoir Dogs* (1992) with displaced Spanish subtitles

would have enabled foreign and deaf viewers to see the focus of the image and to have a viewing experience that more closely resembles that of viewers accessing the original version.

Although perhaps more important from an aesthetic than a narrative point of view, the most common example of subtitles obscuring relevant visual information occurs with the use of close-ups of characters' faces. As mentioned in the section on dubbing, this is the most common shot in contemporary cinema (Redfern, 2010) and is now considered as one of the defining elements of the intensified continuity style applied in modern filmmaking (Bordwell, 2002). Close-ups, as other shots, are often framed following the rule of thirds, an imaginary grid made up of two horizontal and two vertical lines that has been used for harmonious composition in film, photography and painting since it was first coined by John Thomas Smith in 1797 in his book *Remarks on Rural Scenery*. According to this rule, important elements in the frame are normally placed at the intersection of the lines, called *sweet spots* (Mercado, 2010). In close-ups the participant's eyes are often placed around a sweet spot, as is the mouth, which leaves little or no space below the chin for the subtitles to be displayed. As can be seen in Figures 3.46 and 3.47, whereas the original viewers of the documentary *Requiem for the American Dream* (Nyks, Hutchison, & Scott, 2015) watch a close-up framed as per canonical rules, foreign and deaf viewers are presented with a shot that is not only cluttered but also prevents them from looking at the mouth of the speaker, which for some hard-of-hearing viewers is essential to understand the dialogue through lip reading.

As shown in Figures 3.48 and and 3.49, the director and cinematographer of the short documentary *A Grain of Sand* (Dangerfield & Avruscio, 2014) took this into account when framing the main interviews of her film, which also adhere to

Figures 3.46 and 3.47 Original close-up and close-up with subtitles from *Requiem for the American Dream*

Figures 3.48 and 3.49 Wide close-ups from *A Grain of Sand*

the rule of thirds. The interviewees' eyes are around one of the sweet spots but in this case there is enough space to display the subtitles at the bottom without covering their mouths.

As a matter of fact, the use of a bigger shot size enabled the filmmakers to use the settings for characterisation purposes, thus complementing the information obtained by the costume. The viewer can see the gang member wearing a tracksuit and speaking outdoors, in front of a fenced yard, whereas the mayor is wearing a suit and speaking in his office in front of institutional flags. Needless to say, this does not mean that close-ups cannot be used along with subtitles, but rather that it may be useful for filmmakers (and cinematographers) to bear this in mind as they shoot. A way of addressing this issue would be for the cameraperson to have an indication through the viewfinder of where the subtitles would potentially be displayed, so that a decision can be made as to whether a particular shot is to be framed in a subtitle-friendly manner or not.

Whereas the first four cases of subtitling blindness were caused, respectively, by a combination of on-screen text and dialogue (scenario 1), scriptwriting and editing (scenario 2), fast dialogue (scenario 3) and framing (scenario 4), the fifth one is motivated exclusively by (fast) editing. It concerns quick shots that are displayed alongside dialogue or narration. In Figures 3.50–3.52 from the short documentary *Joining the Dots* (Romero-Fresco, 2012a), a shot showing the filmmaker and Trevor (the blind protagonist) on the train is followed by a close-up of Trevor's cane and a third shot of Trevor at home. All three shots are covered by Trevor's narration about how he lost his sight. An eye-tracking analysis of the scene shows how the viewers focus on the image in the first shot, move down to the subtitle as it is displayed on the close-up of the cane and then only manage to look back at the image when this shot has been replaced by the third shot of Trevor at home. In other words, the image in the second shot has not been seen at all.

A study comparing the reception of the original and the subtitled versions of this film found that 80% of the original viewers watched and were able to recall most of the short inserts and transition shots used in the film, whereas none of the foreign viewers viewed or remembered these images, as they were busy reading the subtitles. Translators may be able to alert filmmakers as to the presence of this type of quick shots with dialogue/narration, an issue that may be solved by changing the timing of the subtitling (albeit losing synchronicity with the dialogue) or, if it is possible to intervene in post-production, by changing the editing of the sound or the images.

At any rate, when faced with any of the five very common scenarios of subtitling blindness mentioned here, foreign (and deaf) viewers are effectively watching a different film to those watching the original version, or, at least, they are watching the same film so differently that it becomes a different film.

Figures 3.50–3.52 Eye-tracking analysis of three shots from *Joining the Dots*

3.5 SDH

Also known as *captions* in the US, Canada and Australia, SDH are characterised by the following elements (Neves, 2018):

- They can be intralingual (same-language subtitles) or interlingual (from the source language to another).
- They include verbal and (unlike subtitles for hearing viewers) also non-verbal sound information about character identification, sound effects, manner of speaking and music.
- They can be edited or verbatim. Depending on their speed, they can contain every word included in the audio or not.
- They can be open (burnt on the image) or closed (activated by the users).
- Initially designed for viewers with hearing loss, they are equally useful for, and used by, language learners, foreigners and immigrants, hearing people in noisy environments and people with intellectual or learning difficulties. This is illustrated by the survey conducted in the UK by Ofcom (2006, p. 13), mentioned in Chapter 2, which showed that 80% of SDH users (6 million) are hearing and only 20% (1.5 million) have a hearing loss.

Most of the content included in the previous section about how subtitled films are viewed (viewing patterns, speed, framing, visual momentum, subtitling visibility and most of the scenarios of subtitling blindness) applies also to SDH. However, the specific characteristics of these subtitles deserve special attention from both subtitlers and filmmakers, as they are bound to have an impact on how millions of viewers (with and without hearing loss) watch films.

3.5.1 Background and provision

SDH were first used on TV at the beginning of the 1980s in the US, the UK and France (Remael, 2007; Romero-Fresco, 2018c). These were closed subtitles and, in Europe, they were included within the teletext service. In other words, they were far removed from the audiovisual production process and they involved no contact with the creative team, as has been the case ever since. Thanks to national and international legislation, SDH provision on TV is now close to 100% in many countries, and the focus is now being placed on increasing provision in the cinema and online for on-demand platforms, as well as on improving their quality.

While SDH on TV and on-demand platforms are closed and must thus be activated by the viewers, the provision of SDH in the cinema has always been problematic. Traditionally, the only two options available have been either no subtitles or open subtitles that must be seen by all viewers, whether or not they need or want these subtitles. This has resulted in a limited provision, usually on off-peak days at off-peak times, and in complaints by many subtitle viewers,

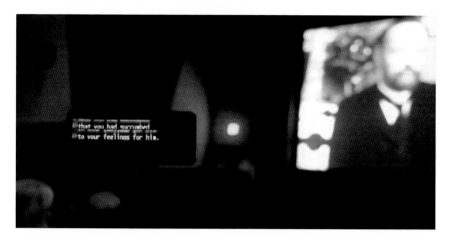

Figure 3.53 Rear-window captioning in the cinema

such as the founders of the Facebook group "Deaf people are alive 7 days a week, not just Sunday/Monday/Tuesday". Alternative methods of provision, such as rear-window captioning (see Figure 3.53), have been around for some years now, but recent technological developments have helped to push them considerably.

One of the most popular methods has been developed by the Italian company MovieReading, which envisages the use of closed SDH on smartphones, rear-window systems and smartglasses (see Figures 3.54–3.56).

Although research has shown that some of these methods still have some aspects to address, including the strain caused by head movement and focal change on the viewers and the logistics at the cinema venues (Romero-Fresco & Fryer, 2016), the prospect for a wider provision of SDH in the cinema is now more promising than ever.

3.5.2 Viewers with hearing loss

Hearing loss is regarded as the most prevalent disability, affecting one in six people worldwide. The total number of people with hearing loss around the world exceeds 700 million and is expected to increase to 900 million by 2050 (WHO, 2018; Davis in Traynor, 2011). This includes 71 million people in Europe and 35 million in North America. Worldwide, 1.1 billion young people between 12 and 35 years of age are at risk of hearing loss due to exposure to noise in recreational settings (WHO, 2018). Although it is difficult to find exact figures on hearing loss in developing countries, they are thought to contain two-thirds of the global population with hearing loss and to experience

Figures 3.54–3.56 Provision of subtitles with MovieReading

it at a younger age, due to untreated ear infections and increased exposure to excessive noise (Traynor, 2011).

Hearing loss is measured by finding the quietest sounds that someone can hear. Table 3.3 shows the different types of hearing loss, the threshold in terms of decibels, the percentage of incidence in the case of the UK, their characteristics and the effect on spoken words.

As for the correspondence between these degrees of hearing loss and the "deaf" and "hard of hearing" categories used for subtitles:

- "hard of hearing" refers to people with mild to severe hearing loss. They usually communicate through spoken language and can benefit from hearing aids, cochlear implants and other assistive devices as well as subtitling (WHO, 2018). Same-language or intralingual subtitles are therefore written in their mother tongue.
- "deaf" people mostly have profound hearing loss, which implies very little or no hearing.

An important distinction is to be made between deaf people, that is, those who are deaf but belong to the social context of the hearing majority and relate to the oral language as their mother tongue, and Deaf people, a social and linguistic minority who use a sign language as their mother tongue and read the national language and subtitles as a second language (Neves, 2008, p. 143).

The causes of hearing loss and deafness can be congenital or acquired, which makes a difference with regards to how viewers relate to film and SDH. Indeed, the description of sounds in the subtitles may mean something completely different depending on whether viewers were once able to hear or whether they were either born deaf or lost their hearing before developing their oral linguistic skills.

As for the viewing patterns of people with hearing loss when watching subtitled films, most of what was described in the previous section applies, with a few exceptions revealed by recent research in this area (Romero-Fresco, 2015a). Viewers with hearing loss (and especially deaf viewers) seem to locate the subtitles on the screen more quickly than hearing viewers (perhaps because they are waiting for them, as they rely on them heavily), but they take longer to read them than hearing viewers, which may be a sign of reading difficulties. However, despite having less time left to look at the images on the screen, the deaf viewers' visual comprehension is just as good as, and sometimes even better than, that of the hearing viewers. In other words, deaf viewers seem to make up for their sometimes substandard reading skills with particularly good visual perception and comprehension.

3.5.3 SDH conventions

SDH guidelines and conventions vary across countries, broadcasters and access service providers. As shown in the BBC Guidelines (Ford Williams, 2009), they

Table 3.3 Types of hearing loss, threshold, percentage of incidence, characteristics and effect on spoken words in the UK.

Type of hearing loss	Threshold (decibels)	UK population	Scale of hearing loss	Effects of spoken words
Normal hearing	0–25 dB	–	–	
Mild	26–40 dB	78%	They may benefit from using a hearing aid. They have difficulty: – Hearing quiet parts of programmes. – Hearing TV at a volume other people find acceptable. – Following a conversation against background noise. – Hearing someone talking in a normal voice in a quiet room.	"Freddie thought he should find a whistle." "Freddie thought – e-ouldind a whi – le."
Moderate	41–70 dB	10%	They have difficulty: – Keeping up with conversations when not using a hearing aid. – Hearing a doorbell, alarm clock or telephone bell. – Following a TV programme at a volume others find acceptable.	"-reddie -ough – e -ould - i – a -i-le."
Severe	71–94 dB	5%	They rely heavily on lip-reading even when they are using hearing aids. Some also use sign language. They have difficulty: – Hearing someone talking in a loud voice in a quiet room. – Following a TV programme with the volume turned up.	LOUD soft soft LOUD soft LOUD soft
Profound	95 dB or more	1%	They rely mostly on lip-reading and/or sign language. They may benefit from cochlear implants. They may only just be able to hear loud speech or sound in a quiet environment.	

are normally made up of a verbal component (most of which is common to inter-lingual subtitling for hearing viewers, described in the previous section) and a non-verbal component that is specific to this type of subtitling for viewers with hearing loss. This non-verbal component requires the translator to make impor-tant decisions that may need to be discussed with the filmmaker in order to ensure that the reception of the film by viewers with hearing loss is as similar as pos-sible to that of the original hearing viewers. The non-verbal elements included in SDH, discussed in the following sections, are character identification, sound effects, manner of speaking and music. Many of the examples used to illustrate this section may be found in the supplemental website of *Reading Sounds: Closed-Captioned Media and Popular Culture* (Zdenek, 2015), one of the most comprehen-sive repositories on SDH currently available.

3.5.3.1 Character identification

Many viewers with hearing loss need characters to be identified, as they often find it difficult to distinguish who is speaking. This has proved to be one of the key priorities for SDH users across different countries (Romero-Fresco, 2015a). As shown in Figures 3.57–3.60, the techniques available to identify characters are dashes/arrows/chevrons, colours (normally, in order of importance of the charac-ters, white, yellow, cyan and green), name tags and displacement:

The decision regarding how to identify characters is normally determined by national practice and the context in which the films are shown. SDH on

Figure 3.57 Use of chevrons for character identification in SDH

Figure 3.58 Use of colours for character identification in SDH

Figure 3.59 Use of name tags for character identification in SDH

Figure 3.60 Use of displacement for character identification in SDH

traditional and on-demand TV normally use colours in Europe and chevrons and dashes in North America, whereas DVD, cinema and on-demand films usually resort to dashes or name tags. However, there is often freedom to change these conventions and decide what technique is more suited to a film on the basis of cinematographic reasons that may be considered by both translators and filmmakers.

Hyphens, arrows and chevrons are the most basic technique. They are the least invasive and subtlest option, but they often need to be combined with other methods, such as name tags, when there are more than two characters in the shot or when a character is speaking off screen.

Name tags are a useful and effective method to identify characters, the only one that leaves no doubt as to who is speaking. The downside is that name tags add words to the subtitles and therefore increase the time the viewers spend looking at them rather than looking at the image. This may be an issue, for example, in films with very fast dialogue, which, as explained in the previous section, normally cause viewers to spend extra time on the subtitles.

Displacement or speaker-dependent placement is a useful option that seems to be very effective, but it depends on whether the composition of the shot allows for an easy distinction between the characters, which is not always the case. Displacement can be combined with colours.

The use of colours has proved to be one of the preferred options by many viewers with hearing loss. A common issue with this technique is the presence of a high number of characters in a film, which requires the use of less legible colours (blue, red, etc.) or the use of one colour for different secondary characters. In general, filmmakers and cinematographers may need to consider the impact that the use of white, yellow, cyan and green subtitles at the bottom of the screen may have on the film, not least from an aesthetic point of view. Recent research (Cutting et al., 2011) on the evolution of the brightness of film images over time shows that films have become significantly darker over the past 75 years. Digital technology allows for darker and more nuanced shades of black, which filmmakers are using to create mood and direct the viewers' eyes. How is this affected by the presence of bright-coloured subtitles (yellow, for example, as the second most common colour in SDH), which are bound to stand out even more on these darker images?

In the scene from *Tree of Life* (Malick, 2011) shown in Figures 3.61–3.63, Mrs. O'Brien wonders where God was when her son died, as the viewers see a wavering light flicker in the darkness and then fade to black.

A recurrent and key visual motif in the film, the wavering light, fades in from the pitch black screen ("Lord") and grows ("Why?") only to fade to black again and leave Mrs O'Brien and the viewers in complete darkness ("Where were you?"). The millions of viewers watching this scene with subtitles are likely to have an aesthetically different experience, with the bright-coloured subtitles first competing for attention with the wavering

("Lord")

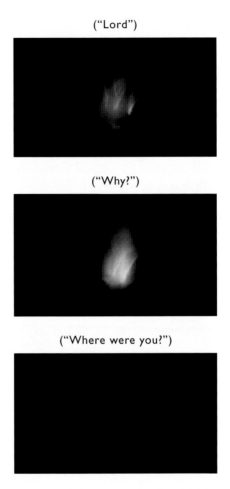

("Why?")

("Where were you?")

Figures 3.61–3.63 Original scene from Terence Malick's *Tree of Life*

light and then standing out even more against the final pitch black shot, when the viewers were supposed to be left with complete darkness (see Figures 3.64–3.66).

There is no easy solution for this, but if filmmakers (and cinematographers) are aware of this issue, they may consider, first of all, whether or not dialogue is needed over these shots. If it is, or if it is too late to change, then it may be worth exploring some of the features of integrated and creative subtitles (see Section 3.6). They can help to reduce the excessive visibility of subtitles in these shots and thus close the gap between the (aesthetic) experience of original and subtitling viewers.

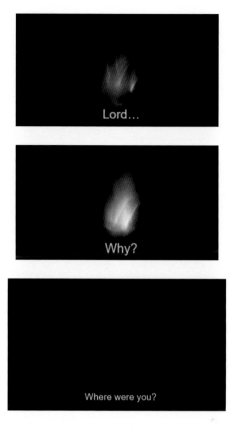

Figures 3.64–3.66 Scene from Terence Malick's *Tree of Life* (2011) with yellow SDH

Finally, character identification can also have a significant impact on narrative. The opening shot of *Joining the Dots* (Romero-Fresco, 2012a), shown in Figures 3.67 and 3.68, includes a black screen as the viewers hear these words by the blind protagonist, whom they have not seen yet: "what I can imagine I'm seeing now would be as if somebody put my head in a bowl of porridge – nothing". If the subtitles are using name tags, should they reveal Trevor's name for the deaf and hard-of-hearing viewers before it is known for the original viewers? Should they simply opt for an unspecified term such as "Man" or perhaps for nothing at all? And why should the translator have to make this decision without knowing the filmmaker's view on it?

Another aspect to take into account regarding the impact of character identification on narrative is illustrated by Alfred Hitchcock's *Psycho* (1960). The film's best-remembered scene, and one of the best known in the history of cinema, the shower scene, was important not only because of its cinematographic

Figures 3.67 and 3.68 Opening shot of *Joining the Dots* with and without speaker identification

value but also because it was one of the first examples of a false protagonist in film (Morgart, 2014). This is a literary technique used to make the plot more jarring or more memorable by fooling the audience's preconceptions, constructing a character who the audience assumes is the protagonist but is later revealed not to be. The scene resulted in the death of Janet Leigh's character 48 minutes into the film, thus leaving the viewers without the protagonist for over half of the film. Aware of the power of this device, which is now being exploited by popular TV series such as *Game of Thrones* (Benioff & Weiss, 2011), Hitchcock set up a "no late admission" policy with the following words (Roberts, 2017):

> We won't allow you to cheat yourself. You must see PSYCHO from the very beginning. Therefore, do not expect to be admitted into the theatre after the start of each performance of the picture. We say no one – and we mean no one – not even the manager's brother, the President of the United States, or the Queen of England (God bless her)!

When producing SDH for *Psycho* (1960) on TV, subtitlers must decide what colours are assigned to each character. Presumably, Janet Leigh's character would be subtitled in white or yellow, as is normally the case for the protagonist. However, this would mean that the subtitler will not be able to use this colour after the first 48 minutes of the film, thus being left with fewer and less legible colours for the

rest of the film. In order to avoid this problem, the subtitler who produced SDH for *Psycho* (1960) on UK TV decided to use green for Janet Leigh's character. The result was considerably worse. Deaf and hard-of-hearing viewers understood straight away that if a secondary colour was assigned to her, it could only be because she was going to either die or disappear, just what Hitchcock was trying to avoid. Again, there is no perfect solution here, but this is one more decision that filmmakers may want to be involved in.

3.5.3.2 Manner of speaking

When necessary and not obvious from the picture, SDH must also convey the tone and mood of the character's words, which comprise elements such as volume, intensity, emotions and accents. This information can be provided with the devices included in Table 3.4.

Subtitlers should also look out for moments of silence that may not be obviously deduced by looking at the images. In Figures 3.69–3.74, from the ending of *The Godfather Part III* (Coppola, 1990), Vito (Al Pacino) reacts to his daughter's murder with a silent scream. He appears to be shouting but there is no sound coming out of him, which catches the attention of the other characters (and, presumably, of the original viewers, too).

Initially, the scene was scripted and acted with two loud screams, but editor Walter Murch decided to remove the sound of the first part in post-production (G. D. Phillips, Welsh, & Hill, 2010), which makes Don Vito's loud scream a few seconds later all the more powerful. Unless a subtitle is used to indicate the silent scream, the viewers with hearing loss will miss this powerful effect in what is arguably one of the most intense moments in this iconic trilogy.

Finally, the translator must also decide whether accents are going to be indicated or not and, if so, whether this is done by means of an explanation ([Glaswegian accent]) or through the use of non-standard language ("Ah'll huv tae stoap sayin' 'ken' sae much", from *Trainspotting*, Boyle, 1996). Challenging and subjective calls also have to be made when it comes to describing utterances that

Table 3.4 Strategies to convey tone and mood in SDH.

In brackets or with capitals	(surprised) SURPRISED I didn't know. I didn't know
With capitals in the subtitle to indicate stress or shout	It's the BOOK I want, not the pen. HELP ME!
With the subtitle in brackets to indicate whispering	(Don't let him near you.)
With an exclamation/question mark in brackets to indicate irony	Charming(!)
A question mark followed by an exclamation mark to indicate incredulity	You mean you're going to marry him?!

Figures 3.69–74 Vito's reaction to his daughter's murder in *The Godfather Part III*

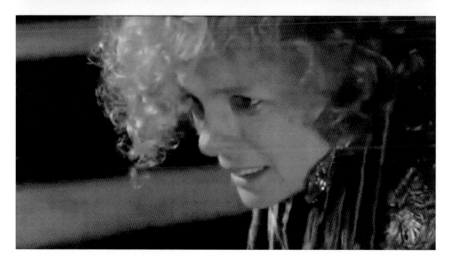

Figures 3.69–74 (Continued)

are difficult to understand for the viewers, such as (drunken speech), (slurred speech), (unintelligible), (incomprehensible), etc., or where there is hesitation or stammering by the characters. SDH guidelines often advise against indicating hesitation and stammering that is anecdotal and recommend to mark only that which is significant for a character or a story, as is the case in Figure 3.75, from *A Serious Man* (Coen & Coen, 2009).

Stammering is particularly important in *The King's Speech* (Hooper, 2010), which begs the question of whether this manner of speaking should be marked once in the film and descriptively (STAMMERS) or every time it occurs and linguistically ("I'm g-g-going home"). At any rate, it seems unfair to leave this decision exclusively on the shoulders of the translator, whose strategy is bound to have a very significant impact on the reception of the film by deaf and hard-of-hearing viewers, as well as by many other hearing viewers watching the film with SDH.

3.5.3.3 Sound effects

As is often the case in subtitling, the key questions when it comes to conveying sound in subtitles are what must be subtitled and how.

Starting with the *what*, in SDH, any relevant sound that is not immediately obvious from the visual action should be subtitled (Ford Williams, 2009). This does not mean that every single creak and squeak must be subtitled, but only those that are crucial for the viewer's comprehension of the story or those required to create atmosphere. In Figure 3.76, the progression of the dog sound causes the male character to react in the second shot, while in the third and fourth shot, the sounds stress the tense atmosphere of the dinner.

Figure 3.75 SDH indicating stammering in *A Serious Man*

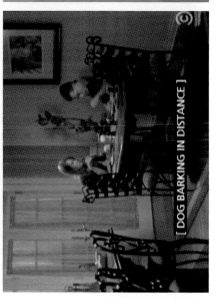

Figures 3.76 SDH indicating progression of sounds

An important aspect here is that subtitles for sound effects are often more concerned with meaning than with sound. For instance, in Figure 3.77, the action is more important than the sound, in other words, the exact description of the sound qualities of a squeaky water tap are less significant than the act of turning the tap off (Zdenek, 2015, 8).

The same goes for Figures 3.78 and 3.79, where the key is the act of turning the radio off, presented here as a consequence of not understanding the singing in a foreign language (ibid.).

Apart from indicating the beginning and end of sound when relevant, SDH can also specify the modulation of sounds (Figures 3.80 and 3.81).

Figure 3.77 SDH indicating action

Figures 3.78 and *3.79* SDH indicating action of turning off the radio

Figures 3.78 and 3.79 (Continued)

Figures 3.80 and 3.81 SDH indicating modulation of sound

According to Zdenek (2015), three more aspects that are normally covered by SDH regarding sound effects are:

- Background voices or chatter that are intelligible and/or important for the narrative (Figure 3.82).

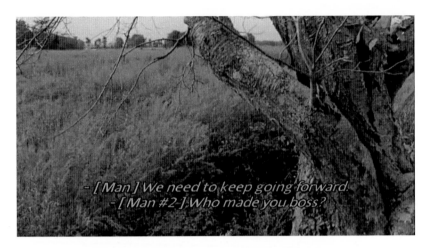

Figure 3.82 SDH indicating background voices

- Sounds made by speakers that cannot or should not be transcribed as distinct speech (Figure 3.83).

Figure 3.83 SDH indicating indistinct speech sounds

- Public announcements or voices coming from electronic devices when they are in the foreground, when they work as a character or when they provide crucial information (Figure 3.84).

Figure 3.84 SDH indicating voices coming from electronic devices

Once the translator has decided what sound must be subtitled, the second decision involves the *how*. From a linguistic point of view, the structure of sound-effect subtitles is normally "subject + verb", as shown in the opening of *Beasts of the Southern Wild* (Zeitlin, 2012), where 8 of the first 14 subtitles convey sound effects:

> [BIRD CHEEPING] [THUNDER RUMBLES] [HEART BEATING], [HENS SQUAWKING] [CHICK CHIRPING] [HEART BEATING], [BIRD CHURRING] [BOARDS CLATTERING].

The difference between using the simple present ("rumbles") or the gerund ("cheeping") is normally related to whether the sound occurs once or is instead a continuous sound. In Figures 3.85 and 3.86, from *Man of Steel* (Snyder, 2013), a distinction is made between Lois' grunting, which occurs throughout the scene, and Clark's grunt, which is heard only once during a fight.

From the point of view of filmmaking, it is important to bear in mind that the description included in these subtitles (and indeed every other aspect included in them) is one more aspect that characterises the language of a film, along with its direction, mise en scène and cinematography, acting, editing, etc. Thus, a

Figures 3.85 and 3.86 SDH indicating grunting in the gerund and the simple present

subtitler can decide to strive for richness and variation, as is the case in the description of the sound of thunder in Figure 3.87.

Conversely, some films make excessive use of the same description, which impoverishes the language of the film for viewers with hearing loss. In *Twilight* (Hardwicke, 2008), the word *gasp* is used 12 times to describe how Bella, one of the main

Figures 3.87 Description of the sounds made by thunder in SDH

characters, is scared, startled, aroused, excited and dying (Zdenek, 2015, 100). As a result, gasping becomes one of Bella's personality traits and, at least as far as this aspect is concerned, the language of the film becomes simplified, flat and repetitive. But if the sounds uttered by the character and the soundscape created by the sound editor in the original film are not flat or monotonous, why should the sound descriptions received by subtitling viewers not have this richness? At the very least, filmmakers should be aware of this issue so that they can have a say if they are consulted.

A different situation arises from the recurrent use of a particular sound description for the same purpose throughout a film. This is the case of the tag "guttural croaking" (see Figure 3.88), which becomes a leitmotif or an "identity marker" (Zdenek, 2015, p. 104) used recurrently to identify the Alien in *Aliens vs. Predator: Requiem* (Strause & Strause, 2007).

Another key aspect that must be considered when describing sounds is the above-mentioned subtitling blindness. Important as it may be to describe the sounds in a scene, the priority should normally be placed on the narrative and the image. The table on viewing speed included in Section 3.4.2.2 should thus be taken into account to ensure that the viewers can watch both the subtitle and the image. In Figure 3.89, by the time the viewers have read the 32 characters in the subtitle, the

Figure 3.88 Description of the sound made by the Alien in *Aliens vs. Predator: Requiem* (2007)

Figure 3.89 Long sound subtitle in *Superman*

shot has already changed. In other words, the viewers have turned into readers who know what sounds were made but who have missed the visual action.

3.5.3.4 Music

Normally, music that is part of the action, or significant to the plot, is conveyed in the subtitles, whether it is diegetic (part of the action and played by the characters) or extra-diegetic (added in post-production) music. If the music piece or song is known, the subtitles should include the title and the lyrics, as shown in Figures 3.90 and 3.91.

If the piece is not known, a description can be provided (Figures 3.92–3.94).

Figure 3.90 Song title indicated in SDH

Figure 3.91 Song lyrics in SDH

Figures 3.92–3.94 Description of music in SDH

When the soundtrack combines dialogue and lyrics simultaneously, the priority is normally placed on the dialogue, but, as shown in Figure 3.95, from *Twilight* (Hardwicke, 2008), it may be very useful to include one or two lines of the lyrics if they are thought to be critical for the storyline.

This is normally a better solution than simply avoiding the inclusion of the lyrics Figure 3.96. At any rate, music in SDH is normally conveyed in a descriptive manner, which means that it becomes very difficult for the viewers to feel what the music adds to the film. This is shown in the opening scene of *Knight and Day* (Mangold, 2010), where the initial theme uses six musical notes to connect the male and female protagonists (Figures 3.97 and 3.98) (Zdenek, 2015, p. 118).[5] It seems very difficult to convey in a subtitle such a distinction and, for the most part, viewers with hearing loss must resign to obtaining a description of the music used in films, in other words, to knowing it rather than feeling it. The use of integrated subtitles (see Section 3.6) may go some way towards solving this problem.

3.5.3.5 Watching film with SDH: a different experience

The above-mentioned non-verbal elements of SDH (character identification, manner of speaking, sound description and music) are bound to have an impact

Figure 3.95 SDH with lyrics in between dialogue subtitles

Figures 3.96 SDH avoiding the inclusion of lyrics

Figure 3.97 and 3.98 Music in the opening scene of *Knight and Day*

on how the viewers receive a particular film. Zdenek (2015, p. 8–9) provides several clues regarding specific limitations of SDH that determine this impact:

- *SDH distil*: Although several sounds may be described, SDH can normally only afford to describe key sounds. Subtitles reconstruct the narrative as a series of basic sounds, which means that sustained sounds are turned into discrete, one-off subtitles. Ambient sounds are reduced (at best) to single subtitles and music is conveyed with a simple description and/or subtitled lyrics.
- *SDH formalise and rationalise*: Reading a description of an accent or difficult speech (see Figure 3.99), written in standard language, may look more formal than its corresponding audio. SDH formalise and also rationalise the sound-scape, as they are forced to describe sounds that may resist obvious classification, such as mood music.

Figure 3.99 Indication of slurred speech in SDH

- *SDH equalise*: Except for captions that introduce a modulation of volume and intensity (for which there is not always enough time), sounds are normally described as if they were all equally loud (see Figures 3.100 and 3.101).

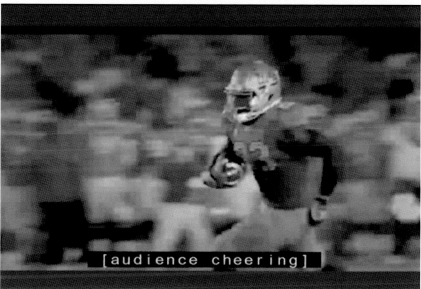

Figures 3.100 and 3.101 Equalisation of sound volume in SDH

- *SDH linearise*: A soundtrack may feature overlapping sounds that are heard simultaneously, but deaf and hard-of-hearing viewers can only read them linearly, one at a time. This is the case even if two different sounds are subtitled together (see Figure 3.102).

Figure 3.102 Linearisation of sound in SDH

- *SDH reveal*: Because viewers do not read at the same time as characters speak, sometimes subtitles will reveal information that has not been disclosed to the audience. In Figure 3.103, the subtitle lets the audience know that the character is going to die before he is killed.

Figure 3.103 Disclosure of information by SDH

Despite the difficulty involved in dealing with these scenarios, the collaboration between filmmakers and subtitlers can be very helpful to make more informed decisions that are in line with the original vision of the film. Furthermore, the use of integrated or creative subtitles, described in the following section, becomes particularly suitable to propose innovative solutions that can at least partly overcome these limitations.

3.6 Integrated titles/creative subtitles

The subtitling guidelines currently available, whether intended for hearing viewers (Carroll & Ivarsson, 1998; Díaz Cintas & Remael, 2008) or viewers with hearing loss (Ford Williams, 2009), are normally accurate and very thorough, covering in detail technical, linguistic and even semiotic aspects of subtitling. They are also often characterised by a somewhat utilitarian view (Vit, 2005) or an "inertia of convention" (A. M. Nornes, 1999, p. 31) that tends to overlook issues such as the typographic challenges and possibilities of subtitles or their interference with the overall visual composition of a film. In short, the invisibility of subtitles is favoured over their creative potential. Yet, as noted by Foerster (2010, p. 83), "subtitles have never been and will never be invisible – so we should try to make the best out of their presence instead of denying it". This creative potential is precisely what can help them overcome some of the constraints described at the end of the previous section.

As noted by Stuart Comer, the curator of film at the Tate Museum, the relegation of subtitling to the end of the filmmaking process and the lack of control by filmmakers (the industrialised model of subtitling mentioned in Chapter 2) may account for the traditional lack of creativity in this area (Rawsthorn, 2007). However, over the past years, this situation has started to change, mostly due to the interference of fans and filmmakers, who have paved the way to a "long overdue new course towards a more integrated approach" regarding film and translation (Fox, 2018, p. 124). Fan subs (subtitles made by fans) experiment with subtitle fonts, colours, positions, number of lines, notes at the top of the screen, glosses in the body of the subtitles, extra information regarding fansubbers and translations for opening and closing credits (Ferrer Simó, 2005). In turn, filmmakers such as Tony Scott or Danny Boyle believe that subtitles are "boring" (Kofoed, 2011) and detract too much attention from the images (Beckman, 2008). As a result, they have begun to apply to subtitles the creativity involved in the production of other types of on-screen text, thus using subtitles to support tone and atmosphere and sometimes even to interact with the mise en scène and become characters in the story. These are the so-called creative subtitles (Foerster, 2010; McClarty, 2012) or integrated titles (Fox, 2018), which respond to the specific qualities of every film, giving the subtitlers and filmmakers more freedom to create an aesthetic that suits that of the original film. Instead of being constrained by standard conventions, these subtitles experiment with font, size, position, rhythm and specific effects to become part of the image and contribute to the typographic and aesthetic identity of the film (ibid.).

From the first silent films, on-screen text has been a key element in cinema. This includes film titles, opening and closing credits, displays (text that has been filmed by the camera and is important for the plot), captions (text added in post-production with information about name and position of a speaker or where/when a scene is taking place), narrative text and inserts (text added in post-production with information to fit the image composition). They all contribute to creating a strong typographic identity "that can make a film more distinctive and add further recognition value" (Fox, 2018, p. 38). In cases such as *Star Wars* or *Harry Potter*, this identity becomes branding or corporate design. Interestingly, and even though their aesthetic value is hardly ever considered, subtitles are a major typographic influence on film. In her analysis of text elements in 52 films selected from lists of the top-grossing feature films in the US, the top-grossing feature films in Germany, the top-rated feature films on Metacritic (as chosen by both critics and users) and the most popular feature films on IMDb, Fox (2018, p. 43) found that subtitles were the second most recurrent textual element (see Table 3.5).

These were open subtitles used to translate additional languages in the original versions of the films, so the subtitles used for the foreign versions can be expected to constitute, by far, the most recurrent textual element in these films. It thus stands to reason that subtitles should be part of the typographic identity of a film or at least not interfere with it, but this is unfortunately not normally the case. All too often, the graphic designers' careful choice of a typeface that is in line with the visual identity of a film is destroyed by the conventional look of the subtitles. When adopting an AFM approach, translators have the possibility to liaise with the graphic designers in charge of the titling, as both professionals are responsible for using text on screen and this discussion may help subtitles contribute to, or at least not clash with, the typographic identity of the film. This seems more important now than ever, as the use of on-screen text is becoming one of the defining tools used by contemporary filmmakers to portray the ever-present text-based communication that characterises our modern-day society.

Table 3.5 Frequency of text elements in the 52 films analysed by Wendy Fox (2018).

Element	Count	Percentage (%)
Film title	65	5.56
Opening credits	29	2.48
Closing credits	57	4.87
Displays	560	47.86
Captions	107	9.15
Narrative texts	10	0.85
Inserts	–	–
Subtitles	342	29.23
	1,170	100.00

At any rate, the use of creative or integrated subtitles means that subtitles are no longer a late addition to the film, but an integral part of it, and, as a result, they are often produced in collaboration with the creative team of the film. They are thus an example of AFM, but not a requirement. They are one more option available for those filmmakers who would like to consider translation and accessibility as part of the (post-)production of their films.

3.6.1 Font

In an integrated and collaborative approach such as AFM, and for anybody creating and subtitling content online, it makes sense to experiment with fonts and to consider how the typeface[6] of the subtitles can contribute to the typographic identity of the film, the identification of characters and their manner of speaking or the distinction between verbal and non-verbal sounds. Yet, despite the evidence that typeface always carries meaning (Nørgaard, 2009, p. 158) and that design is also information (Hans-Rudolf Lutz in Neuenschwander, 1993), very little research has been conducted regarding the meaning-making and aesthetic role played by fonts in subtitling. The lack of flexibility in this area that was once justified by the constraints imposed by analogue technology, especially on TV, no longer seems to apply in the digital era. Most research on the readability of subtitles has tested only a few standard typefaces (Bartoll & Martínez Tejerina, 2010), such as Arial, Verdana or Helvetica. However, the collaboration involved in AFM may trigger discussions about the use of different types of fonts, which means it is essential to consider their key features and the meanings and associations that they carry.

One of the very few thorough contributions on the use and importance of fonts in subtitles is Max Deryagin's "Subtitle Appearance Analysis. Part 1: The Font" (2018), which discusses font readability and font aesthetics. Font readability comprises the four key features of characters in a font (typicality, distinctiveness, uniformity and contrast potential) and the four types of spacing (tracking, kerning, word spacing, leading). Font aesthetics is mainly concerned with issues of print personality and font psychology, that is, the (subjective) connotations conveyed by every font and the effect they have on the readers/viewers. Firstly, in order to be read quickly, glyphs (i.e. character designs) must be legible[7] (easy to distinguish from one another), that is, typical, distinctive, uniform and with high-contrast potential. Typicality is the extent to which a glyph resembles the readers' idea of what the character should look like, which helps readers recognise it faster. Figure 3.104 includes a range of typical to non-typical "A"s.

Figure 3.104 Range of typical to non-typical "A"s (Deryagin, 2018)

In a subtitle, a non-typical glyph, such as "k" in Figure 3.105, can disrupt the viewers' reading process. As well as typical, readable glyphs are also usually distinctive, that is, unlike the "I" and the "l" in the widely used Gill Sans (see Figure 3.106), the different letters are distinct from one another. Even if glyphs are typical and distinctive, they also need to have uniformity, so that the letters do not look different depending on the combinations, as is the case with "f" and "i" in Figure 3.107.

Finally, readable glyphs must also have high-contrast potential so that they can stand out against backgrounds. This is particularly important in subtitling, as letters are often displayed against different types of images instead of a blank page. Narrow strokes, big counters (i.e. the "empty" spaces inside the characters) and thin elements such as serifs, all of which are used in Figure 3.108, are to be avoided in subtitles, which normally resort to semi-bold or even bold sans serif fonts.

> There you can prime the rocket for launch.

Figure 3.105 Subtitle with non-typical "k" (Deryagin, 2018)

Ill children are treated here.

Figure 3.106 Non-distinctive use of "I" and "l" in Gills Sans (Deryagin, 2018)

This affix feels weird.

Figure 3.107 Non-uniform combination of "f" and "I" (Deryagin, 2018)

Figure 3.108 Subtitle font with low contrast potential (Deryagin, 2018)

As well as using typical, distinctive, uniform and high-contrast glyphs, readable subtitle fonts must also feature optimum spacing. This concerns the tracking or distance between all glyphs (see Figure 3.109), the kerning or space between two specific characters (see Figures 3.110 and 3.111 for examples of clashes between the "f" and the apostrophe in Georgia and the italicised "l" and the question mark in Tahoma) and the leading or line spacing (Figure 3.112 shows excessive space between the lines).

Whereas font readability is, to some extent, objective, font aesthetics is subjective, as it is based on the readers' or viewers' perception. Yet, the meaning or connotations conveyed by certain fonts seem to apply across different types of viewers, as is the case with the associations of time and space evoked by the fonts in Figure 3.113.

Oh my god, a cookie!

Oh my god, a cookie!

Figure 3.109 Text with different tracking (Deryagin, 2018)

The elf's smile subsided.

Figure 3.110 Clash between the "f" and the apostrophe in Georgia (Deryagin, 2018)

Have you watched *Daredevil*?

Figure 3.111 Clash between the "l" and the question mark in Georgia (Deryagin, 2018)

A huge loggerhead turtle
emerged from the sea.

Figure 3.112 Excessive leading (Deryagin, 2018)

Medieval Europe

1930s Germany

THE WILD WEST

Figure 3.113 Associations of fonts with specific contexts (Deryagin, 2018)

This leads us to the notions of print personality (Jordan et al., 2017), that is, the long-held belief (Poffenberger & Franken, 1923) that fonts elicit information in the reader in addition to the meaning conveyed linguistically by words, and font psychology (Shukla, 2018), which is concerned with how fonts affect cognition and behaviour, and with the deliberate use of particular styles and sizes of characters to produce a desired effect in the viewer. Serif fonts such as Times New Roman are often seen as reliable and bookish, or, as in the case of Garamond, graceful, refined and feminine (Secrest, 1947). Sans serif fonts elicit fewer qualities but they may be described as no-nonsense and restrained, as in the case of Futura, or modern and cool, as in the case of Avantgarde (Spiekermann & Ginger, 1993).

Figures 3.114–3.119 show some of the most recurrent qualities evoked by six of the main types of fonts (serif, sans serif, slab serif, script, decorative and modern), including their descriptions and the contexts they are best suited for.

Figure 3.114 Most recurrent qualities evoked by serif fonts (Marks, 2014)

Figure 3.115 Most recurrent qualities evoked by sans serif fonts (Marks, 2014)

Figure 3.116 Most recurrent qualities evoked by slab serif fonts (Marks, 2014)

Figure 3.117 Most recurrent qualities evoked by script fonts (Marks, 2014)

Figure 3.118 Most recurrent qualities evoked by decorative fonts (Marks, 2014)

Figure 3.119 Most recurrent qualities evoked by modern fonts (Marks, 2014)

Date #A

Date #B

Date #C

"Effortlessly stylish and well-balanced"

"The type of man who would bring you breakfast in bed but you could also go on a night out with, with expensive taste and g of soap."

"An unstable wannabe with no style and a 50s moustache who, on a date, would take you for a hotdog at a bowling alley, all the while smelling of Joop aftershave."

Designers (and often women) would date Lubalin Graph Book, describing it as cool, contemporary and stylish, an arty type.

Non-designers (and often men) saw it as too straightlaced, harsh and abrasive.

Figure 3.120 Qualities assigned to potential dates based exclusively on the different fonts used for the word "date"

The congruent use of fonts (i.e. the word "reliable" written in Times New Roman) has been shown to aid readability (Zachrisson, 1965), comprehension (Lewis & Walker, 1989), memorability (Poffenberger & Franken, 1923) and persuasion (Juni & Gross, 2008). Sarah Hyndman, author of *Why Fonts Matter* (Hyndman, 2016), offers further proof of the extent to which we assign qualities to fonts and how this influences our behaviour and even our senses. Figure 3.120 includes

Figure 3.121 Descriptions of flavour on the basis of the font used to display the text "eat me"

the views of participants in one of her tests, who described the qualities of their potential dates based exclusively on the different fonts used for the word "date".

Figure 3.121 shows the result of another test where audience members were asked to described the flavour of two sets of jelly beans while looking at the words "eat me" displayed in two different fonts. The flavour was described differently despite the fact that, although the audience did not know about it, the jelly beans were the same. This shows further evidence of the impact that font can have on our perception of reality and on our senses.

The readability of the glyphs and spaces used in the subtitle font and the qualities and effects they evoke on the viewers can inform the discussions between filmmakers and translators/MA experts, not least in cases when subtitles are displayed alongside other types of on-screen text.

Figures 3.122–3.126 from *Out of Kibera* (Romero-Fresco, 2012b), a documentary about a school for girls in one of the largest slums in Kenya, are followed by some thoughts by Martina Trepzcyk, the cinematographer of the film, regarding the different typographic options considered for the use of on-screen captions and subtitles:

The subtitle font used in this shot [see Figure 3.122] and in the next ones is the same: Helvetica. Like Arial and other sans serif fonts, it is one of the most legible fonts for on-screen text due to its absence of serifs, simplicity, spacing and formation of negative space [the space between the letters]. It is accessible for most viewers and it looks very familiar thanks to its use in advertising, government material and transportation settings. It is often regarded as neutral but beautiful and it would be a good match for a documentary that aims to be modern and nicely shot but also unassuming. In this particular shot, although the glyphs in this font are typical, distinctive and

Figure 3.122 First typographic option for an interview from *Out of Kibera*

uniform, the readability of the subtitle is compromised because the font does not have a high enough contrast with the background [the white shirt worn by the interviewee]. A background box or a black outline may be needed. The caption [Ryan Sarafolean/Director of KGSA Foundation] uses a slab serif font [also known as antique or Egyptian typeface], a typeface character-ised by block-like serifs. Slab serif fonts are generally regarded as modern but they also include classic typewriter fonts such as Courier. In this shot, the use of a slab serif font allows the caption to stand out and to be easily separated from the sans serif font used in the subtitle. Although both fonts combine well aesthetically speaking and the dark background provides good contrast, the narrow strokes of the font may cause the viewers to spend a bit more time reading it, so the caption could be left on screen for slightly longer than usual or could be used with a bigger size than the subtitles. The font used in this caption is sometimes used in war-related films, so it may not be 100% appropriate for this documentary.

In this case [see Figure 3.123], the subtitle and the caption have more consistency as they both have sans serif fonts. The subtitle opts for Hel-vetica but, unlike the previous shot, the black outline around the letters here increases its readability, which is nevertheless still compromised. In order to enhance the distinction between the two sans serif fonts, the caption resorts to Stag Sans Serif, a more modern type of font than the Helvetica used in the subtitles. The name and the job description are made more distinctive and dynamic by using two different formats: the former in capitals and bold, the latter in italics [to indicate secondary information] and regular.

Figure 3.123 Second typographic option for an interview from *Out of Kibera*

Figure 3.124 Third typographic option for an interview from *Out of Kibera*

The caption in this shot [see Figure 3.124] uses a serif font, the oldest family of typefaces from which everything else derived. Serif fonts have their origin in the hammer and chisel technique used to engrave letters in stone walls or bricks during the Roman Empire. They are normally used for print, as the serifs create an optical line that makes it easier to glide through without skipping

RYAN SARAFOLEAN
Director of KOSA Foundation

We didn't know where we would go from there

Figure 3.125 Fourth typographic option for an interview from *Out of Kibera*

lines when reading quickly. Serif fonts like the one used here are associated with attributes like noble, wise, strong, sincere or true, hence its use by lawyers or newspapers such as The New York Times and The Guardian. This type of font is however not normally used in film and in general in moving images due to its very delicate lines and to the fact that when it is small, the serifs become dots and readability suffers. It could be used in a big size for a title, but again, the connotation would be that of a serious/classic/old film. It seems too bookish for the speaker in the shot and for this film in general.

Here [see Figure 3.125], the subtitle still uses Helvetica but its readability against the white background is significantly improved by the use of a banner or translucid background box. From an aesthetic viewpoint, though, this is is more common in factual programmes than in fictional films and it can be regarded as institutional, news-like and/or too detached. It certainly does not work well with the font used in the caption, which is childish, not very readable and draws attention away from the image.

Finally, cinematographer Martina Trepzcyk also considered different options for the format of the caption, which carry their own connotations and can be more or less in line with the subtitles used (see Figure 3.126).

In general, the captions used in these four examples introduce a new visual element and draw attention to them and away from the subtitles and the

Figure 3.126 Different options for captions for an interview from *Out of Kibera* (2012)

rest of the frame. The red background increases the readability of the narrow strokes of the slab serif font used. It is modern but it also has a classical component. It may be seen in a BBC documentary. The white background used in the second shot is neat, clean and unassuming, and it goes well with the Stag Sans Serif font used. It could be used in a gripping, intense or dramatic documentary where viewers need to know who is speaking but the text is not supposed to take too much attention away from the interviewee. The third shot [white font underlined in gray] seems much less legible than the others and it reinforces the bookish or journalistic style of the font. The colour used in the last shot is, after white, the most readable colour when displayed against dark backgrounds. It sometimes allows the size of the font to be reduced without having a negative effect on readability. It could provide the film with a young, informal, pop-style look but it would need a different font, perhaps the sans serif font used in the second shot.

For *Notes on Blindness* (Middleton & Spinney, 2016), after a discussion with the filmmakers, the typeface chosen was Adelle (see Figure 3.127). This is a slab serif font and, as such, it is unusual in subtitling, but it helps to portray here the literary look that permeates the script and especially Jon Hull's narration. Unlike more traditional serif fonts (Times New Roman), Adelle was designed to be used in both print and online media, and is therefore readable enough while adhering to what the filmmakers believe is the aesthetic and typographic identity of the film. Its glyphs are typical, distinctive and uniform, and its bold format, used for the subtitles in this film, guarantees high contrast with the background.

Figure 3.127 Use of Adelle font for *Notes on Blindness*

Figure 3.128 Use of Roboto font for *Notes on Blindness*

In contrast, a standard, sans serif Roboto was used for the sound coming from the TV or the radio, with an innovative use of the superscript to indicate the source of the sound (TV, radio, cassette, etc.) for viewers with hearing loss (see Figure 3.128). Developed by Google for its mobile operating system Android, Roboto has been described as "clean and modern, but not overly futuristic" (Topolsky, 2011), which contrasts well with the more classic font used for John and the rest of the characters in the film.

A final example can be found in the creative subtitles produced by the translator and researcher Rebecca McClarty for the Spanish film *Camino* (Fesser, 2008). The strict mother of the protagonist is subtitled with a standard sans serif font whereas the daughter is assigned a comic-like sans serif font (with shadows to increase contrast with the background) that is in line with her age (see Figures 3.129 and 3.130).

In sum, although subtitling fonts still carry the burden of the rigidity that characterised the analogue era, the use of digital technology, the proliferation of user-generated online audiovisual content and fan-made subtitles and the involvement of filmmakers should lead to a more adventurous use of fonts in subtitling. Research on the readability of these new fonts is also needed. Following an AFM approach, it seems essential for translators and graphic designers to start working together so that the use (and look) of on-screen text, a defining feature of contemporary cinema, can be harmonised with that of subtitles, considering both readability and aesthetics. Otherwise, the subtitling font will be yet another factor contributing to the increasing gap between the original and the translated/accessible versions of a film.

Figure 3.129 Use of standard sans serif font in *Camino*

Figure 3.130 Use of comic-like sans serif font in *Camino*

3.6.2 Size

As shown in some of the examples above, font and size can work together to achieve different effects and contrasts in both captions and subtitles, but size can also be considered and altered on its own. In subtitling, the key requirement is to use a legible size, but this could also be used creatively in integrated titles. In SDH, a dwindling size may be used, instead of a description, to indicate that the

Figure 3.131 Subtitles indicating the intensity of the noise made by a kettle in *Thursday Morning*

volume of dialogue or of a particular sound is decreasing. Conversely, size can also be enlarged progressively, as in Figure 3.131, from the short fiction film *Thursday Morning* (Camacho, 2014), to show the increasing intensity of the noise made by a kettle.

In this way, viewers with hearing loss can have a visual representation of the sound, as opposed to an explanation between brackets, so as to appeal more immediately to their senses than to their understanding.

3.6.3 Placement

The placement of integrated titles is perhaps their most characteristic feature. In many cases, this placement helps to improve some of the issues described in Section 3.4.2.2, such as problems with subtitle legibility, subtitling blindness (visuals obscured by subtitles) or character identification. As pointed out by Fox (2018, p. 121), the aim here is not to use alternative positions at all costs, but only "if this leads to a better processing and experience than the traditional placement could offer".

Indeed, if a shot such as that shown in Figure 3.132 has been framed so that the focus is placed on both sides of the frame, why should foreign and deaf viewers be forced to look down to the bottom-centre of the frame, where standard subtitles would be and where nothing happens, thus wasting precious time to take in the details of the image?

On some occasions, this type of placement may solve issues of subtitling blindness such as the scenario 4 mentioned in Section 3.4.2.2: shots where the subtitle covers important visual elements. In the comic BBC One sketch from *The One*

Figure 3.132 Displaced subtitles in a dialogue scene from *Notes on Blindness*

Ronnie included in Section 3.1 as an example of untranslatability, the subtitle for viewers with hearing loss covers the very object the characters are making a joke about (see Figure 3.133).

The use of integrated titles below each speaker would enable the viewers to see the object they are referring to, which is no longer obscured but rather framed by the subtitles (see Figure 3.134). In Figure 3.135, the displaced subtitle is used to indicate the location of the off-screen speaker. Placement in integrated titles can also be based on aesthetic reasons. In Figure 3.136, both the eyes of the protagonist and the subtitle are placed, as per the rule of thirds, around the sweet spots, close to the intersection of the lines where important elements are normally arranged in the frame. On other occasions, integrated titles may be designed to take advantage of a specific composition that may or not have been arranged beforehand (see Figures 3.137 and 3.138).

In some cases (Figures 3.139 and 3.140), the placement of these titles may be based on a combination of factors, such as composition (in this case, the rule of thirds) and contrast against the background to increase legibility.

Interestingly, many of these factors on which the placement of integrated titles is based contribute to mitigating one of the most recurrent reservations regarding this type of subtitle: the fear that viewers may take too long to find them and read them. Indeed, when subtitles are placed closer to the characters who are speaking, closer to the sweet spots of the rule of thirds or against high-contrast background, they become more legible, as they are in line with the audience's

Figure 3.133 Subtitles obscuring important visual information

Figure 3.134 Displaced subtitles to avoid obscuring visual information in the centre

viewing patterns. This is further explained in section 3.6.6, which sums up the results of Wendy Fox's eye-tracking experiment on the use of integrated titles for *Joining the Dots* (2016).

In a different study, Fox (2017) analysed 744 integrated titles from several films, looking at the different positions that have so far been used depending

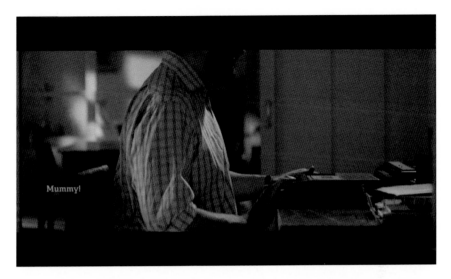

Figure 3.135 Displaced subtitles indicating origin of sound in *Notes on Blindness*

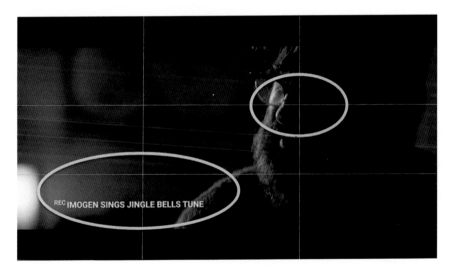

Figure 3.136 Subtitle displaced for aesthetic reasons in *Notes on Blindness*

on whether the shot features an on-screen speaker, more than one on-screen speaker or an off-screen speaker. Integrated titles for one on-screen character (see Figure 3.141) may be placed below (1), above (5), next to (4) or even around (3) the speaker, which highlights the central position of the speaker and allows

Figures 3.137 and 3.138 Subtitles displaced to match image composition

to focus on his face during the reading of the title. They can also be used to indicate speaking direction (2), which can be useful in conversations to enable quick focus change between speakers.

When there is more than one speaker in the shot (see Figure 3.142), a decision must be made as to whether the focus is placed on the speaker or the addressee. The title can thus be placed below the speaker (2), below the focus

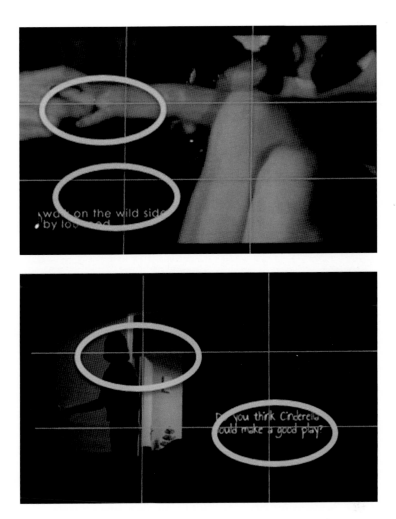

Figures 3.139 and *3.140* Subtitles displaced for composition and contrast

Figure 3.141 Positions for integrated titles with one on-screen speaker

Figure 3.142 Positions for integrated titles with two on-screen speakers

Figure 3.143 Positions for integrated titles with off-screen speakers

(3) or in between them (5). The traditional bottom-centre area (1) was rarely used in the sample analysed by Fox and the positions next to speaker and focus (4, 6) only seemed to be used in order not to cover important image areas or elements.

Along with the standard position (1), integrated titles for off-screen speakers (see Figure 3.143) may be placed below (2) or next to (3) the focus of the shot, or they may be placed so that they indicate the location and speaking direction of the off-screen speakers (4).

Finally, placement can also be used more playfully to merge with the mise en scène of the shot, as in Figure 3.144, which, admittedly, may have been more efficient if the sentence had been written upwards instead of downwards, thus implying that "it gets hard".

Based on the examples of films that pioneered the use of integrated titles (*Man on Fire, Slumdog Millionaire, John Wick*, etc.) and of other films that used them as part of a more systematic approach to AFM (*Joining the Dots* and *Notes on*

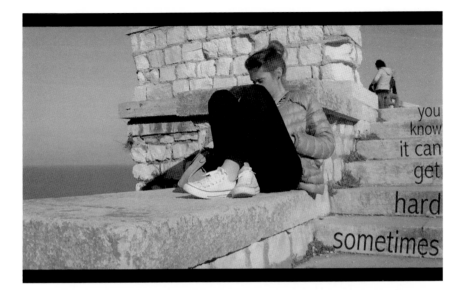

Figure 3.144 Placement of subtitle merging with mise en scène

Blindness), Fox (2018, p. 133) distinguishes six objectives for the identification of suitable positions on screen:

- Short distance between the title and the main focus area, which should allow extra time to explore the image and should trigger a similar viewing behaviour to that of the viewers of the original version.
- No coverage of primary areas.
- Indication of speaker and speaking direction.
- Legibility, which is normally achieved through contrast with the background.
- Individual aesthetic and/or typographic concepts, which normally support the tone, atmosphere and image composition of the film.
- Accessibility, which may be achieved not only through character identification but also information about sound description or mood.

Above all, though, integrated titles must be comprehensible and consistent, which has not always been the case in the above-mentioned films that pioneered their use:

> While the design and typographic identity of titles can be quite individual depending on the film, consistency is demanded in all mentioned characteristics. Therefore, the placement strategies should be consistent and comprehensible.
>
> (ibid., p. 196)

Finally, it is worth remembering that most films that have so far resorted to integrated titles combine standard and more creative positioning. In other words, the be all and

end all is not to find unusual positions for the subtitles but rather to find a placement that can offer the viewers the best possible cognitive and aesthetic experience.

3.6.4 Rhythm and display mode

Integrated titles also play with the rhythm and display mode of the subtitles. In order to avoid the above-mentioned spoiler or time-shifting effect of traditional subtitles, which often reveal content before it is uttered by the characters and which, as noted by Fox (ibid., p. 115), might cause the audience to perceive the scene as faster and more hectic than it actually is, add-on or cumulative subtitles can be used for synchrony (see Figures 3.145 and 3.146).

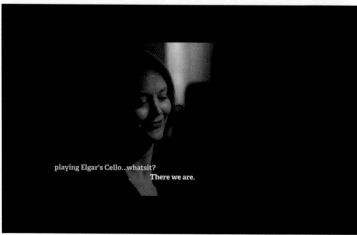

Figure 3.145 and 3.146 Add-on subtitles in *Notes on Blindness*

Figure 3.147 Add-on subtitle for an enumeration in *Notes on Blindness*

Add-on subtitles can also be used for lists or to indicate, as in Figure 3.147, that someone is sifting through something.

When dealing with music in SDH, add-on subtitles can provide the viewers with a synchronous indication of the instruments used in a particular song and their intensity (see Figures 3.148–3.151).

Another important element regarding the rhythm and display mode of integrated titles is the use of fades. Whereas film can resort to fades, dissolves and wipes as an alternative to a normal straight cut between shots, most subtitles only pop on and out of the screen. Thus, as images (and on-screen text such as captions) fade slowly into black or dissolve into another image, subtitles appear and disappear suddenly from the screen. Since the use of fades and dissolves carries meaning (normally indicating ellipsis or transition), once again the combination of these editing devices and traditional subtitles means that the original and the translated versions of the film are telling a different story and using a different language. In *Notes on Blindness* (Middleton & Spinney, 2016), the integrated titles fade in and out in instances where either the image of the film is fading or the narration is particularly slow and contemplative, in an attempt to reflect in the subtitles the tone conveyed by both the image and the narration (see Figure 3.152).

By definition, integrated titles highlight the visual side of subtitles as one more element in the image. This is sometimes done through the interaction of subtitling timing and film kinetics, in other words, by matching the appearance or

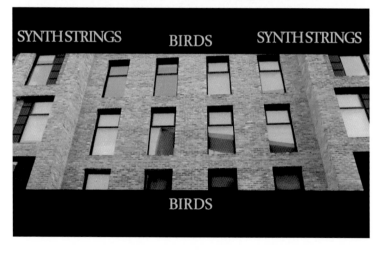

Figures 3.148–3.151 Add-on subtitles indicating instruments

Figures 3.148–3.151 (Continued)

Figure 3.152 Use of fade in the subtitles of *Notes on Blindness*

disappearance of the subtitle with the characters' movements. In the following shots, the characters' hands move and seem to wipe the caption (Figures 3.153 and 3.154) and the subtitle (Figures 3.155 and 3.156) off the screen.

3.6.5 *Effects*

Finally, integrated titles also resort to different effects that can often be found in online text or on on-screen titles in original films and series such as those used

Figures 3.153 and 3.154 Interaction of participant and name caption in *A Grain of Sand*

in *Sherlock* (Gatiss & Moffat, 2010). As a matter of fact, the boundaries between integrated titles and other types of on-screen text are increasingly blurred. Pictures, speech bubbles, chatlike features and special background effects can be very useful to identify the characters in the shot (see Figures 3.157 and 3.158).

Effects can also be used to convey a particular tone. In Figures 3.159 and 3.160, the threat posed by the angel in the Spanish film *Camino* (Fesser, 2008) is shown in the choice of font, the background behind the subtitle and the illegible subtitle in the second shot. Instead of adding a standard tag such as [incomprehensible],

Figures 3.155 and 3.156 Interaction of character and subtitle in *Thursday Morning*

the subtitler has opted for an illegible subtitle, thus choosing to show rather than to explain the effect; that is, to appeal to the viewers' senses. In other words, integrated titles, especially in the case of SDH, follow the old "show-don't-tell" principle of cinema much more closely than descriptive and standard SDH.

A somewhat similar effect is used in Figures 3.161 and 3.162, from *Notes on Blindness* (Middleton & Spinney, 2016), where the two characters talk about the last remains of John's vision.

Figures 3.157 and 158 Use of effects and speech bubbles for character identification

Figures 3.159 and 3.160 Use of effects to indicate tone in *Camino*

Figures 3.159 and 3.160 (Continued)

Figures 3.161 and 3.162 Use of effects to indicate tone in *Notes on Blindness*

The more comic and informal short fiction film *Common Threads* (Santacreu, 2015) resorts to a different effect, green check marks, as the character mentally reviews what she is supposed to bring for her first day at university (see Figure 3.163).

A common effect used in integrated titles is depth, which can be achieved by enhancing the interaction between the subtitles and people or objects in the mise en scène. Firstly, subtitles, integrated as one more element in the image, can be impacted upon by the characters and/or objects in the shot. In Figures 3.164–3.167, the characters obscure the subtitles as they move.

Figure 3.163 Use of green check marks in the subtitles of *Common Threads*

Figures 3.164 and 3.165 Interaction between subtitles and mise en scène in *Joining the Dots*

Figures 3.164 and 3.165 (Continued)

Figures 3.166 and 3.167 Interaction between subtitles and mise en scène in *Notes on Blindness*

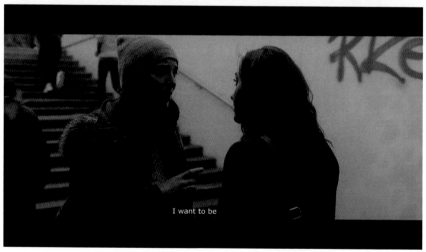

Figures 3.168 and 3.169 Interaction between subtitles and mise en scène in *Dawn of the Deaf*

An interesting example can be found in Figures 3.168 and 3.169, which show a scene from the short film *Dawn of the Deaf* (Savage, 2016) where the two Deaf protagonists are having a heated discussion in sign language. As the camera circles around them, the viewers miss not only some of the signs that they use but also some of the words in the subtitles, which are obscured by the characters. The use of integrated titles in this scene is a good example of AFM, as it manages to

convey to hearing viewers the sense of incomplete communication felt by Deaf viewers, thus bridging the gap between the original and the foreign/accessible versions of the film.

The interaction between subtitles and the mise en scène does not only consist of obscuring visual elements. In Figures 3.170 – 3.174 , subtitles are deleted by a car as it drives over them and by the protagonist as she draws the curtains open.

Figures 3.170–3.174 Interaction between subtitles and mise en scène in *Inner Thoughts*

Figures 3.170–3.174 (Continued)

Figure 3.175 Subtitles impacting on a character in *Inner Thoughts*

In the examples above, it is the characters/objects in the shot that impact on the subtitles. This can be more or less noticeable for the viewers and can be done in post-production, although an earlier intervention would be preferable. A second and more extreme approach to enhancing the interaction between the subtitles and mise en scène is to have the subtitles impact the characters or objects in the shot, which normally requires planning at the (pre-)production stage. Figure 3.175 from *Inner Thoughts* (Fraga, 2015) is a case in point, as the protagonist squats to avoid being hit by a red subtitle.

Finally, movement is another effect that can be very useful in integrated titles. It is used in Figures 3.176 and 3.177, from the short film *Thursday Morning* (Camacho, 2014), to convey the sound of steps as the protagonist walks towards his room.

Figures 3.178–3.180 show a lovely combination of movement and interaction between text (the title of the short film *Living Afloat*, Bermejo, 2015) and mise en scène, with a seagull seemingly bringing the title into the shot and underlining it as it flies away.

A final example from Wendy Fox's integrated titles for *Sherlock Holmes: A Game of Shadows* (Ritchie, 2012) illustrates some of the creative possibilities of integrated titles and their potential to address the limitations of traditional subtitles discussed in Section 3.5.3.5, namely the fact that subtitles distil (sounds are transformed into discrete, one-off subtitles), equalise (all sounds are equally loud) and linearise (sounds are presented linearly, one at a time). In Figures 3.181–3.183,

Figures 3.176 and 3.177 Indication of movement in the subtitles

the subtitle of the dialogue between Sherlock and Watson shares the screen with a subtitle of the words uttered by Mycroft, Sherlock's brother. As Mycroft walks away into the distance and his voice becomes fainter, his subtitle moves with him, becoming smaller and fading into the background, while providing a comic contrast with the subtitle showing Watson's ironic remark. Through the creative

Figures 3.178–3.180 Combination of movement and interaction between text and mise en scène

Figures 3.181–3.183 Subtitles indicating change of volume and depth in *Sherlock Holmes: A Game of Shadows*

use of font, size, position, rhythm/display mode and effects, the integrated titles used here manage not to distil the audio, equalise or linearise the sound. Instead, they add a third dimension to the normally two-dimensional subtitles, providing a visual depth that matches the complexity and comic tone of the acoustic landscape.

The examples included here show some of the possibilities available for the use of integrated titles, but this is an incipient area whose full potential is still to be exploited. The collaboration between graphic designers, filmmakers and translators, the lessons learnt from fan-made subtitles and new developments in text design are bound to offer many more options to integrate subtitles as part of the mise en scène of films and to improve the viewers' experience.

3.6.6 Research

The first eye-tracking study on integrated titles, conducted by Fox (2017) and comparing the original English version of *Joining the Dots* (Romero-Fresco, 2012a), the German version with standard subtitles and the German version with integrated titles, has shown promising results. The findings of the experiment show that while viewers take a little more time to find integrated titles than standard subtitles, the overall reading time is reduced. The viewers preferred the integrated titles over the standard ones, since the former allowed them to have more time to watch and explore the images. Interestingly, these new subtitles triggered in the participants very similar eye-movement patterns to those of the viewers of the original film with no subtitles (see Figures 3.184–3.186).

Figure 3.184 Viewers' eye movements watching an original shot from *Joining the Dots*

Figure 3.185 Viewers' eye movements watching the same shot with standard, bottom-placed subtitles

Figure 3.186 Viewers' eye movements watching the same shot with creative sub-titles from *Joining the Dots*

In a further experiment on the use of standard and integrated titles for *Sher-lock: A Game of Shadows* (Ritchie, 2012), Wendy Fox found that in scenes such as the one shown in Figure 3.187, the viewers watching the film with standard subtitles only had the chance to focus on the subtitles at the bottom of the screen and at the central points of the image where Sherlock and Watson were.

Figure 3.187 Viewers' eye movements watching a scene from *Sherlock: A Game of Shadows* with standard, bottom-placed subtitles

Figure 3.188 Viewers' eye movements watching a scene from *Sherlock* with creative subtitles

In contrast, the viewers watching the integrated titles managed to spot the two characters walking behind them (see the circle in Figure 3.188), who happen to be crucial from a narrative point of view.

These findings suggest that integrated titles and AFM may bring about a degree of similarity in the way in which original and translated/accessible films are received that is not normally found in films that are translated or made accessible at the distribution stage. In other words, the use of creative/integrated titles within AFM can go a long way towards bridging the gap between film and translation, or between the experience of the original viewers and of the foreign/deaf viewers, while providing an opportunity of collaboration and innovation for filmmakers and translators.

3.7 AD[8]

AD is the access mode that filmmakers might find the strangest of all. Films are meant to show, not tell. AD turns that on its head by telling what is shown. It is an extra commentary that describes the images for people who cannot perceive them for themselves (Fryer, 2016). That might be sighted people who have nipped out of the room to make a cup of tea or, most commonly, people who are blind or partially sighted.

3.7.1 Background

AD has operated informally for centuries with sighted family and friends explaining to blind companions what is happening on screen or stage. The problem with this method is that the AD is improvised and the describer ends up talking over the dialogue and important sound effects, ruining the film not only for the person they are trying to help but also for anyone else trying to listen in the same space, be that in a domestic setting or at a cinema. Instead, in the early 1980s NTV, a commercial broadcaster in Japan, pioneered the first audio-described broadcast on TV. In the West an early pioneer was Gregory Frazier, a professor at San Francisco State University, who developed a system he called "television for the blind". In 1987, the Boston-based TV station WGBH began its descriptive video service (AD is called video description in the US). The idea was exported to Europe and a pilot AD service for TV (AUDETEL) ran from 1993–1996. In 1994, the RNIB (Royal National Institute for Blind People) set up a home video service. A description track was mixed with the original soundtrack and a library established whereby blind people could borrow the videos containing AD.

Like subtitles, there are two methods of delivering AD. It can be "open", as with the RNIB videos, so that everyone hears it mixed into the original soundtrack, or it can be "closed", which is the method used in cinemas today. This means that the AD is carried on a separate sound channel, broadcast in the cinema auditorium and accessed by the AD user via a headset on a short-range radio frequency or more commonly via an infrared signal. Mobile phone apps have also been developed whereby blind people can download the AD onto their mobile phone and listen using their own headphones. The AD is synched with the soundtrack of the film. The AD user simultaneously hears the soundtrack unmodified as it plays to the rest of the audience, while the AD is relayed into their ear. The difficulty with this method is that during noisy sequences such as battle scenes, the AD can be hard to hear. Some, but not all AD tracks make it onto the film's DVD release and can be accessed as a separate audio track (usually listed under languages on the DVD menu) mixed with the original soundtrack. A list of the latest cinema screenings and DVDs with AD is available from Your Local Cinema.com. The website also has examples of audio descriptive tracks to listen to on MP3.

In the UK, the provision of AD was encouraged by the Disability Discrimination Act (1995, 2005) and the Equality Act (2010), which made it unlawful for

any organisation or business to treat a disabled person less favourably than an able-bodied person. Businesses were required to make "reasonable adjustments" to make their services accessible. For people with impaired sight these adjustments included the provision of information in an audio format or braille or "offering an AD service for films, plays and exhibitions". The Communications Acts (1996, 2003) introduced quotas for the percentage of TV to be broadcast with AD. Broadcasters such as the BBC and Sky regularly broadcast around 20% of their output with AD. Recently, streaming services such as Netflix have made a commitment to making AD available for some or all of their output.

In general, descriptions for films are outsourced to translation bureaux and facilities houses, including Deluxe, Ericsson, IMS, Red Bee Media and SDI media, with little or no contact between the describers and the original filmmakers. Sometimes describers only write the AD script, which is then voiced by a professional voice-over artist. In other instances, the script is also voiced by the audio describer, depending on their background and experience and the suitability of their voice. The film distributor may be involved in the selection of the voice; otherwise, it is left to the AD provider.

3.7.2 Guidelines

Following the AUDETEL pilot, the ITC (Independent Television Commission) produced guidelines for TV AD in the UK. These have since been adopted and updated by Ofcom. The main guidance is that description should avoid masking the dialogue or important sound effects. This means that AD is heavily constrained by the duration of the "gap" between bursts of dialogue, given that the describer has to convey visual information in verbal form so that the AD user is left in no doubt as to the location of the scene, the identity of who is speaking as well as what they look like and any action that is taking place. Here is an example, from *Charlie and the Chocolate Factory* (Burton, 2005):

AD: *Mister Wonka bends down to unlock the tiny door, then pushes on the circular panel which opens up on to a magical Technicolor landscape. There's a huge chocolate waterfall, and a chocolate river, flowing through a bright acid green meadow which is covered in strange brightly coloured plants and giant red and white toadstools. Wonka leads them in . . .*

WONKA: "Now, do be careful my dear children . . ."

The guidelines encourage the description of colour on the grounds that the vast majority of blind people have lost their sight following accident or disease. Only around 4% of the blind population is born blind and even those with congenital blindness will still have an understanding of the cultural connotations of colour or will be able to link colour to non-visual modalities such as temperature. They will know that red is associated with danger, heat and passion while green is associated with youth and freshness and the smell of fresh mown grass.

Some sound effects are self-explanatory, for example a doorbell or a gunshot, while others can only be interpreted by the accompanying visuals. For example, the creaking in an early scene of *Sweeney Todd* (Burton, 2007) could be the sound of rigging as we have recently seen Sweeney arriving in the port of London by sailing ship. However, it is in fact the creaking of floorboards as he goes to inspect a dingy room he is hoping to rent from Mrs. Lovett. In this case, the description of the location will allow the sound effect to be correctly interpreted.

Controversially, the guidelines (2015, A4.29) advise that

> the description should only provide information about what can be seen on the screen. Information unavailable to the sighted viewer should not be added though discretion is always necessary . . . Generally, "filmic" terms such as camera angles should not be used.

This is controversial not only because camera angles can be seen but also because they have been deliberately chosen by the filmmaker in order to affect the way the sighted audience interprets the visual content. Furthermore, research has shown that the majority of blind people found AD which included description of the camerawork to be more engaging and immersive (Fryer & Freeman, 2012, 2013). An AFM approach can help the describer decide whether or not to include details of the camerawork. For example, in *The Progression of Love* (Rodgers, 2010), time is shown passing by a fade to black. The describer opted for the direct approach of describing what was seen (a fade to black) whereas the director preferred to hear it described more poetically (time passes).

An alternative way to convey filmic information is via an *audio introduction* (AI). These are pieces of continuous prose, spoken by a single voice or a combination of voices lasting between 5 and 15 minutes incorporating information about the film's visual style, fuller descriptions of characters and settings, a brief synopsis and cast and production details (Romero-Fresco & Fryer, 2013). Although not currently provided for most films, recent research (ibid., p. 287) concluded that "AD providers should consider the use of AIs as a complement to standard film AD". The inclusion of an AI was one of the access strategies adopted for *Notes on Blindness* (Middleton & Spinney, 2016). It allowed for an explanation of the complex camerawork that was key to the beauty of the film and became a metaphor for John Hull's sight condition:

> His deteriorating sight is illustrated more by the way the filmmakers create the shots than by John's physical appearance. John is often filmed from a dark, neighbouring room, through an open doorway that cuts off part of our view of him, narrowing our visual field; figures or the landscape is blurred in soft focus, from which only gradually a crisp image resolves. Sun spots or lens flare often blot the image with dazzling haloes of light as the filmmakers deliberately shoot into the sun. Many of the shots are streaked by shadow. The filmmakers also incorporate faded photographs and home movie footage

of the Hull family, the photos static but with elements that move – such as snow that falls around a posed picture of Marilyn or birthday candles that flicker on a motionless cake. Reference to other senses, such as touch, temperature and skin sensitivity are illustrated by wind rippling fields of long dried grass bleached by the sun or by tough spiky marram grass and slender reeds blowing on dunes on the edge of a beach. Views through windows are obscured by rain or condensation. Much use is made of silhouette, John a dark shape against a brighter background.

The information included in the AI does not have to be restricted to camerawork, as this excerpt from the AI for *Die Wandt* (*The Wall*) (Pölsler, 2012) illustrates:

> Both the landscape and indoor shots are characterised by the natural colour and lighting conditions, which constantly reflect the changing seasons and weather. When the protagonist sits in the sparse hunting lodge, writing her report, the dark room is lit only by the grey winter light and the yellow glow of the oil lamp.

Arguably, the true reason for Ofcom's guideline is that many describers lack the vocabulary or knowledge to correctly identify different film shots. This is another area where an AFM approach can improve the situation, giving the describer access to the knowledge and vocabulary of the filmmakers.

As far as the voicing or delivery is concerned, Ofcom Guidance (ITC, 1990, p. 31) suggests that it should be "steady, unobtrusive and impersonal in style, so that the personality and views of the describer do not colour the programme". However, Ofcom also recognises that "it can be important to add emotion, excitement, lightness of touch [. . .] to suit the mood and plot development" (ibid.). It is thought to be cheaper to use an electronic voice and blind people say that they would be willing to accept a synthesised voice if it led to greater availability of AD. However, research also shows that an AD script delivered by a synthesised voice was less likely to convey the emotion of the film to AD users than the same script delivered by an emotive human voice (Fryer & Freeman, 2014). This is thought to reflect the importance of prosody in natural speech "such as phrasing and stress, which can alter perceived sentence meaning" (Silverman et al., 1992). For example, using a higher pitch for a name or a location suggests it is new information rather than a character or setting we have encountered before. Too often, a synthesised voice or an AD script recorded in isolation fails to reflect these natural nuances of tone. The presence of the scriptwriter or director at the recording can help ensure continuity.

One relatively straight-forward choice regards *gender*. Most guidelines agree that while the AD should live with the soundtrack, it should also be easy for blind people to distinguish the AD voice. For example, as *Notes on Blindness* (Middleton & Spinney, 2016) is mostly narrated by the main protagonist, John Hull, it seemed appropriate to use a female voice for the AD. However, the filmmakers

recorded another version with the actor Stephen Mangan to give AD users a choice and because they felt his voice was more empathetic. American guidelines argue that a celebrity voice can be distracting.

In the case of a foreign film, the AD has to include voicing of the subtitles, reducing still further the amount of time available for description. Many of the issues that have been covered in Section 3.4 (e.g. whether the subtitles should be read verbatim, summarised or adjusted to make it clear who is speaking) would then apply to this practice, which is known as *audio subtitling* (Braun & Orero, 2010). Furthermore, it might seem appropriate to use more than one voice. For example, in *Coco Before Chanel* (Fontaine, 2009), Coco's subtitled speech is voiced by a female with a French accent. Her sister, Adrienne's subtitled speech, is voiced by a different female, in this case with an English accent. While this makes it easy to distinguish who is saying which line, it makes their relationship less realistic. A male voice with just a hint of a French accent voices the subtitles of the male characters and a female voice with an English accent voices the main AD.

The use of AD voices of different gender is not only helpful for voicing subtitled speech, it can also be used creatively. For example, in the Pixar animated cartoon *The Incredibles* (Bird, 2004), a female voice is used to describe the scenes where the superheroes are going about their business as ordinary human beings, while a male voice describes the scenes of their adventures as their superhuman alter egos. Yet, it is not always necessary to increase the number of voices. For example, in *Kill Bill: Volume 2* (Tarantino, 2004), the subtitled speech of the Bride's Chinese martial arts teacher, Pei Mei, is voiced by the describer, using just enough inflection to convey the emotional nuances without actually acting and without having to explain "Pei Mei says" each time.

Going back to the AD of *Coco Before Chanel*, another issue is that, although the *lyrics* of the sisters' music hall songs are subtitled, these are not voiced in the AD, and are therefore lost to any of the blind audience that does not speak French. As with subtitling, so the presence of a *song* presents difficulties for AD, especially where the lyrics are critical to understanding the mood or emotion of a scene. In *Slumdog Millionaire* (Boyle, 2008), for example, 36.8% of songs with lyrics are covered completely by a combination of AD and dialogue (Igareda, 2012). Although not everyone in the sighted audience will understand the lyrics, some of which are in Hindi, by speaking over the lyrics the describer will guarantee that none of the blind audience will have even the possibility of understanding them. Whether or not the lyrics are not understood, they still contribute to the "foreignness" of the location and therefore to our emotional response to the film. Another example is where the action that occurs during the song amplifies the lyrics as when Mr. Cellophane in the film of the musical *Chicago* (Marshall, 2002) paints his face to look like a sad clown while singing his poignant trademark song. The saving grace for the describer is that lyrics are repeated, so that the AD can be placed over them, without making them inaccessible to the AD user. The

difficulty with this is that the user does not know that they are not missing out as they will not be able to hear that the lyrics are repeated. This scene further illustrates the constraints of AD as, at the end of the song, the scene cuts from Mr. Cellophane on stage to him retreating from an office doffing his hat and meekly muttering "I hope I didn't take up too much of your time". The moment the door closes, an open newspaper is lowered from the perspective of the unseen reader where it has been concealing his view of the door and the reader instantly says, "I'm sorry, I didn't know you were there".

Humour is particularly challenging. Timing is often believed to be the secret of good comedy, and by the time the describer has described the joke the moment has usually passed. The filmmaker can help by extending the shot. For example, in the scene from *Joining the Dots* (Romero-Fresco, 2012a) discussed in Section 3.4.2.2, which begins with a close-up of Mags's sign which reads "A lovely lady and a grumpy old man live here!", the shot is immediately followed by Mags exclaiming "He's just a grumpy old man!" Without knowledge of the sign this would sound like a non sequitur. In the original cut of the film there was no time for the sign to be described at all. The director agreed to extend the shot by a crucial couple of seconds to allow for an incomplete description ("*a sign reads lovely lady and a grumpy old man*") that at least helps Mags' comment to make sense.

The use of J-cuts (i.e. the practice of running the sound of the next location under the image of the previous scene) also makes it difficult for the describer to synchronise the AD with the image. This type of synchrony is encouraged in AD and is especially helpful for people with partial sight.

Section 3.4.2.1 demonstrated how the gaze pattern of sighted people is task driven and determined by subjective experiences. A describer will almost certainly view an image differently from a casual viewer and maybe one describer will view it differently from another. This has led to fears that AD is inherently subjective. Moreover, the very choice of the words with which to capture an image will affect how AD users interpret it. While describers are advised to choose language that is vivid, Ofcom guidelines warn that "adverbs are a useful shorthand to describing emotions and actions, but should not be subjective" (2015, p. 21). One way around this has been to use what is called "auteur AD". This "incorporates the director's creative vision in the AD script . . . and thus gives the audio describer the artistic license to depart from the dictate of objectivism" (Szarkowska, 2013, p. 383). An AFM approach clearly makes this a more practical possibility than the describer faced with a classic film, such as a Lean or a Hitchcock, where the director is no longer available to discuss their choices. However, in such cases Szarkowska recommends turning to the original screenplay. She cites as an example Almodóvar's description of the character Raimunda in the screenplay of his 2006 film *Volver*:

> Raimunda, of an astounding and racial beauty, is firmly grounded by her luscious rounded bottom and her bosom, which one can hardly take one's

eyes off. Uncompromising, resolute, exuberant, courageous and fragile at the same time.

Raimunda's bosom leads nicely into consideration of explicit content. Ofcom (2015, p. 21) reminds us

> The description should not censor what is on screen. However, it should not be necessary to use offensive language, unless (for example) when referring to content that is integral to understanding the programme, such as graffiti scrawled on a wall.

Research shows that a direct realistic description that does not shy away from brutal realities on screen works best for audiences with a visual impairment (Walczak & Fryer, 2017). Again, the director or scriptwriter can advise on word choice, so that explicit images are not censored for one sector of the audience.

As advanced in the introduction, this chapter has focused mainly on how the different AVT and MA modalities impact on the nature and reception of films. More detailed information can be found in specialised journals and books, some of which have been cited here, but the information provided so far should suffice to enable filmmakers, film scholars, translators and translation scholars to initiate the collaboration that is envisaged within the AFM model and outlined in the following chapter.

Notes

1 Voice-over is explained in the following section.
2 It is worth noting that eye tracking can only detect the central vision obtained by the fovea (Slaghuis & Thompson, 2003). Foveal vision allows us to obtain detailed information typically within 6 degrees of our field of vision, that is, spanning five words in a row when reading printed text at ordinary size at about 50 centimetres from the eyes. Parafoveal or peripheral vision, which can span up to 120 degrees, is thus not detected by eye trackers. However, even though peripheral vision can be used to differentiate movement from stillness and even certain types of rhythms and contrast, it cannot help to distinguish colours, shapes or details (Wästlund E, Shams, & Otterbring, 2017). For the purpose of this study, peripheral vision could potentially be used, given the right conditions, to differentiate whether a mouth is moving or not, but certainly not to discern the degree of (a)synchrony between moving lips and the dubbed audio. In other words, participants whose fixations are found on the characters' eyes cannot be expected to be put off by the imperfect synchrony of lips and audio often found in dubbing.
3 To mention but one example, when faced with a close-up that makes it difficult to keep both lip synchrony and meaning/style of the script, filmmakers and translators may choose to prioritise meaning/style, given that, as per the dubbing effect, the viewers' eyes may be mainly focused on the characters' eyes and not on their mouths. This should however be approached with care, as extreme asynchrony may draw the viewers' attention to the characters' mouths.
4 In Latin, Cyrillic and Arabic alphabet languages, subtitling speeds may be expressed in words per minute (wpm) or in characters per second (cps), which are calculated

differently by the various subtitling programs. The latter measure depends on the average number of characters per word, which is generally considered to be five. In the case of double-byte languages like Chinese, Japanese and Korean, subtitling speed is always measured in cps and the standard hovers between 4 and 5 cps.

5 The numbers have been added by the researcher Sean Zdenek (2015) to mark the notes.

6 Technically speaking, a typeface is a particular design of type that includes many fonts with different weights (light, medium, bold), styles (serif, sans serif, slab serif), sizes, etc. However, these terms are now often used interchangeably, as is the case in this section.

7 Readability is the ease with which a reader can recognise words, sentences and paragraphs. Legibility is concerned with how easy it is to distinguish characters and is a component of readability, along with font choice, point size, kerning, tracking, line length, leading and justification.

8 This section has been written by Louise Fryer.

Chapter 4

Integrating translation and accessibility into the filmmaking process

The aim of this chapter is to describe how translation and accessibility can be taken into account and integrated into the different stages of the filmmaking process, and more specifically in pre-production, production and post-production and before distribution.

4.1 In development and pre-production

Different issues regarding translation and accessibility often crop up at the pre-production stage but they are normally addressed by non-professional translators or ad hoc linguist experts who are not involved in the subsequent translation of the film. Adopting an AFM approach at this stage may help to identify what impact translation/access can have on the film before production and how to make a more efficient use of translators by involving them throughout the process and providing them with the information they require to do their job.

4.1.1 Translation in the scriptwriting process

Translation/accessibility can be a very important element in the creation of multilingual scripts, that is, those involving several languages in the original version. One way of dealing with this is to write the whole script in the main language and then have it translated later. This is what Paul Laverty, habitual scriptwriter for Ken Loach's films, did for the dialogue of the Spanish characters in the original version of Bread and Roses (Loach, 2000), which was translated from English into Spanish by some of his native-speaking friends and colleagues (de Higes, 2014). In this case, the original dialogue is the one featuring in the English script, which is then translated into the "foreign language" to be spoken by the characters of the film as if it was original and is subsequently subtitled into English for the viewers of the original version. When choosing this approach, some scriptwriters and filmmakers, such as John Sayles in Men with Guns (1997), end up writing dialogue to fit the subtitle format of 30-odd characters per line (Molyneaux, 2000, p. 242), which may be seen as more concise and aphoristic than may normally be expected (O'Sullivan, 2011, p. 126).

A different approach is that of Jim Jarmusch, whose non-English dialogue in *Mystery Train* (1989) or *Night on Earth* (1991) was created in collaboration with the actors in a bilingual environment where the juxtaposition of dialogue and subtitles is foreseen from the start:

> I wrote the script in English, and then a Japanese director named Kazuki Oomori translated my script into Japanese. I worked on the dialogue with the actors and my interpreter, Yoshiko Furusawa. As with all actors, I let them improvise in rehearsal, and then I changed my script according to what made us all feel most comfortable about the language. For me, the creation of a character is always a collaboration with the actor, which also comes from writing with specific actors in mind. In Japanese the process was a little complicated, since I couldn't know exactly what the nuances of the changes were. My interpreter was very helpful in trying to explain those nuances, but I couldn't know precisely how the dialogue was changing. I had to rely on intuition and trust the actors. Then, when the film was shot, I had yet another translator translate the Japanese dialogue back into English, and then I translated that English in to my choice of English, and my retranslation is what appears in the subtitles. In the end the subtitles are pretty close to my original script.
>
> (Sante, 2001, p. 94)

The fact that some of the non-English dialogue used in the original version of these films is a co-creation with native speakers explains why the French dialogue in the scene shown in Figure 4.1 from *Night on Earth* (Jarmusch, 1991) can

He's an "Y voit rien."

Figure 4.1 Pun subtitled from French into English in *Night on Earth*

include plays on words such the one between "*Ivoirien*" ("from Ivory Coast") and "*Y voit rien*" ("can't see a thing"), which the two characters on shot use to mock the driving skills of the Ivorian taxi driver who is giving them a lift (O'Sullivan, 2011, p. 123). This pun would have been very difficult to produce if the French dialogue was a translation of a script written originally in English.

In general, when dealing with different languages in the original version of a film, allowing for collaboration with native speakers and even for the co-creation of certain lines can provide the dialogue with a degree of freshness and original-ity that cannot always be obtained when the dialogue is a translation from an original script written in English. In those cases in which this co-creation is not possible or desired, the involvement of native speakers to translate the original script into other languages is useful, but it would also be advisable to involve a professional translator at this early stage. After all, translators are specialised in producing natural-sounding dialogue and their early involvement in the pre-production process will help them become familiarised with the film and will put them in an ideal situation to take care of the dubbing or subtitling once the film has been postproduced.

4.1.2 Translation of scripts for funding (co-productions)

As explained by O'Sullivan (2011, p. 13), film scripts often need to be translated internally for international co-productions and/or casting. Financial constraints and the current cost of film production mean that there is an increasing need to pull resources from different countries, which is done by means of co-production treaties. Canada, a bilingual country, has 54 of these treaties (Brioux, 2016), and in countries such as Belgium, Ireland and the Netherlands, the number of co-productions exceeds that of domestic productions (Albornoz, 2016, p. 11). In the UK, 14 of the 19 films that Ken Loach has made over the past 30 years have been continental European co-productions (D. Jones, 2016). In the US, leading production companies such as Disney, Universal, Sony, Warner and DreamWorks Animation have set up joint ventures with Chinese companies for film co-production (Albornoz, 2016, p. 11), which has resulted in collaborative efforts such as *Iron Man 3* (Marvel Studios/Paramount in partnership with Chinese DMG Entertainment) and *Transformers: Age of Extinction* (Paramount and oth-ers, with China Movie Channel). Co-productions seem to bring about both financial and cultural benefits. On average, they are released in twice as many markets as national productions, and their revenues are almost three times higher than national productions (Kanzler, 2008, p. 1). From a cultural point of view, the European Convention on Cinematographic Co-production (Europe, 2017, p. 1) considers international co-production as "an instrument of creation and expression of cultural diversity".

Even in those cases in which the input from the international partners is only financial and not creative, at the very least a full translation of the script is nor-mally required. As mentioned in the previous section, it would make sense to

involve professional translators for this job and keep them for the subsequent translation of the film for dubbing or subtitling, as they will already be familiar with the script and the changes it has undergone once it has been filmed. On other occasions, co-productions involve cross-cultural artistic collaboration, which requires on-site translation. This will be discussed in Section 4.2.1 alongside the on-site translation sometimes required in documentary filmmaking.

4.1.3 Provision of material for translators

Despite the advice included in the new *ISO Guidelines on Subtitling* (ISO/IEC DIS 20071–23) for producers and filmmakers to make available pre-production material to translators, the latter hardly ever have access to pre-production documents such as pre-production scripts, treatments and shooting scripts. This is often one of the reasons why translated and especially accessible versions of films (those that are distributed with SDH and AD) sometimes seem to "speak" a language that is different to that of the original film. Having access to this material, which is often detailed and highly descriptive, can help translators find the right tone and style to describe the sound for viewers with hearing loss or the images for audiences with visual impairments. A case in point is the beginning of Asghar Farhadi's *The Past* (2013), whose opening scene, described in detail in the script, is entirely visual, subtle and very significant for the rest of the film:

> Behind the glass wall, which separates the baggage claim area from the busy airport terminal, MARIE is awaiting the arrival of a passenger. She is holding a simple bouquet of flowers. She scans the crowd of the newly arrived passengers. Marie's gaze reveals a sense of worry. Her eyes fix on a man who has his back towards her. She looks more carefully, uncertain that he is the man she is waiting for. The man is waiting along with the other passengers for his suitcase. Marie changes position so that perhaps she'll be able to see his face. She briefly sees his profile. He's AHMAD, forty-four years old. She spontaneously raises her hand to catch his attention but changes her mind. She takes off her wristbrace and stuffs it into her purse. She prefers to watch him for a few moments from afar. Marie is intensely watching Ahmad; he has not yet seen her. One by one, the passengers take their suitcases and leave. Only Ahmad is still waiting next to the empty carousel for his suitcase. Ahmad wanders through the baggage claim area looking for a representative to report his missing suitcase. He speaks to a member of the airport staff. Marie tries to get his attention from afar by waving her hand. She signals to a passenger who is holding a suitcase and walking by Ahmad to get him to look at her. The passenger speaks to Ahmad. He now turns his head and sees Marie through the glass wall. Happy, he walks towards her. They both come face-to-face on either side of the glass wall. They cannot hear each other. From the expression on their faces, it is clear that they have not seen each other in a long time. She understands that his luggage has not arrived with the flight.

If this script is not made available to the audio describer, they will have to find their own words and style to describe the images and especially the subtle way in which the performance by the two main actors tells the viewers what kind of relationship and history they have. The audio describer would thus be duplicating an effort that was already made by the scriptwriter before the script was translated into images by the director. The same goes for subtitlers producing SDH, who can benefit greatly from accessing the description of sounds often included in pre-production scripts. After all, and just as in the case of the images described in the AD, those sounds were first described in writing in the script before they were produced for the film. The following section from the script of *Wall-E* (Stanton, 2008) provides the subtitlers with everything they need to know in order to describe the sounds of the scene as originally conceived by the scriptwriter and the filmmaker:

> (Beeping) (Wall-E groaning) (Clanging) (Groans) (Clanks) (Muttering) (Moaning) (Beeping) (Electronic bell chiming) (Whirring) (Skittering) (Cockroach squeaking) (Sighs contentedly) (Squelches) (Screams)
> – Aw!
> (Wall-E exhales in relief) (Shuddering) (Whistling)
> – Whoa!
> (Squeaks) (Keys rattling) (Car alarm chirps) (Grunting) (Whistles)
> – Whoa. Ooh!

Unlike pre-production scripts, shooting scripts can include scene numbers, camera angles/directions, special effects, detailed stunt work/action sequences, specific information on sets, costumes, lighting and special notations regarding acting. Shooting scripts are designed to guide the director of photography in setting up the shots and the editor in post-production, but they can also be extremely useful for translators. Figures 4.2 and 4.3 show a document including not only very useful descriptions of images and sounds for the audio describer and the SDH subtitler, but also relevant information about shot changes and shot sizes for the translators in charge of dubbing and interlingual subtitling. Indeed, the translators can flag up to the filmmaker, before the shoot, issues that may have an impact on the translated film and its reception, such as potential cases of subtitling invisibility due to quick shot changes or difficulties in the translation of certain lines for dubbing due to the use of close ups. If the filmmaker wishes to address any of these issues, it would be ideal to do it at this stage, before the production starts.

In sum, the consideration of translation and accessibility at pre-production stage can be of immense help for translators to do their job faster and more efficiently. The early involvement of translators in the filmmaking process will provide them with a degree of familiarity with the project and access to the creative team that can be essential to guarantee that the original vision of the filmmaker is preserved in the version received by millions of deaf, blind and foreign viewers.

Marking The Shooting Script

The "lined script," or "shoot script," has all the scenes numbered, camera angles and shots indicated and contains directorial requirements to guide the director of photography in setting up the shots and the editor in postproduction.

1

FADE IN: #1A—WS #1B—MS

(1) INT. LIVINGROOM - DAY. #1C—CU (1)

CHRIS is sitting in a comfy overstuffed chair, reading. KIRSTEN enters.
She holds something in her hands, but we can't see it. She stands before
Chris, miffed, waiting for him to notice her. After a BEAT, he does.

 KIRSTEN
 Do you love me?

Chris looks up, perplexed by the question. He is certain in his response.

 CHRIS
 Yes.

 KIRSTEN
 (eyes him incredulously)
 I found these next to your bed. You could have
 told me about this... I don't understand why you
 felt you had to hide this stuff... Chris? You're
#1F—XCU supposed to be able to talk to me...

While she rants, she holds something we still can't see; Chris slowly
looks down to see what she has. His face drops with recognition of what
she's found. His jaw opens, grasping helplessly for some explanation.

 KIRSTEN
 (continuing)
 ...So I'll ask you again... do you love me.

 CHRIS #1D—OS #1E—CU Rv Ang
 (less sure, maybe convincing himself)
 Yes... yes...

 KIRSTEN
 More than chocolate?

He is unable to answer... He looks from her face to the bag. And back...
Silent... Apologetic. She is incensed. Without warning she throws the bag
at him and storms out of the room. Chris opens the bag to reveal a pile of
imported dark chocolate bars. #1G—INSERT

 CUT TO: BLACK

There is the sound of a candy bar wrapper being torn open...the sound of
munching... FADE SOUND OUT.

 THE END.

 (8/8)

1A – MASTER – wide shot encompassing most of living room with CHRIS
 screen right reading, dining room visible in b.g.
1B – MS KIRSTEN – CHRIS in comfy chair off-camera
1C – CU CHRIS – 3/4 profile looking up at KIRSTEN who continues to talk
 off-screen
1D – OS favoring KIRSTEN – from CHRIS' level tilt as CHRIS looks up at
 KIRSTEN, we see her reaction
1E – CU reverse angle – KIRSTEN'S POV of CHRIS
1F – XCU CHRIS – reaction shot of what he sees in KIRSTEN'S hand
1G – CU – CHRIS' POV opening bag to reveal chocolate bars.

Figures 4.2 and 4.3. Example of shooting script

4.2 In production

Translation and accessibility also play a significant role at the production phase, for instance facilitating the communication amongst crew members who speak different languages and considering the impact that mise en scène and cinematography may have on the reception of the film by foreign and sensory-impaired audiences. At this stage, when the relevant decisions regarding the mise en scène and cinematography are being made, there is still certain flexibility to address issues that can help to ensure that the filmmaker's vision is maintained in the translated and accessible versions of the film.

4.2.1 On-site translation/interpreting

On-site translation and interpreting during film production may be needed for different purposes, two of the most common ones being communication amongst the members of the crew and communication between the filmmaker/film crew and the participants in a documentary.

As mentioned above, co-productions are becoming increasingly frequent, and on many occasions this involves not only financial but also cross-cultural artistic collaboration amongst members of the crew who may not have a language in common. A case in point is the Swedish producer Erik Hemmendorff, whose career is based on building such co-productions. His critically acclaimed film *Force Majeure* (Östlund, 2014) obtained its $3.8 million budget from 15 investors in Sweden, Denmark, Norway, France and Italy. Its crew included a Swedish director, a Danish editor, Swedish and Norwegian sound mixers, a Swedish cinematographer and grips and technicians from all three countries. More importantly, since the film was shot in Italy and France, Östlund and Hemmendorff, who consider themselves as "international filmmakers", worked with Italian and French crews that they hired locally. In those cases in which translation is needed for communication amongst the crew members, whether from, for instance, Swedish to Italian or from these languages to English as a lingua franca or common language for all, it may make sense to opt for professional interpreters. Many translation and interpreting schools now train their students in both interpreting and different modalities of translation, including AVT. It is thus possible to find professionals who can be employed during (pre-)production to provide interpreting services for the crew and the cast and who can later on produce the first translated/accessible version of the film. Their early engagement with the project will make it easier for them to provide an informed translated/accessible version that can be in line with the original intention of the filmmaker.

Whereas on-site interpreting for documentaries can also consist of facilitating the collaboration amongst the crew members, in other cases, especially in ethnographic documentaries, translation and/or interpreting is required for essential communication between the filmmakers/crew and the participants. This often

involves non-hegemonic languages for which professional interpreters may not be readily available. As explained in Chapter 2, ethnographic documentaries involve cultural and linguistic translation (Barbash & Taylor, 1997, p. 420). This is cross-cultural filmmaking that requires filmmakers to be brokers of meaning and turns translation into a cultural act involving interpretation, negotiation and compromise. Here, on-site translation is not only about understanding the language:

> Words are not always spoken coherently and, unless the translation is done by someone who was actually at the scene and is aware of what has happened and the relationship between the various film subjects, the words can lose their meaning.
>
> (Ichioka, 1995, p. 451)

This is the reason why what is normally needed in these cases is someone who can act as an interpreter, assistant and local guide:

> Chief Pulitala's English was far from fluent, yet I feel that the reason that this particular project ended successfully was largely thanks to him. Although it was necessary to be able to understand the background to what was being said, to an outsider like myself this was extremely difficult. Sometimes he was too optimistic in his interpretations, but he was able to make interpretations going beyond language translation. He was able to give advice on the protocol of offering greetings, the timing and method of giving presents, and cooperated as an organizer.
>
> (ibid., p. 449)

Needless to say, the difficulty involved in working with this type of non-professional translator is that they do not always find it easy to distinguish between translation and their own subjective interpretation. As recommended by Cole based on his experience making *The Colours of the Alphabet* (Cole, 2016), the first step once a potential non-professional interpreter has been found is to discuss this distinction and to establish what is needed in the project. As far as the methodology is concerned, and apart from the translation required for basic communication with the participants, Ichioka (1995, p. 450) advises filmmakers to undertake the translation of the footage as early as possible:

> My basic policy (for the translation of conversation, discussion, incantations or songs) is to have all such materials translated while we are on location by the person in charge of interpreting. The reason for this is that when we move off somewhere it is difficult to find someone who can speak the language of the former region.

He adds that he normally records on tape the English translation of the foreign-language footage, relying on this when it comes to editing:

> When a direct translation does not make sense, I ask the interpreter or the person who actually spoke concerning the meaning, and write down the additional interpretation. Although only a little remains by the time of the final editing, by going through this translation process one is able to reach some understanding of the psychology, thinking and meaning behind the actions of the subjects being filmed, which is extremely important for a director.
>
> (ibid., p. 451)

4.2.2 Mise en scène

As well as facilitating communication between the filmmaker, the crew and the cast/participants in a film, translation and accessibility can also be very important during the production stage due to the impact they may have on the nature and reception of the film. More specifically, they should be taken into account for the organisation of space in the frame, which includes the mise en scène (what is seen) and the cinematography of the productions (how it is seen).

The mise en scène can be described as the contents of the frame and the way in which they are organised (Gibbs, 2002, p. 1). For Bordwell and Thompson (1997, p. 115), this is the most memorable aspect of filmmaking – the one that viewers remember more vividly and are more familiar with.

The mise en scène allows directors to stage the event for the camera and essentially shows their control over what happens in the film frame, what the viewers see, when they see it and for how long. Unfortunately, this tends to apply only to the viewers of the original film. The spectators of the translated and accessible versions are not commonly factored in here, as most filmmakers are unaware of the impact that translation and accessibility may have on the mise en scène of their films.

For Bordwell and Thompson (ibid.), the mise en scène encompasses setting, costumes and makeup, lighting and staging. The first element (*setting*) includes, amongst other aspects, colours, composition and props. Colours can carry political, religious and cultural connotations. They can represent gender and have emotional and physical effects on us. Most importantly, they are one of the most important visual tools at the disposal of cinematographers and filmmakers to tell their stories. The consideration of translation and accessibility during the production stage can help the audio describer understand the importance of colours in a film and choose how and when this can be described for viewers that may or may not have been born blind, which makes a significant difference in terms of understanding and experience. Admittedly, though, this can also be done if translation/accessibility are considered later on in post-production. The consideration of subtitles during production is, however, more important, as it can flag up certain issues that can only be fixed at this stage. Firstly, the use of colours in

a setting may have a negative impact on subtitling legibility, making it difficult for the viewers to read the subtitles due to lack of contrast (see Section 3.4.2.2). Filmmakers should be aware of the fact that traditional subtitles for hearing audiences normally use white or yellow whereas subtitles for viewers with hearing loss can use a wider range (white, yellow, cyan, magenta and even green, red and blue). When there are issues of contrast and legibility, changing the subtitle colour is an option, and so is using an opaque or translucent box as a background. Secondly, on those occasions on which the symbolic use of colours is helping to tell the story, filmmakers should ensure that the colour used in the subtitles for viewers with hearing loss is telling the same story. In his famous 1924 black-and-white classic *Greed* (see Figures 4.4–4.6), Erich von Stroheim coloured certain

Figures 4.4–4.6 Gold-coloured shots from *Greed*

Figures 4.4–4.6 (Continued)

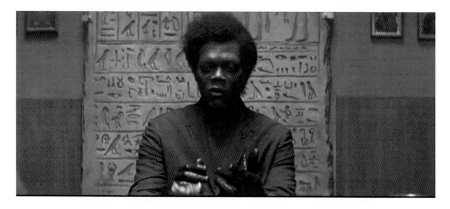

Figures 4.7 Colours assigned to characters in *Unbreakable* (2000)

scenes with gold tinting to mark the appearance of money and greed, which dominates the screen in the final scene.

In situations such as this one, the use of yellow subtitles (which is very common in the versions subtitled for viewers with hearing loss and even in the ones for hearing viewers) is bound to be marked with a great deal of unwanted connotations. The filmmaker and the translator must thus decide what colours should be used for the subtitles and whether yellow can be included in this palette. In other cases (see Figure 4.7), the film may assign specific colours to particular characters, such as in *Unbreakable* (Night Shyamalan, 2000).

The colour used for a character may also change as the character develops, as in the case of the clothes worn by Termé, the daughter of a rocky marriage in *A Separation* (Farhadi, 2011) (see Figures 4.8–4.10).

In all these cases, and unless a discussion is held between the translator and the creative team of the film, the inadvertent use of any of these colours in

Figures 4.8–4.10 Variation in colour assigned to a character in *A Separation* (2011)

the subtitles may contribute to the storytelling in a way that is perhaps not intended or not in line with the meaning conveyed by the use of colours on screen.

Composition and props are also regarded as important elements in the setting of the mise en scène. The composition, or the overall design of a setting, can shape how we understand story action and is often used to guide the viewers' attention (Bordwell & Thompson, 1997, p. 117). In Figure 4.11, from *Day of Wrath* (Dreyer, 1943), the viewers are expected to focus first of all on the couple at the bottom of the screen and then, following their eye lines, to end up on the horse carriage that takes up the upper (and brightest) part of the frame. The use of traditional, bottom-placed subtitles is thus likely to trigger a similar pattern for viewers watching the subtitled film.

In contrast, Figure 4.12 is arranged differently. The framing, the position of the actress, her costume and the lighting highlight her face as the main focus of the shot, where the viewers' attention is supposed to be focused. A second focus point would be the bright lower right side of the frame, following her eye line. This could prompt a discussion between the filmmaker and the translator as to the convenience of using creative or integrated (sub)titles displaced towards that corner, where the viewers' eyes are naturally drawn, as opposed to using traditional subtitles placed at the bottom, which is not in line with the way in which the shot has been composed.

Figure 4.11 Bottom-up composition of a shot from *Day of Wrath* (1943)

Figure 4.12 Composition from *Day of Wrath* (1943) with a focus on the character's face

Those filmmakers who are interested in exploring the potential of subtitle position to trigger in subtitling viewers similar eye movements to those of the viewers of the original film (Fox, 2018), in other words, those filmmakers who would like the composition of their images to guide the attention of all their viewers (and not just those of the original film), may have to engage with this aspect during production. Integrated titles or creative subtitles can also be produced in post-production but then there will be no freedom to experiment with the composition of the image.

Along with colour and composition, the setting is also made up by the use of props. Short for property, this term refers to the objects used on screen by the actors. When it comes to subtitling and as explained in Chapter 3 (see scenario 4 of subtitling blindness in Section 3.4.2.2), filmmakers and translators may want to consider at this stage those shots and scenes where key props are positioned at the bottom of the screen. In Figure 4.13, from *Groundhog Day* (Ramis, 1993), the dialogue and movement of the main character's hand prompts the viewers to look at the props at the bottom of the frame, where the subtitles are likely to obscure the key element in the shot.

Again, these subtitles can still be displaced in post-production. However, addressing this issue in production means that there are many more options to

Figure 4.13 Subtitles obscuring props at the bottom of the screen in *Groundhog Day* (1993)

choose from, including playing with the dialogue and the acting to leave enough space for the subtitling viewers to see the food at the bottom of the screen before words are said and subtitles are displayed on the screen.

The three other elements (apart from the setting) that make up the mise en scène are costumes and makeup, lighting and staging. Costumes and makeup are often used by fiction filmmakers as one more tool that contributes to characterisation and storytelling. By interacting with the setting, costume and makeup may help to reinforce narrative and thematic patterns (Bordwell & Thompson, 1997, p. 122). Even in documentary filmmaking, directors may have a certain degree of control over this, as it is often possible to consult with the main participants what they will wear for an interview that has been arranged beforehand. Patterns, contrast, colours and shapes are the four areas to look out for here and the usual recommendation is to avoid whites, blacks, reds, oranges, high-contrast combinations and busy patterns, all of which can have a negative impact on the viewers' experience (Nulph, 2007). However, if filmmakers are planning to reach foreign or deaf audiences through subtitles and wish to have control over (or be aware of) the mise en scène, then they must also consider the impact that subtitles may have on it, and in this case the way in which the subtitles interact (or clash) with costumes. In Figure 4.14, from the short documentary *A Grain of Sand* (Dangerfield & Avruscio, 2014), the clash is caused both by the patterns in Ofelia's outfit and the high exposure of part of the background setting, which was only partially solved by the filmmakers through the use of a black outline for the subtitles.

Figure 4.14 Clash between the subtitles, the character's outfit and the high exposure of the background setting in *A Grain of Sand* (2014)

Black-and-white patterns can thus be problematic if subtitles for hearing audiences are going to be used. When deciding on costume, filmmakers may also want to consider that other colours are often used in subtitles for viewers with hearing loss (typically white, yellow, cyan, magenta and sometimes even red and blue).

On paper, the last two elements of the mise en scène, lighting and acting/staging, require less consideration from a translational/accessibility point of view at the production stage. Light is often used to shape the viewer's experience in film, which has been defined as "the drama and adventure of light" (Bordwell & Thompson, 1997, p. 131). Apart from dealing with issues of subtitling legibility, the translator (and, more specifically, the audio describer) must be able to interpret and describe the meaningful use of light in a scene if it contributes to the overall storytelling, but this is something that can be done at the postproduction stage. As far as acting is concerned, an actor's performance consists of visual elements (appearance, gestures, facial expressions) and sound (voice, effects) (ibid., pp. 132–133). Filmmakers whose films are going to be dubbed for a foreign audience may need to pay special attention when the balance in any of the actors' performance is tilted towards sound. This is often the case in films where accent becomes a crucial element in characterisation, such as *Gangs of New York* (Scorsese, 2002) and *There Will Be Blood* (Thomas Anderson, 2007). As discussed in Chapter 2, Daniel Day-Lewis built his vintage early American Californian accent for *There Will Be Blood* (2007) around the oral posture, "with his tongue stuck in the middle of his mouth, bracing against the molars, leaving his cheeks loose" (Singer, 2016), whereas for his 19th-century New York accent

in *Gangs of New York* (2002), he had the tip of his tongue hit his teeth while producing a colourful tone with a great deal of nasality (Singer, 2016). Unlike the original actors, dubbing actors typically have very little time for preparation or rehearsal. As a matter of fact, it is not uncommon for them to receive the script for the first time in the dubbing studio, just before they have to start dubbing. In films where performances are so heavily focused on the actors' voices, extra time should be allowed for discussions with the translator regarding what strategy may be adopted in translation but also to allow dubbing actors to prepare, given that their work may be one of the most important aspects for the success of the film. Here, it may be a good idea to ask the original actor to provide a brief account of what they have done, which may help the dubbing actors with some of their choices. The earlier in the filmmaking process this can be factored in, the better.

An extreme case is that of non-visible performances, for example in animation films or in films such as Rodrigo Cortés' *Buried* (2010). Set entirely inside a coffin, the film shows only the main character trying to survive, while the others are heard through the phone. The millions of viewers of the dubbed versions in Spain, France, Italy or Germany do not have any access to the voice of Samantha Mathis as the main character's wife or that of Robert Paterson as Dan Brenner, a colleague trying to rescue the protagonist. Instead, they hear the voices of the dubbing actors. In other words, in this case the director has no control over the performance of 90% of the cast, which means he may again want to allow more time for casting dubbing voices and supervising their performance. It may also be worth discussing with the distribution company whether subtitling can be a better option in order to keep the performance of the original actors in the translated version.

4.2.3 Cinematography

Cinematography is also concerned with the organisation of space but, unlike the mise en scène, it does not refer to what is filmed but to how it is filmed. This includes the photographic image, the duration of the image and framing. In the latter, the choice of shot sizes can have a significant impact on how the translated/accessible film is received by the viewers. As explained in Chapter 2, research shows that the close-up has become the most common shot in contemporary cinema (Redfern, 2010). A film like *Blue Is the Warmest Colour* (Kechiche, 2013), where most of the conversations between the two protagonists are filmed in tight close-ups, is a case in point. The involvement of a translator in the (pre-) production stage may be useful to flag up some of the potential issues that this can cause in the translated/accessible versions of the film. For dubbing, this means that every shot with dialogue filmed in a close-up will need to be translated with lip synchrony, which often makes it difficult to produce a translation that is faithful to both the content and the style of the original dialogue. A discussion between the translator and the filmmaker may be useful here to decide whether

instances that are particularly difficult to translate may require wider framing or perhaps a more flexible approach to lip synch so that a more faithful translation can be found.

In the case of subtitles for hearing and deaf viewers, filmmakers, and especially cinematographers, are often appalled at the sight of subtitles obscuring the lower part of their carefully composed close-ups, where they obscure characters' mouths (see scenario 4 of subtitling blindness in Section 3.4.2.2). For those deaf viewers who wish to resort to lip-reading in order to follow the dialogue, the damage is not only aesthetic but also communicational. As pointed out by Paul Henley (2010, p. 308) in his work on Jean Rouch's films, this can be easily avoided at production stage provided that the camera operator leaves enough room at the bottom of the screen for the subtitles. Alternatively, as shown in Figure 4.15, from *The Progression of Love* (Rodgers, 2010), the use of creative subtitles may help to circumvent this issue while keeping viewers' attention on the key areas of the screen and allowing them to explore the shot for longer than if they had to look down at the bottom of the screen.

Needless to say, filmmakers and cinematographers may not always want to use creative subtitles or to open up a close-up so that the eventual display of subtitles over it does not cover the character's lips. However, it is important that they are aware of the aesthetic impact that bottom-placed subtitles can have on every shot during production, as they are shooting or about to shoot. A plug-in that can show this through the camera viewfinder would be particularly useful and, at any rate, this simple but essential aspect should be part of directors' and cinematographers' training.

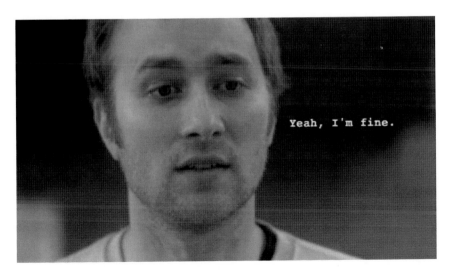

Figure 4.15 Creative subtitles for *The Progression of Love* (2010)

4.2.4 The transcription of documentaries

Finally, another advantage of the integration of translation and accessibility at the production stage relates to documentary filmmaking. When asked to translate a documentary or make it accessible, translators may or may not have at their disposal a transcript of the original dialogue. Often, and especially in the case of same-language SDH, translators start off by creating this transcript. Below is an account provided by Lukasz Daniluk, professional transcriber, of the duplication of efforts often involved in the post-production of documentaries in the UK:

> Documentaries with a great deal of footage often require transcription so that the edit producer can find the best sounding lines in the footage without the need to view it all. This transcription is done manually. The footage is then assembled into a rough cut, modified several times, scrutinised by the executive producers and the channel commissioner and sent to "picture lock", where graphics, colour grading and narration are added. The film is then sent to the broadcaster for transmission and to subtitling companies, where translators often transcribe the documentary from scratch. The original transcripts, created by "loggers" at the beginning of the process, are usually put in recycling bins at the post production facility.

It stands to reason that a more holistic approach to translation as an element included from production could save some of the work currently involved in this process. Firstly, the transcription of the original footage could be done through respeaking instead of manually, that is, resorting to live subtitlers who normally use speech recognition software to produce subtitles for live programmes (Romero-Fresco, 2011). Research shows that this process is at least twice as fast as (and considerably less tedious than) manual transcription, which normally involves a ratio of 10 to 1, that is, 10 minutes of real time per 1 minute of recorded audio/video (Matamala, Romero-Fresco, & Daniluk, 2017). There is also speech recognition software available that allows the automatic transcription of recordings. The transcription function in the commercial software Dragon, available in several languages, can produce a real-time transcription (1:1 ratio) with a few errors that can then be corrected by the transcriber. The accuracy rate can be high (over 90%) as long as the footage has good sound, no background noise and clear enunciation. If Dragon is not available or another language is needed, the new Web Speech API by Google is available in 42 languages and, although still under construction, its accuracy rate is also very high, which makes it a much more efficient option than manual transcription. At any rate, using (live) subtitlers may often be the best option. They will become familiarised with the documentary at an early stage and, once the final edit is ready for distribution, they will be able to prepare the template for subtitles and SDH, which can then be used as a basis for translation into other languages. Making the original film script available to audio describers can be extremely helpful, too, as it enables them to see the names of all characters (some of whom may not be named in the dialogue until

some minutes into the film) and can also help in identifying locations, rather than obliging the describer to guess.

4.3 In post-production

If it is not possible to consider translation and accessibility during production, integrating this notion during post-production can still help to solve some of the issues that widen the gap between the experience of the original viewers and that of those who watch the translated or accessible film. The key here is to consider the impact that editing has on the different modalities of translation and accessibility. While it does not have much bearing on dubbing, other translation modalities such as AD and especially subtitling (for hearing or deaf viewers) are tightly connected to editing.

4.3.1 The rule of six

Unlike the mise en scène and cinematography, editing is not concerned with the organisation of space, but of time. Not present in other arts, editing is the cinematic tool par excellence, one that shapes the viewers' experience and determines the rhythm of the film (Bordwell & Thompson, 1997, p. 226). However, as pointed out by Walter Murch, award-winning film editor and sound designer, editing is not only about rhythm. In his great book *In the Blink of an Eye* (1992), Murch presents his so-called "rule of six", that is, the six priorities that in his view must be taken into account when editing a scene:

1 *The emotion*: Is the edit true to the emotion of the story? Does the cut add to an emotion or subtract from it? This is the rule that should be adhered to at all costs as, for Murch, the top priority is to make the audience feel what you want them to feel all the way through the film.
2 *The story*: Does the edit move the story forward in a meaningful way?
3 *The rhythm*: Is the cut at a point that makes rhythmic sense?
 These three priorities are the essential ones for Murch (ibid, p. 20):

> Now, in practice, you will find that those top three things on the list . . . are extremely tightly connected. The forces that bind them together are like the bonds between the protons and neutrons in the nucleus of the atom. Those are, by far, the tightest bonds, and the forces connecting the lower three grow progressively weaker as you go down the list.

4 *Eye trace*: How does the cut affect the location and movement of the audience's focus in that particular film? Be aware of where in the frame you want your audience to look, and cut accordingly.
5 *Two-dimensional place of screen*: Do the cuts keep the action along its correct path of motion and maintain the continuity?
6 *Three-dimensional space*: Is the cut true to established physical and spatial relationships?

While editors often work with these principles in mind (whether explicitly or implicitly), there is almost no record of any filmmaker or editor considering how editing and those six priorities affect the subtitling viewer. Once again, and as is the case for most stages of the filmmaking process, the millions of viewers who watch the film with subtitles are not taken into account. As shown in Chapters 2 and 3, subtitles change the eye trace of the viewers and, in doing so, they change the rhythm at which a shot is seen (see Dwyer and Perkins (2018) in Section 2.2.2 and discussion of visual momentum in Section 3.4.2.2). Given that, as Murch says, the three top priorities in editing are interconnected and virtually inseparable, the presence of subtitles is also bound to impact on story and emotion. In other words, subtitled films are explored differently (rule 4: eye trace), they are watched at a different pace (rule 3: rhythm) and, as a result, they may be understood (rule 2: story) and felt (rule 1: emotion) differently.

Figure 4.16, from *The Progression of Love* (Rodgers, 2010), shows a turning point in the story when, two-thirds into the film, the protagonist suddenly sees the girl he has been trying to chat up as a woman he can potentially be in love with. Cinematographically, this is marked with the first tight close-up in the film. In the editing, this is shown with a shot that is significantly longer than the average shot shown so far (rule 3: rhythm) and that asks us to look at the protagonist's eyes (rule 4: eye trace) and to understand that his reply ("nothing") to her question ("what were you saying?") means anything but nothing (rule 2: story) as he falls in love with her (rule 1: emotion).

Figure 4.16 Standard subtitles for *The Progression of Love*

The viewer watching this shot with traditional subtitles will surely understand the scene similarly, but the reception is likely to be slightly different. By placing the subtitle at the bottom of the screen, where nothing happens, we are asking viewers to look down and then back up (changing their eye trace, rule 4) and to perform a quick movement (different rhythm, rule 3) that is at odds with the calm focus on the protagonist's eyes that the shot calls for. The subtitled shot will surely still allow the viewers to understand the scene and feel part of the emotions it triggers. However, as Murch points out, by changing the rhythm, that is, the tempo at which the shot breathes, the viewers' emotions (rule 1) inevitably change, too. The slow realisation of the protagonist's feelings experienced by the original viewers as they focus (exclusively and slowly) on his face and especially on his eyes is different to the subtitling viewers' experience, who arrive at his eyes after a frantic movement down the screen and thus without the calm called for by the original editing. In an attempt to minimise this gap between the experience of original and subtitling viewers, Figure 4.17 places the subtitle closer to the protagonist's face.

The focus is kept around the protagonist's face (little impact on eye trace), the movement of the eyes is minimised (similar rhythm to the original, unsubtitled shot) and as a result subtitling viewers are allowed similar time to understand and feel the shot.

Regardless of whether creative subtitles are used, editors should consider how the presence of subtitles interacts with editing and, more specifically, how this changes the way in which subtitling viewers understand and especially feel a scene.

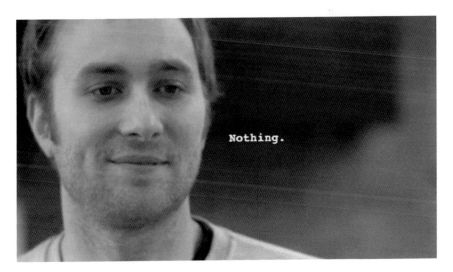

Figure 4.17 Creative subtitles for *The Progression of Love*

4.3.2 Transition shots and cutaways

Transition shots allow editors to pivot from one sequence to the next and to link separate scenes (Shook, Larson, & DeTarsio, 2000, p. 55). Similarly, in documentaries, cutaways are part of the coverage obtained during the production, for instance, of an interview. They are used by editors to cut away from the main interviewee, show something else and then cut back to the interviewee at a different time without jump cutting. Rabiger (2004) distinguishes between a cutaway (a shot of something outside the frame) and an insert (an enlargement of something in the main frame). For this author, these shots, "drawing the viewer's eye to significant detail, arise from (and are motivated by) the storyteller's narrative intentions"' (ibid: 366). How transition shots and cutaways are edited has a very significant impact on the foreign, deaf and blind audiences watching the film. By using transition shots with no narration or interview over them, filmmakers can manage to bridge the gap between original and foreign viewers, as the translated film becomes, if only briefly, the same as the original one. These shots allow subtitle users to watch and not read, dubbing viewers to enjoy the image with no distraction from dubbing synchronies and blind audiences to listen to the description of the images. This is the case in Figure 4.18, from *A Grain of Sand* (Dangerfield & Avruscio, 2014), where every pair of shoes hanging from the wires stands for a dead person in the Colombian armed conflict. Original and foreign/deaf viewers are in a similar position to explore the shot and its meaning.

For blind viewers to have a similar experience to original and foreign/deaf viewers, the shot would need to be displayed for longer, so that they can listen to the description of the image and then have some seconds to process it and think

Figure 4.18 Transition shot from *A Grain of Sand* (2016)

about it. If the filmmaker and/or the editor decide to use dialogue or narration over a cutaway or a transition shot, they should leave the shot on screen for long enough so that viewers can read the resulting subtitle and view the image. Table 4.1, included in Chapter 3, provides an indication of how fast the subtitles can be in order to allow the viewers to view the image for long enough.

The cutaway in Figure 4.19 creates a contrast between what the interviewee is saying (there is lack of solidarity in the community) and the image of two children helping each other to climb down a hill. The duration of the shot and the short length of the utterance, subtitled in only one line, gives the viewer enough time to read and watch.

Finally, filmmakers should be particularly careful with the use of cutaways and transition shots that combine narration or interview and on-screen text, as they are difficult to process for target viewers (see scenario 1 of subtitling blindness in Section 3.4.2.2). The translated version of Figure 4.20 would need a subtitle to

Table 4.1 Time spent by the viewers on subtitles and images depending on the speed of the subtitles.

Viewing speed	Time on subtitles	Time on images
10cps[1]	±40%	±60%
12–13cps	±50%	±50%
15–16cps	±60%–70%	±40%–30%
19–20cps	±80%	±20%

Figure 4.19 Cutaway from A Grain of Sand (2016)

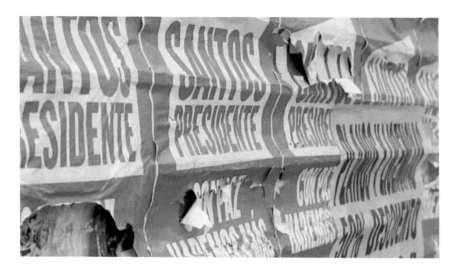

Figure 4.20 Transition shot from *A Grain of Sand* combining interview with on-screen text

translate the interview that is being heard and another one to translate the content of the on-screen signs ("con paz haremos más"), which will make the resulting image as difficult to process as cluttered and aesthetically different from the original.

This clash between subtitles and on-screen text is particularly relevant in documentaries, since the use of captions to name and describe participants in interviews is one of the defining features of this genre. Extra time should be allowed for this type of shot (see example in scenario 1 of subtitling blindness in Section 3.4.2.2).

4.3.3 L-cuts and J-cuts

Another important element in editing regarding translation is the use of overlaps, also known as overlap cuts or split edits (Salt, 2002). This technique is used to bring the sound earlier than the images (*J-cut*) or the images earlier than the sound (*L-cut*) in order to avoid straight cuts and thus soften the transition between shots (Rabiger, 2004, p. 231). In a J-cut, for example, the editor uses anticipatory sound or dialogue to draw our attention to the next shot. Just how many frames before the next shot this dialogue is brought forward depends on many factors, none of which has so far been related to translation. However, subtitling guidelines do refer to these types of cuts, as they often cause subtitles to run over shots (Ford Williams, 2009; Netflix, 2017). The recommendation is that for dialogue starting more than 12 frames before the shot change, the subtitle should come in before this shot change, whereas for dialogue starting less than 12

frames before the shot change the subtitle should be displayed in the next shot. The former carries an additional risk: The subtitle will be shown across cuts and may be read twice, once in each shot. This is thus one more consideration to be taken into account by filmmakers and editors when they are preparing a J-cut or any other type of split edit.

To conclude this section on AFM in post-production, it is worth highlighting the role played by editors in the production and reception of film. As the quintessential cinematic technique, editing determines the rhythm of a film and, most importantly, shapes the viewers' experience. However, most editors have so far focused exclusively on the audience of the original film, being unaware of, and having no control over, the impact of their work on millions of viewers who watch the translated or accessible versions. As explained by Murch, these viewers are not only watching the film at a different pace as compared to the original viewers, but they may also be, as a result, understanding it and feeling it differently. Involving editors in an AFM approach may help to ensure that the experience of the viewers of translated and accessible films is shaped as originally intended by the director.

4.4 Before distribution

Even if the translator or MA expert does not have the opportunity to collaborate with the filmmaker or the creative team before or during post-production, it is still possible to adopt an AFM approach by securing this collaboration before the film is distributed. This was the case for both *Notes on Blindness*[2] (Middleton & Spinney, 2016) and *The Progression of Love* (Rodgers, 2010), which illustrates how the reception of the film by foreign and sensory-impaired audiences can be borne in mind by filmmakers even after the film has been edited. Partly based on the contents included in Chapter 3, this section outlines some of the aspects that could be discussed in the meetings between filmmakers and translators or directors of accessibility and translation (see Figure 5.1).

4.4.1 General translation issues

Regardless of the translation/accessibility mode adopted and even the language used, cultural references and humour often pose significant difficulties for translators, who may want to discuss potential solutions with filmmakers. For films that are expected to be translated into different languages, filmmakers may want to produce, alone or in collaboration with a translation expert or director of accessibility and translation (see Chapter 5), a guide with some tips regarding how to go about the translation of some of these general issues. This is the approach usually adopted by Alastair Cole (2015, pp. 138–139) in his films:

> In preparation for the release of the film, a full subtitle guide document was created by myself with the producer of language and accessibility. This was

a single extensive document with the full original transcript, alongside the full translation, the English subtitles, Italian subtitles, as well as a notes section for my comments regarding specific moments for subtitlers to be aware or which were important to be viewed in a certain way for translation. It was also expected that the subtitlers of the various foreign versions would communicate directly with me with any questions on the content of the film during their work.

4.4.2 Dubbing

If the filmmaker happens to have a choice between dubbing and subtitling, which is not always the case, they may want to consider the implications of choosing one modality over the other one. In countries such as Spain, France, Germany or Italy, the audience is more accustomed to dubbing. Subtitling is becoming increasingly common for online viewing, but its use is still marginal on TV and in the cinema in these countries. In other countries such as Denmark, Sweden, Finland, Greece or Portugal, the audience will be more used to subtitling, and dubbing will only be used in cartoons and animation films. Dubbing, which is not accessible for people with hearing loss, does not allow viewers to hear the original soundtrack of the film but, in return, it gives them the opportunity to focus on the images as much as they wish without having to read subtitles.

When considering this choice, filmmakers may want to bear in mind how their films lend themselves to one modality or the other. Multilingual films or those with a heavy focus on accents, songs and vocal performances may be tricky for dubbing. They can be dubbed, but a lot of the decisions that determine their reception by the target audience will be adopted by the dubbing director. If this is the case, the filmmaker may want to be involved in some of those decisions and to offer some guidance that can help the translator, the dubbing director and the dubbing actors to preserve the original vision of the film. More specifically, the discussions between filmmakers and dubbing translators before distribution may revolve around the translation of:

- *Close-ups*: Because close-ups normally require lip synchrony (which poses a great challenge for translation), translators and filmmakers may need to discuss specific instances where a choice must be made between an accurate synchrony or an accurate translation. As mentioned in Chapter 3, filmmakers and translators may in some cases choose to prioritise the latter over the former, given that, as per the dubbing effect, the viewers' eyes may be mainly focused on the characters' eyes and not on their mouths. This should however be approached with care, as extreme asynchrony may draw the viewers' attention to the characters mouths.
- *Isochrony*: Does the need to match the translated text with the time in which the screen characters have their mouths open compromise the meaning of the translation?

- *The language used in the dubbed dialogue*: Is dubbese (see Section 3.2.1) being used and, if so, can or should it be avoided? Are colloquial terms, swearwords and taboo language being eliminated, as is usually the case in dubbing?
- *Language variation*: How are accents being dealt with in the dubbed dialogue?
- *Songs*: Are songs being dubbed or subtitled?
- *Multilingual dialogue*: Is the presence of other languages in the original film being marked or does the dubbed film only feature one language? Which one of the strategies to dub a multilingual film outlined in Section 3.2.1 is being used, and how does this affect the nature of the film?

4.4.3 Voice-over

When choosing to have their film voiced-over into another language, filmmakers may want to consider the implications of this translation modality. On the one hand, supporters of voice-over stress its connotations as a trustful translation mode that contributes to the reality, truth and authenticity of factual programmes such as documentaries, while maintaining the original viewing experience of looking and listening. In contrast, its detractors consider that this modality, which is not accessible to viewers with hearing loss, domesticates the reality shown in a film so that viewers do not need to make an effort to get familiarised with "the foreign", which is presented through the national language. For them, this method denies access to original voices, intonations and emotions and contributes to an imperialistic view of culture.

If voice-over is chosen as a translation mode, filmmakers and translators may want to discuss some of the following issues:

- *Synchronies*: Does the need to maintain synchrony between sound and images or to let the audience hear the original speech at the beginning and end of every utterance (and thus to reduce the translation with regard to the original) compromise the meaning of the translation?
- *Language variation*: Are swearwords and accents being altered or eliminated, as sometimes happens in voice-over translations?
- *Emotion*: Does the translated voice offer a steady and homogeneous delivery, devoid of signs of happiness, fear, sadness, variations in volume and alterations of intonation or is it closer to the "emotional voice-over" often found in the translation of reality shows?
- *Songs*: Are songs being voiced-over or subtitled?
- *Multilingual dialogue*: Is the presence of other languages in the original film being marked or does the voice-over film only feature one language?

4.4.4 Subtitling

Choosing subtitling as a translation mode means that the viewers will have access to the original soundtrack and that the film will be at least partly accessible to

viewers with hearing loss. On the downside, viewers will spend less time watching the images than if the film was dubbed, which is especially the case for dubbing viewers who are not familiar with subtitles, and it may be difficult to screen the subtitled film on TV and in the cinema in dubbing countries.

These are some of the issues that could form the basis of a discussion between the subtitler and the accessible filmmaker before the distribution of the film:

- *Subtitlese, language variation, songs and multilingualism*: What has been lost in the transition from oral to written language? How has the subtitler dealt with discourse markers, interactional features, intonation, grammar and lexical errors, registers (especially colloquial) and accents, all of which are often toned down or neutralised in subtitling? Should the songs in the film be subtitled and, if so, to what extent has it been possible to convey the content, rhythm and rhyme? Has the presence of other languages in the original film been marked in the subtitles? If so, which one of the strategies outlined in Section 3.4.1 has been used, and how has this impacted on the nature of the film?
- *Overlapping voices*: In instances when more than one or two people are speaking, what utterance should be subtitled and which one should be left out?
- *Background dialogue*: Should dialogue occurring at the back of the main action be foregrounded in the subtitles (thus competing for the viewers' attention at the same level as the images) or omitted altogether?
- *Subtitling legibility*: Are there any instances in which the subtitles are not legible? What can be done to solve this, bearing in mind that the editing has already been locked?
- *Visual momentum (sense of pace) and subtitles*: Should the subtitler play with the balance between one-line and two-line subtitles to increase or decrease the sense of pace in the film for the subtitling viewers?
- *Dialogue reduction*: How much of the dialogue has been lost in the often inevitable reduction involved in subtitling?
- *Time on images*: Are there shots or scenes where the subtitles are too fast and significantly reduce the time the viewers can spend on the image? If so, and should the filmmaker decide that the time on the image must be increased, it may be possible to lower the speed of the subtitles by shortening them.
- *On-screen text*: Does the presence of on-screen text in the original film clash with the subtitles? If so, are they on screen for long enough for the viewers to read them and see the images?
- *Subtitling blindness*: Are there any instances in which reading a subtitle prevents viewers from watching an important visual element in the image? Candidates for this would be shots with dialogue/narration over on-screen text, shots where the subtitle covers important visual elements, short shots with dialogue/narration, instances where there is an important visual element at the beginning of a scene with dialogue and finally instances where there is an important visual element in a scene with fast dialogue.

4.4.5 SDH

If the film is to be made accessible to people with hearing loss, it will require the use of SDH. Whereas standard interlingual subtitles for hearing viewers are not fully accessible to deaf and hard-of-hearing people (since they lack description of non-verbal sounds), SDH can be and are often used by hearing viewers. In other words, using interlingual SDH may be a way of providing at the same time a translated and an accessible version.

An AFM discussion on SDH before distribution would normally focus on the following issues:

- *Character identification*: If there is a choice, should characters be identified through the use of colours, name tags, displacement or hyphens/chevrons? What difference does this make regarding how information is revealed and conveyed to the viewers throughout the film?
- *Manner of speaking*: How often should information about volume, intensity, silence, emotions and accents be indicated in the subtitles and how should this be done (i.e. describing an accent or reproducing it linguistically)? Can descriptions of, for example, emotions, be used for characterisation purposes?
- *Sound effects*: What sounds should be described, how and how often? Is it possible to liaise with the scriptwriter and sound editor, who have previously verbalised the sounds, so that the description used in the subtitles can be consistent with the words used in the script?
- *Music*: Should subtitles be used for both diegetic (part of the action and played by the characters) and extra-diegetic music (added in post-production)? Is the standard use of subtitles for the title and the lyrics of known songs and the use of a description for unknown songs suitable for this particular film? In the event of a clash between dialogue and music, which one should be prioritised?
- *Subtitling blindness*: Does the need to include the above non-verbal information prevent in any instance the viewers from being able to watch the images?

4.4.6 Creative/integrated subtitles

One of the key decisions to be made regarding the use of subtitles in AFM is whether to use standard or creative/integrated subtitles. The former are always accepted but allow little or no flexibility in terms of format. The latter allow filmmakers to experiment with subtitles so that they can be integrated in the aesthetics of the film and enable the viewers to watch the film as similarly as possible to viewers watching the original film.

If the filmmaker decides to use creative/integrated subtitles, choices will have to be made regarding the following aspects:

- *Font*: What font (or fonts) is going to be used in the subtitles, and what meaning and connotations does it carry? Is the subtitle font similar or different

from the fonts used for the opening and closing credits, as well as for the on-screen text in the film? To what extent does the subtitle font contribute to the typographical identity of the film?

- *Size*: Are all subtitles the same size, or are different sizes being used to indicate volume, distance, importance, etc.?
- *Placement*: Will subtitles be placed only at the bottom of the screen, or will other positions be used? In the latter case, what criteria will be used (i.e. short distance between the title and the main focus area, no coverage of primary areas, indication of speaker and speaking direction, legibility, individual aesthetic and/or typographic concepts, accessibility, etc.)? Some examples of placement options may be found in *Notes on Blindness* (Middleton & Spinney, 2016), *The Progression of Love* (Rodgers, 2010) and in the films discussed by Fox (2018).
- *Rhythm and display mode*: Would the film benefit from using add-on subtitles, which can increase the synchronicity between the sound/music/dialogue and the subtitles? Does it make sense to fade in and/or out some of the subtitles (instead of having all of them pop in and out of the screen) in order to indicate pause or reflection?
- *Effects*: Would the film benefit from using pictures, speech bubbles or chat-like features in the subtitles? Is it worth experimenting with position and size to indicate depth and background dialogue or with the interaction between characters and subtitles, for example hiding subtitles behind elements of the image or making them appear or disappear from the screen coinciding with visual elements or actions?

4.4.7 AD

If the filmmaker cares about how their film will be received by blind or partially sighted audiences, choices will have to be made regarding the following aspects:

- In standard AD only a single voice is heard, is that appropriate for this particular film? When the AD is used in a subtitled film, although increasing the number of voices will increase the cost of the AD, how important is it that more than one voice is used? This could range from two (one for the AD and one for any character whose voice is subtitled) to a new voice for each character whose speech is subtitled. The decision would need to be made as soon as possible, as it will affect how the AD script is written;
- The choice of voice is also important (i.e. age, gender, accent, etc.). If the describer is to voice their own script they will need to include less information (e.g. pronunciations) than might be needed if the script is to be voiced by someone unfamiliar with the film;
- Will the filmmaker make the script/shooting script available to the describer?
- Will the director or the film scriptwriter want some involvement in the development of the AD script?

- Will the filmmaker want the describer to include elements of the cinematography?
- Will the filmmaker be present at the recording of the AD to "direct" the AD voicing? Will they encourage the standard neutral or objective vocal style or something more emotional?
- Will the sound editor create a mixed track weaving the AD into the original soundtrack or is an automatic default fade sufficient?
- Is an audio introduction required? If so, where will it be available (can it be downloaded as a sound file or an audio track from the film's/cinema's website, for instance?)
- The filmmaker might also want to consider whether the AD will itself be translated for accessible versions in other countries or whether each country will produce their own. It is common in TV AD for one "master" AD script to be created in English that is then translated into multiple target languages. However, it has been suggested that it is better for the AD to be created by a describer native to the source culture from which the film originated. This AD script in the source language can then translated into multiple target languages in order to avoid loss of cultural references (Jankowska, A., Milc, M., & Fryer, L., 2017).

The filmmaker needs to be aware that even a small editing change can affect the AD, which cannot be written and certainly not recorded until the final edited version is available. If the AD version is to be available in time for the premiere, sufficient time must be allocated between the finishing of the film and the first screening. This is another reason why it is helpful to have the director present at the AD recording, so that any last minute changes can be incorporated there and then.

Notes

1 In Latin, Cyrillic and Arabic alphabet languages, subtitling speeds may be expressed in words per minute (wpm) or in characters per second (cps), which are calculated differently by the various subtitling programs. The latter measure depends on the average number of characters per word, which is generally considered to be five. In the case of double-byte languages like Chinese, Japanese and Korean, subtitling speed is always measured in cps and the standard hovers between 4 and 5 cps.
2 This applies to the SDH, since the AD was discussed from the start.

Chapter 5

Integrating AFM into the filmmaking industry

After presenting the wide notions of MA and film studies that constitute the theoretical framework underlying AFM (Chapter 2), this book has provided filmmakers with research-informed knowledge about what happens when their films are translated or made accessible so that they can have meaningful discussions with translators (Chapter 3), and it has also outlined the specific issues those discussions can focus on throughout the different stages of the filmmaking process (Chapter 4). In doing so, it has helped to close the maker–expert–user gap (a concept created by Greco, 2013, and adapted to film by Branson, 2018), which exists between filmmakers and MA professionals (Chapters 2 and 4) and between filmmakers and sensory-impaired/foreign viewers (Chapter 3).

Despite the fact that, as explained throughout this book, adopting an AFM approach does not necessarily need to be difficult and, as shown in Section 2.3.3, it is being done on a regular basis, it is not uncommon to find scepticism regarding its feasibility. The main reservations are related to time ("it will take too long", "it will alter the current filmmaking process and schedule"), money ("it will be too expensive") and general interest ("filmmakers will not care enough about this"). This chapter addresses these three issues. Firstly, it outlines briefly the role played by the different parties involved in this collaboration and especially by the director of accessibility and translation (DAT), a new professional figure that can help to liaise between filmmakers, MA professionals and foreign and sensory-impaired viewers. Also included here is the optional role of sensory-impaired MA consultants, who strengthen the link between MA professionals and sensory-impaired viewers and thus bridge the third and final gap in the maker–expert–user triangle (see Figure 5.1). The second section includes a workflow made up of several steps recommended for a film to adopt an AFM approach from pre-production, production or post-production. The third section addresses the cost of implementing the AFM model, with different quotes for a basic AFM package or one with extras such as an audio introduction and creative subtitles. Finally, the fourth section gives the floor to filmmakers who have inadvertently or intentionally applied the AFM model, in an attempt to dispel the myth that filmmakers do not care about translation, accessibility and their foreign and sensory-impaired viewers.

Figure 5.1 The maker–expert–user gap, as adapted in this book

5.1 The director of accessibility and translation (DAT) and consultants with sensory impairments

Constant references have been made throughout this book to the translator or MA expert working in collaboration with the creative team of the film as part of the (post-)production process. This professional may suffice to adopt an AFM approach in relatively small productions requiring translation and/or MA provision into only one language. For larger productions, a different type of professional may be needed, one who can liaise between the creative team of the film and the translators and MA experts. There are not many precedents for this yet. For his film *Colours of the Alphabet* (2016), Alastair Cole hired a "producer of language and accessibility" (2015, p. 138) to undertake this task, whereas other productions draw on what they describe as consultants. Until now and despite their title, most MA consultants focus on the accessibility of websites, assistive technology or educational issues. There are however others who do focus on film and audiovisual media such as Louise Fryer, Joan Greening or Andrew Lambourne in the UK and Matt Lauterbach in the US.

In the film industry, the closest role may be that of scientific consultants, who are hired by producers to provide films with scientific verisimilitude (Kirby, 2003). The demand for this service is such that several scientists have become full-time consultants, and there are several companies in the US focused exclusively on connecting scientists with filmmakers and television producers (ibid.). Although areas such as astronomy and physics are particularly demanded for both classic and contemporary films such as *2001: A Space Odyssey* (Kubrick, 1968) and *Interstellar* (Nolan, 2014), other profiles may also be required. A recent case

in point is the Oscar-nominated science-fiction film *Arrival* (Villeneuve, 2016), for which the director Denis Villeneuve hired Jessica Coon, an associate professor in the Department of Linguistics at McGill University (Canada), in order to lend verisimilitude to the story of a linguist trying to find a way to communicate with extra-terrestrial visitors. Regardless of the area they work on, these consultants are constantly having to strike a balance between scientific accuracy and production constraints. More importantly, "they are still part of the filmmaking process and, as such, will have some 'authorship' in the way the science is depicted" (Kirby, 2003, p. 267).

While this connects them with the notion of AFM, the professional needed to look after translation and accessibility as per this model, the director of accessibility and translation (DAT), is a different figure. The DAT advises on and manages the production of a film's accessible and translated versions, thus ensuring that these versions are coherent with one another, that they inform and complement one another and that the creative vision of the filmmakers is preserved for viewers across the different versions. The extent to which this figure is involved in this process depends on the film's distribution. For films that are widely distributed internationally, the DAT may closely coordinate the production of the accessible versions and subsequently act as a consultant and as a liaison between filmmakers, distributors and translators for any foreign-language version. An important aspect of their work in this case concerns the production of an accessibility and translation guide to be used by translators and MA professionals. The DAT must have knowledge of both film and translation/MA and be able to "speak both languages". Firstly, they need to be able to read/interpret/discuss film in relation to translation and accessibility. Secondly, they also need to have knowledge of the different stages of film production and distribution and the subtitling/dubbing workflows as currently used by language service providers and how these interrelate. This will help the DAT to fulfil other duties, such as the following:

In pre-production

- Consulting with director/producers regarding MA requirements and creative possibilities and finding a compromise between these requirements and production constraints.
- Recruiting and coordinating translators, if required to work on the translation of texts such as screenplays and treatments, and interpreters, if needed during meetings or on the film set.
- Introducing these professionals to the AFM approach (if they are not already aware of it) so that they understand what the collaborative process involves.
- Producing a quote for the delivery of all the film's accessible (and translated) versions.
- Creating a tailored proposal that outlines the approach to translation and MA and presents creative ideas.

In (post-)production

If not involved from pre-production, the DAT would be required to do all of the above plus:

- Coordinating the production of all accessible versions of the film, which involves liaising between directors, producers, post-production coordinators, MA professionals/translators and, possibly,
- Organising and leading at least two meetings per each accessible version (AD and SDH) between filmmakers and MA professionals, which serve to discuss creative ideas and their eventual implementation: the first meeting, to discuss an initial draft during which filmmakers are able to provide feedback; the second, to discuss the implementation of any changes proposed during the initial meeting.
- Managing the quality control process, which involves checking the linguistic and technical aspects of the additional versions. This process may also involve consultants with sensory impairments.
- Overseeing the recording of the AD, which requires being present in the studio, along with the film director and the audio describer. The presence of these figures is important in case any late changes to the script are required.
- Producing an accessibility and translation guide that is to be used by all translators and MA professionals working on the film. This guide will include all the metadata (treatment, screenplay, storyboard) made available to the MA professionals, as well as specifications regarding dubbing and subtitling conventions (reading speed, characters per line, font, etc.). It will also include a source language subtitle template that acts as a reference for subtitlers working into foreign languages and a section with comments regarding potential translation difficulties. In the case of multilingual films, it will also include translations of any foreign dialogue.

This list of duties is based on my experience as DAT on *Notes on Blindness* (Middleton & Spinney, 2016) and on that of Josh Branson for his work on *The Progression of Love* (Rodgers, 2010), *Acquario* (Puntoni, 2018) and *Chaplin* (Middleton & Spinney, 2019), but it is by no means exhaustive and may be expanded as new projects adopt the AFM model.

Finally, as noted by Branson (2018), another interesting role for AFM is that of MA consultants with sensory impairments, who can provide an informed opinion about how the film may be received by deaf and hard-of-hearing viewers and/or blind and partially sighted spectators. These professionals could provide a similar service to that of the standard viewers used for test screenings in many big-budget productions. They might also be included earlier on in the process if the filmmakers are intending to employ innovative accessibility strategies and they require initial testing of concepts. Furthermore, in line with the notion of inclusion supported in Chapter 2, there is no reason why they could not also play the role of DATs described above. Consultants with sensory impairments have regularly been

hired for SDH and AD by companies such as Ai-Media and Bayerischer Rundfunk, respectively, but normally after the production process and involving no contact with the creative team. As per the AFM model, it is now time to involve these MA consultants with sensory impairments in the filmmaking process.

5.2 The ~~workflow~~

Drawing on the work carried out by Branson (2018) on the films *The Progression of Love* (Rodgers, 2010) and *Acquario* (Puntoni, 2018) and on my work with Wendy Fox and Louise Fryer on *Notes on Blindness* (Middleton & Spinney, 2016), this chapter presents a workflow made up of 16 steps recommended for a film to adopt an AFM approach (see Figures 5.2, 5.3a and 5.3b). Depending on when exactly the collaboration between the translator/MA professional/ DAT and the filmmaker begins, this workflow can be implemented from pre-production, production or post-production. Of the 16 steps, the first 5 belong to the pre-production phase (which is optional), the next 2 to the production phase (also optional) and the following 9 to post-production (required). While all these steps are recommended, not all are strictly necessary. If the collaboration starts in pre-production, the minimum requirements can be fulfilled in six steps: 3, 4, 10, 12, 13 and 16. If the collaboration starts in the production phase, the minimum requirements are 10, 12, 13 and 16; whereas if AFM is to be implemented in post-production, only five steps are needed: 8, 10, 12, 13 and 16.

As mentioned in Chapter 4, when AFM starts in pre-production, it is particularly useful to ensure that the translator/MA expert remains involved in the project through the following phases, too, as their familiarity with the film will be very useful. A discussion with the filmmaker prior to shooting can be very beneficial in order to avoid heavy-handed interventions at a later date, to gain access to pre-production material (storyboards, shooting scripts, etc.) and to allow the director to better understand the AFM approach. If the production requires the presence of a DAT, they will be responsible at this stage for recruiting translators and interpreters, if needed during the pre-production and production stages, introducing them to the AFM approach if they are not already aware of it, producing a quote for the delivery of all the film's accessible (and translated) versions and creating a tailored proposal outlining the approach to translation and MA and presenting creative ideas.

During production, the translator/media access expert/DAT may also be needed for on-set translation and interpreting in multilingual shoots and for the transcription of documentary footage using respeaking (speech recognition-based subtitling).

Finally, AFM in post-production may be regarded as the essential or basic approach, the only one that is indispensable. This is made up of nine steps, of which five are essential: the provision of shooting material for the translators, an initial meeting with the creative team, the production of a first translated/accessible version, a subsequent meeting or feedback and a final version, including an accessibility and translation guide and a source language template. If the production requires the presence of a DAT who was not present at an

STEPS FOR PRE-PRODUCTION STAGE

01 **(MULTILINGUAL FILMS)**
Translation in the scriptwriting process

02 **(CO-PRODUCTIONS)**
Translation of script for funding

03 **(ALWAYS)**
Provision of pre-production material to the PAT

04 **(IDEALLY)**
Ini tial meeting with the director and production of
a translation/accessibility proposal

05 **(IDEALLY)**
recruitment of MA professionals,
translators and, if need be, consultants with sensory impairments.

STEPS FOR PRODUCTION

06 **(MULTILINGUAL SHOOTS)**
On-set translation and interpreting

07 **(DOCUMENTARIES)**
Transcription of footage for editing using respeaking
(speech recognition-based subtitles)

Figure 5.2

STEPS FOR
POST-PRODUCTION PRIOR TO DISTRIBUTION

08 **(ALWAYS, IF NOT PROVIDED IN PRE-PRODUCTION)**
Provision of film, script and further docs to either the DAT or the:
- dubbing translator
- subtitler
- audio describer

09 **(IDEALLY)**
Preparation of:
- dubbing script
- subtitles
- audio decription

10 **(ALWAYS)**
Meeting between the filmmaker/creative team and the DAT or the:
- dubbing translator
- subtitler
- audio describer

11 **(ONLY IF DEEMED NECESSARY AND IF THERE IS ACCESS IN POST-PRODUCTION)**
Amendments to the editing of the film

12 **(ALWAYS)**
Preparation (and recording) of accessible versions of:
- dubbing script
- subtitles
- audio decription

13 **(ALWAYS)**
Meeting between the filmmaker/creative team and the DAT or the:
- dubbing translator
- subtitler
- audio describer

14 **(IDEALLY)**
Amendments to:
- the dubbed track
- the subtitles
- the audio decription

Figure 5.3a and 3b AFM workflow: steps for pre-production, production and post-production (prior to distribution)

15 (IDEALLY)
Feedback from the director

16 (ALWAYS)
Final versions of:
• dubbing
• subtitles
• audio decription
Preparation of translation and accessibility guide for the film

Figure 5.3a and 3b (Continued)

earlier stage in the film, they will be responsible for the tasks described for the pre-production stage (recruiting and informing professionals, producing a quote and a tailored proposal) as well as for coordinating the production of all translated/accessible versions of the film, organising the meetings between filmmakers and MA professionals, overseeing the quality control process and producing both the translation and accessibility guide and source language template.

5.3 The cost

Two of most common criticisms levelled at AFM is that filmmakers will not be interested in applying this model and that film producers will not be willing to pay for it. Section 5.4 addresses the first criticism, including testimonies from filmmakers who have embraced AFM. As for the cost, it can hardly be presented as an obstacle. A minimal application of the model would involve the most basic collaboration between translators/MA professionals and the filmmaker, with at least one meeting. This does not necessarily need to cost more than a standard provision of translation/MA services, and it is already a step forward regarding quality. Table 5.3c, included in the BFI-funded *Accessible Filmmaking Guide* (Romero-Fresco & Fryer, 2019) and based on the experience of Josh Branson as DAT on several films, includes the approximate cost involved in a basic AFM package for the provision of AD and SDH with a DAT (from £5,000). It also includes a more developed package with extras such as the provision of an audio introduction, creative subtitles and the participation of the DAT at the pre-production stage (from £11,000).

Although these rates may be higher than what is normally spent on MA, it is essential to bear in mind that, as per the AFM model, accessibility is considered before distribution and should thus be included as part of the main film budget. The cost of this AFM package with extras would then amount to 0.1% of a relatively low-budget film and 0.01% of a major studio film (Simonton, 2011). In other words, financial implications do not seem to carry much weight as an argument not to adopt an AFM model.

ACCESSIBLE FILMMAKING YOU *CAN* AFFORD IT!

The budgetary implications of Accessible Filmmaking:

STANDARD PACKAGE (APPROX COSTS)

AD
AUDIO DESCRIPTION - £2,300
Script: £700
Recording: £500
Studio Hire: £400
Studio Editor: £500
Meetings/Amendments: £200

SDH
SDH: £1,100
Origination: £650
Proofreading: £250
Meetings/Amendments: £200

DAT
DIRECTOR OF ACCESSIBILITY: £1,600
(During post-production only, 8 days)
Recruitment, coordination, meetings, quality control, accessibility and translation guide

TOTAL: £5,000 (MIN)

ADDITIONAL EXTRAS (APPROX COSTS)

AI
AUDIO INTRODUCTION: £300
Script: £100
Recording: £100
Studio: £100

C/IS
CREATIVE/INTEGRATED SUBTITLES: £4,100
Concept: £500
Implementation: £3,600

DAT
DIRECTOR OF ACCESSIBILITY
(During pre-production, based on 3 days): £600
Recruitment, budget, meeting, proposal

CSI
CONSULTANT WITH SENSORY IMPAIRMENTS
SDH = £250 per day
AD = £250 per day

ELT
ENGLISH LANGUAGE TEMPLATE
(To be used by interlingual subtitlers.): £500

TOTAL (BASIC + EXTRAS): £11,000 (MIN)

Figure 5.3c

Note: These rates are based on a 90-minute English-language film. It is important to note that they are approximations and that any final rates will vary depending on the duration, language and type of audiovisual product and the availability of scripts

5.4 The filmmakers' view

Even when the issues of time (impact on workflow and filmmaking process) and money have been dealt with, the AFM model often triggers a certain degree of scepticism, not least within the AVT community, regarding the filmmakers' involvement in this process.

With the exception of filmmakers such as Ridley Scott, Taylor Hackford, George Lucas and James Cameron (Sanz Ortega, 2015) or more classic examples such as Alfred Hitchcock, Federico Fellini, Martin Scorsese, Woody Allen and Stanley Kubrick (M. Nornes, 2007), most directors do not normally get involved in the translation or accessibility of their films. Filmmakers, it is often said, simply do not care about this, as it only complicates matters and interferes with their creation. However, we are yet to meet one filmmaker who, after hearing the case for AFM, has not got on board with it. This suggests that the key is not whether or not they are interested in AFM, but whether or not they know about the impact that translation and accessibility have on the nature and reception of their films. This section includes testimonies from filmmakers who have discovered this and have acted upon it, whether or not they were aware that they were adopting an AFM approach.

5.4.1. Inadvertent accessible filmmakers

Acclaimed British director Ken Loach and his long-time collaborator and script-writer Paul Laverty are good examples of filmmakers who have discovered, much to their dismay, how translation can alter the original vision they had for their film. The Spanish version of their contribution to the collective film *11'09"01 – September 11* (Loach, 2002), the story of a Chilean immigrant in the UK, was dubbed by an actor with a Spanish accent. By losing the "beautiful accent and gentle voice" of the Chilean actor, the foreign viewers miss "all the emotion in his speech", which for Laverty equates to a sort of "vandalism" over which he and Ken Loach have no control (de Higes, 2014, p. 42). A more serious case is that of their film *It's a Free World . . .* (Loach, 2007), the story of a British woman who sets out to find work for Polish immigrants in the UK. Whereas the original version features conversations in English and Polish and scenes with an interpreter liaising between English and Polish speakers, the Spanish version is fully dubbed into Spanish. The English speakers are dubbed into standard Spanish and the Polish speakers are dubbed into broken Spanish. This includes the scenes with the interpreter, who becomes one more Spanish speaker taking part in a group conversation. For Paul Laverty, dubbing is "a disaster" (de Higes, 2014, p. 47), "a terrible separation that breaks the trust between you and the audience" (ibid., p. 48). In the same vein, Ken Loach highlights the key role played by language and accents in his films, explaining that "language is about power and identity" and that accents are "a more nuanced element of language that tells you about class, tells you about history, tells you about humour" (ibid., p. 50). Referring to not only translated films but also original versions where English is chosen as the main language for non-English-speaking characters (e.g. *Schindler's List*, spoken in English by German characters in Germany), Loach insists that "films

shouldn't pretend they're speaking another language" and that "the characters should speak their own language" (ibid.). This is why he and Paul Laverty prefer subtitling over dubbing, even though they seem to have no control over this choice: "We just say 'Don't do it' as much as possible, but it destroys the film" (ibid., p. 51).

In other cases, it is subtitles themselves that are the problem, either because they do not meet the creative expectations of the filmmakers or because their quality is too low. For Tony Scott, "subtitles are boring because they're there generally to serve us with information to make you understand what people are saying in a different language" (Kofoed, 2011), which led him to use creative subtitles for the original version of his 2004 crime film *Man on Fire* (Scott, 2004), spoken in English and Spanish. This rationale also applied to the innovative subtitles used by Danny Boyle to make the Hindi dialogue of the original version of *Slumdog Millionaire* "more exciting" (Beckman, 2008) or to the very creative subtitles produced for *Night Watch* by filmmaker Timur Bekmambetov (2004), who took it upon himself to turn these subtitles into "another character in the film, another way to tell the story and to enhance the visual experience of the spectators" (Rosen, 2006). Other filmmakers have become involved and interested in subtitles after experiencing their bad quality. According to Oscar-winner director Guillermo del Toro, "a bad translation or an awkward rhythm in the subtitles can destroy dialogue and any sense of mood" (Murphy, 2007). Del Toro learnt this lesson following the American release of his 2001 supernatural historical drama *The Devil's Backbone* (2001), whose subtitles, which he never reviewed, were criticised for being "awkward and cold" (ibid.). For his next film, *Pan's Labyrinth* (del Toro, 2006), he produced the English subtitles himself in collaboration with his writing partner, Mathew Robbins.

Indeed, the realisation of the impact that subtitles can have on the reception of a film often leads filmmakers to take it upon themselves to produce them or at least oversee them, as is the case for Álvaro Gago's award-winning short film *Matria* (2017), Hannes Stöhr's *One Day in Europe* (2005), Fatih Akin's *The Edge of Heaven* (2007) and Alejandro Gonzalez Iñarritu's *Babel* (2006), for which the Mexican director "handed over a complete English script and went over the [Spanish] translation himself to make sure it was up to his standards" (Murphy, 2007). An interesting case is that of Quentin Tarantino's Second World War drama *Inglourious Basterds* (2009), which features 70% of the dialogue in French and German. Tarantino made it a priority to preserve the multilingual nature of the film in both the original and the translated versions. With regard to the original version, he pointed out that

> When you see the Germans speaking English with a German accent or sounding like British thespians, it just seems very quaint. That's one thing I don't want this film to have. If Spielberg hadn't made *Schindler's List* yet, I joke, I like to think that after our movie he'd be shamed into doing it in German.
>
> (Hohenadel, 2009)

For the foreign versions, Tarantino included in the original script specifications as to whether subtitles should be incorporated and involved translators from Deluxe Digital Studios at the post-production stage to "oversee, transcribe and translate all of the footage" during the editing process (Sanz Ortega, 2015, p. 157). As a result, subtitles were altered daily according to changes in the editing. He also decided on the particular shade of yellow he wanted for the subtitles, on the omission of subtitles from certain scenes and on the addition of lexical elements to preserve a certain degree of international appeal. Aware of the prevalence of dubbing in countries such as Spain, France, Italy, France and Germany, Tarantino even produced a "dubbing bible" with indications and suggestions to combine dubbing and subtitles for certain multilingual scenes. This was trialled but not accepted by the distribution company in Spain, where the film was finally fully dubbed into Spanish (ibid.).

A similar case is that of Clint Eastwood, who provided his captioning studio with the English subtitles for his Second World War drama *Letters from Iwo Jima* (2006), shot entirely in Japanese, and with input regarding the translation of the film into other languages. He also relied on on-site interpreters to communicate with the cast and on script consultant Joy Nakagawa to ensure the accuracy and authenticity of the dialogue (Murphy, 2007). More recently, Alfonso Cuarón was heavily involved in the production of the English subtitles for his Oscar-winning film *Roma* (2019). In his decision to use brackets in the subtitles to clarify when the characters speak Mixtec versus Spanish, he shows that he is aware of the different audiences and how they receive the film: "it's very important for the audience that doesn't speak Spanish to denote that there are two distinct languages in the film". Cuarón also reflects on the impact of subtitles on the editing and rhythm of the film ("subtitling is not only about translating, but also about creating a rhythm") and on the risk of subtitling blindness: "If you have a viewer that's too worried about reading the subtitles they are going to stop reading the image." Another example is *Captain Fantastic* (2016), whose French subtitles were produced by the subtitler in collaboration with the director, Matt Ross. For the latter, this communication is essential for the translation to preserve his intentions, as the subtitler has "the power to illuminate or obfuscate the spoken language".

As noted in Chapter 2, other renowned filmmakers who have demanded to be involved in, or to keep some degree of control of, the foreign versions of their films are Alfred Hitchcock, Federico Fellini, Martin Scorsese, Woody Allen and Stanley Kubrick (M. Nornes, 2007). Of these, the latter two are particularly noteworthy. Woody Allen's productions often feature a supervisor who monitors the dubbing process (Whitman-Linsen, 1992, p. 216), paying especial attention to the choice of voice talents to dub the different characters in the film, not least his own (Whittaker, 2016). Allen is often "consulted on difficult decisions or ambiguities in the film" (Whitman-Linsen, 1992, p. 217) and since he is "aware of the great importance that the linguistic transfer (be it subtitling or dubbing), and therefore the translator, has in the appreciation of his movies in non-English speaking countries" (Diaz Cintas, 2001, p. 206), he often provides translators with fully annotated dialogue lists in order to help with what he considers are the most challenging parts of the script.

Yet, the most significant case of thorough and consistent integration of translation into the production process in classic Hollywood filmmaking remains that of Stanley Kubrick, who seemed to devise his own AFM model for dubbing and subtitling based on close collaboration with the translation team. This allowed him "to remain in control of the filmic text and to ensure that his vision was adequately represented in translation" (Zanotti, 2018b, p. 2). Thanks to recent archival research by Zanotti (2018b), we now have firsthand evidence of Kubrick's approach to translation, often through personal correspondence. Kubrick used assistant editors or personal assistants to help him supervise the translators' work (LoBrutto, 1997), a rough equivalent of the DAT presented in this book. He phoned translators to discuss their approach before they started translating and provided them with annotations not only to warn them about potential pitfalls but also to guide their translation, be it for dubbing or subtitling. Again, this is not dissimilar to the meetings and the accessibility and translation guide proposed in the AFM model. Finally, as shown by his letter to Jack Weiner, head of European production for Columbia Pictures during the release of *Dr. Strangelove or: How I Learned to Stop Worrying and Love the Bomb* (Kubrick, 1964), he had a "Brain Trust", that is, a group of target-language consultants with whom he would discuss issues such as the translation of the subtitle of *Dr. Strangelove*:

Dear Jack,

[. . .] "DR. STRANGELOVE" on its own does not reveal the subject matter and I definitely reject the proposal of dropping the subtitle.

I went to a tremendous effort in translating the title into all the languages, especially into German, Italian, French and Spanish. I consulted writers and newspapermen, ordinary people, embassies, etc. In all cases the final subtitles were felt to be both informative in the way I believe necessary, and also funny.

If any of your local people have a better translation of the subtitle, I should be most interested to have it and try it out on my international Brains Trust.

As noted by Alain Riou for *Le Nouvel Observateur*, Kubrick looked after the dubbed versions of his films "like a father with his children" (Riou, 1987, pp. 53–54). For Kubrick, dubbing was "like making another movie", that is, a process where two things can go wrong: "first of all they can be very badly translated, then they can be very badly acted" (Heymann, 2005, p. 46). In order to avoid some of these issues, Kubrick made a point of hiring film directors instead of dubbing directors, writers or literary translators instead of audiovisual translators and professional actors instead of dubbing actors (Zanotti, 2018a). He also demanded control of the final sound mix, as he regarded the studio-recorded sound often used for dubbed films too rich and clean, devoid of the authenticity of outdoor sound. Kubrick's approach to dubbing was very much in line with the principles of AFM. Apart from collaborating with the translation team and resorting to language consultants for films such as *Barry Lyndon* (1975) and *Dr. Strangelove* (1964), he shot with foreign versions in mind, filming text inserts in different languages in order to

ensure that viewers in dubbing countries could watch the film without having to read a subtitle translating the insert. Furthermore, as shown by his advice on the translation of *Dr Strangelove*, he was acutely aware of how language variation and multilingualism can impact on the nature and reception of dubbed films:

> The Russian Ambassador when speaking in Russian, should never be translated but should always speak Russian. The meaning of what he says is always learned later on.
>
> Major Kong, the pilot of the Bomber is Texan. His accent and his vocabulary are colorful in a rustic way. He should not be translated or dubbed as being foolish or stupid, but simply in some equivalently humorous rustic accent. Texans are legendary for their bravery and fighting ability, so if you have a choice of rustic accents, choose from that. Dr. Strangelove has a German accent and this could be retained. Obviously in the German dubbing this will have no particular significance, but he should remain German. The President should have an educated accent, but he should be played by a boisterous and loud person. Group Captain Mandrake is obviously English and if any special comedy effect might be gained from having the actor have an English accent, this should be done.
>
> <div align="right">(Words included in the document "Notes to translators
and dubbing directors from Stanley Kubrick", retrieved
from the Stanley Kubrick Archive
by Zanotti, 2018b)</div>

For subtitling, he would often supervise and comment on the register of the subtitles:

> Please do not proceed with French subtitling until you receive my notes on script which will be sent within next few days stop Translation is good academic job but totally missing colloquial flavor example catch them with their pants down translated as take them by surprise stop Also military terms are not accurate and don't have sound of reality stop When will you send first half of French dubbing translations Regards Kubrick.
>
> <div align="right">(Cable from 10 February 1964 retrieved from the
Stanley Kubrick Archive by Zanotti, 2018b)</div>

and he insisted on having back-translations done for all subtitles, so as to ensure that no important features were missing from the foreign versions:

> Dear jack
>
> The japanese translation is very faithful to the original and very intelligently done. Please present my compliments to the translator. I have no changes to make. But I do want to know whether the translator must now begin to eliminate informational content in order to get it on the screen? If there is to be a further reduction for the subtitling, I would like to have an english version of this so I can see if any important story information has been left

out. I promise to respond to this one within a few days of receiving it.

Best regards,

Stanley Kubrick

(Letter from 20 December 1971 retrieved from the Stanley Kubrick Archive by Zanotti, 2018b)

His letter to Jack Weiner on 3 January 1964 provides telling evidence of his approach to translation, the reasons behind it and how close it was to what we understand today as AFM; in his case, a particularly authorial approach to AFM:

> Dear Jack,
>
> Regarding your cable on December 26th, 1963, I consider the translation and dubbing of the film an intrinsic part of the artistic side of the production of the film. While I am quite sure your people are the most able in the country, I am nevertheless the director and writer of the film and absolutely do not accept the principle that I must accept anyone else's opinion in regard to artistic matters over my own. My request to have a copy of the dubbing script for Germany, France and Italy in sufficient time to check them and make whatever revisions I think required is reasonable and consistent with the principle of my artistic control spelled out in my deal with Columbia.
>
> (Typescript SK/11/9/120 retrieved from the Stanley Kubrick Archive by Zanotti, 2018b)

In Zanotti's view (2018b, p. 1), Kubrick's example is an unorthodox practice within the film industry, "offering an alternative model in which film translation is integrated within the creative process of filmmaking through the film director's active participation in the translation process". Albeit inadvertently, Kubrick seems to be following many of the steps involved in AFM: collaboration with the translation team, use of target-language consultants and awareness of how translation impacts on the nature and reception of the film (with special attention to key issues such as accents, multilingualism, register and even condensation in subtitling). Kubrick is certainly not the norm in the film industry, but his approach to translation is not dissimilar to that of many other filmmakers who are engaging with translation because they are making multilingual films involving translation in the original version, they are in need of creative approaches to translation or they are simply aware of the impact that translation can have on their film. Some of these filmmakers are producing the translated version themselves. Others seem to be implementing some of the steps envisaged as part of the AFM model, such as the production of an accessibility and translation guide and the collaboration with on-site interpreters, translators and language consultants. This shows that, despite being unorthodox in the current industrialised translation and accessibility landscape, the AFM model is largely based on common sense and is made up of the logical steps that would be followed by any filmmaker who decides to consider their foreign and/or

sensory-impaired viewers. However, it also highlights the importance of adopting a more systematic approach to the implementation of this model, as is the case with the filmmakers included in the next section, in order to ensure that their efforts to consider translation/accessibility are not wasted and that their vision is truly maintained when it reaches foreign and sensory-impaired viewers.

5.4.2 Accessible filmmakers

The content included here is made up of interviews and material obtained from some of the many filmmakers who have decided to adopt AFM as part of their production practice.

Jon Garaño and Aitor Arregui

Founders of the production company Moriarti in 2001, Garaño and Arregui have worked together on several acclaimed films over the past years, including *Loreak* (2014), nominated for Best Film at the Goya Awards and at the San Sebastián Film Festival, and *Handia* (2017), winner of 10 Goya Awards and of the Best Film award at San Sebastián. Garaño and Arregui have been adopting an AFM approach from their first film:

> All our films have so far been made mainly in Basque, so translation and, more specifically, subtitling is an essential element. We bear in mind the Basque viewers but also those of the Spanish version and of other language versions. We do the translation into Spanish ourselves and then work closely with the subtitling company to adapt our translation to subtitling requirements. We also work closely with the English subtitlers, as we like having control, at the very least, of the Spanish and English versions.
>
> (2018, personal communication)

During the premiere of *Handia* at the London Film Festival in October 2017, I approached Garaño and Arregui to let them know that the English subtitles for their film did not show that the original dialogue switched in some scenes from Basque to Spanish. This is essential for characterisation and plot development purposes and had been missed by most viewers at the screening. Both filmmakers commissioned an AFM report, that was produced by AVT researcher Ana Tamayo, from Universidad del País Vasco, with an assessment of the quality of the translation and suggestions regarding how to indicate the presence of the two languages. Since then, the subtitles used for the foreign version of *Handia* have included these suggestions. Garaño stresses that improving the experience of the foreign viewers is for them always a priority and, for this reason, it is necessary to adopt "a collaborative approach to translation" and "to listen to those who know most about it, which includes both professionals and researchers" (ibid.). However, although Garaño believes that translation must be discussed from pre-production and produced before distribution, he is not so convinced about integrating it during the editing process. In his view, just like colour correcting or sound effects, "it is better

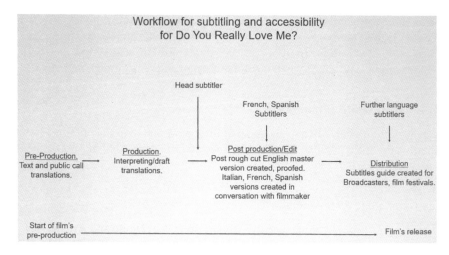

Figure 5.4 Integration of translation and access in Alastair Cole's *Do you really love me?*

to incorporate this once the editing has been locked, or else you'll never manage to finish the film" (ibid.). Still, Garaño points out, for dialogue-heavy films, translation may end up impacting upon the editing and, in any case, the collaborative approach to translation proposed by the AFM model is not negotiable.

Alastair Cole

Specialised in films about multilingualism, New Zealand-born Alastair Cole has been integrating translation and access into his filmmaking practice for many years now. For his multilingual short comedy *Do you really love me?* (Cole, 2011), premiered in Cannes 2011, he dealt with translation and interpreting from pre-production and hired a "head subtitler" to oversee the subtitling process before post-production (Cole, 2013) (see Figure 5.4).

He also produced a subtitle guide with indications as to where and how subtitles could be used (Figure 5.5).

For *Colours of the Alphabet* (Cole, 2016), his feature-length documentary about multilingual education in Zambia, he hired a producer of language and accessibility (equivalent to the DAT) to coordinate the translation and monitor its quality (Figure 5.6).

Cole praises subtitling over what he regards as "the dehumanising and arguably more intrusive practices of voice over or dubbing" (Cole, 2015, p. 139). In his view, filmmakers should make it a priority to understand and tackle the problematic elements of translation and subtitling: "by engaging with the practice as a filmmaker alongside translators and subtitlers, and viewing it as a creative part of the filmmaking process that can start early in production, many of these obstacles

English dialogue	Subtitle creation notes	English dialogue	Subtitle creation notes
In Hungarian there's no gender, Soto always mixes 'she' and 'he'. This is very hard to follow... Sometimes.		[Slovenian] Do you like to touch me? [Czech] Yes, I like to touch you. I think I'm a bit drunk	
		Ah, that's why you 're laughing at the time	
He is a liar!	Keep timing as in English subtitles (slightly longer than normal)	I'm laughing because funny things happen! In Czech It's map te'. In Slovenian it's ljubim so'. is more I love you but...	Keep St. version of mluti to' in subtitle Keep St. version of ljbim to'. in subtitle
We started to have some problems, and it was really hard to discuss them... ...because of the linguistic problem		we don't say this at all.	
	Place in italics for sung words If you have the same childhood song with the same content in your culture translate it otherwise translate semi-literally	In Slovenian if you say to Somebody ljubim to ' it's kind of.... It is written in books and stuff. Imagine if we don't understand,we don't have English...	Simplified TL to replicate basic English
other by the board...		... it would be kind of animal.	
[French] We hold each other by the board...			
the first one who laughs gets a slap!		We would just have sex	Can be paraphrased if needed in Italian 'staremo a letto tutto a tempo' – we wouldjust stay in bed all the time
Nowadays we have Figured out a solution... now we stop and we exchange e-mails, we speak in e-mails. Because it's easier then just go and shout Something and you don't understand.		all the time, I guess. [Kyigyz] Say I love you. [Besnian] I love you. [Besnian] He look is a carass.	Keep sung text in Italics. This is a popular battans. It may have an existng of Besriar/ Sartba-Croatian plesso. Feel free to translate fom orignal text which is

Figure 5.5 Subtitle guide used by Alastair Cole in *Do you really love me?*

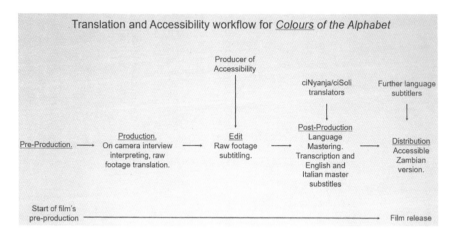

Figure 5.6 Integration of translation and access in Alastair Cole's *Colours of the Alphabet* (2016)

can be addressed and mitigated" (ibid., p. 157). Cole advocates for "the creative and thorough engagement with the subtitling of a film" as a means to "assist in the meaning making process" (ibid.) and "influence the pacing and emotional engagement of the film" (ibid., p. 138). This is all the more important in documentary filmmaking, where AFM becomes, for Cole, an issue of responsibility:

> The common, and often inevitable requirement to outsource the creation of various foreign language versions of films can result in removal of the director from any translation and subtitling debate, thus shifting ultimate responsibility for the translation and the representation of the characters involved in the film away from the person with whom the people in the film have entrusted their stories. Fully understanding the implications and procedures of subtitling, recognising the key role of the director in any debate, and understanding one's own ideological perspective within the creation of the subtitles and the film as a whole is, I suggest, critical to mitigating the obvious dangers and harm mistranslation, and misrepresentation can entail.
>
> (ibid., p. 148)

Luke Rodgers

Before making *The Progression of Love* (2010) and even in the production of the French subtitles for this film, Luke Rodgers had always outsourced the production of subtitles at the distribution stage: "the process was pretty kind of slap-dash. It was just get 'em down and get 'em in. It wasn't a very considered process" (Branson, 2017, p. 67). For this film, he worked with Josh Branson,

who oversaw the film's accessible versions, including the production of creative subtitles by Kate Dangerfield. This experience helped Rodgers look at his film "from a different perspective" (ibid., p. 66). In his view, AFM enhanced his ability to tell a good story and it raised questions that he would not have asked himself. Thinking about how someone is going to see the film with subtitles or AD added "another layer, another dimension" (ibid., p. 69) to what he set out to do and expanded his "sense of this story and these characters" (ibid., p. 70), which enabled him "to learn more and more about what I'm trying to do and my relationship to the audience" (ibid., p. 67). Rodgers believes that AFM can be integrated early on, to ensure, for example, that subtitles are compatible with the rest of the on-screen text used in the film. He chose creative subtitles for his film, which, he thought, enhanced the film by being "much more integrated into the story" than traditional subtitles (ibid., p. 73). For Rodgers, this was an "enjoyable, fascinating and enlightening process" (ibid., p. 66).

> I've been surprised and I've been quite inspired by the process because the level of the detail, the kind of minutiae of every choice, I just think it's been brilliant. I just think that you and everyone that we've worked with has done a really wonderful job to consider every possibility and in doing so expand the opportunity for deaf and blind viewers to experience the film in a kind of deeper, more interesting and ultimately more meaningful way. It's just great.
>
> (ibid., p. 68)

Rodgers stresses his intention to adopt this approach as part of his practice and advocates for AFM as a regular element in filmmaking:

> Filmmakers should have an awareness of these different kinds of layers and dimensions to the story and of the experience that the story and the film has on the audience. And I think this is a consideration that I'm really pleased to have built into my practice now.
>
> (ibid., p. 70)

Pete Middleton, James Spinney and Archer's Mark

As part of the production of the acclaimed documentary *Notes on Blindness* (2016), filmmakers Pete Middleton and James Spinney, as well as producer Jo-Jo Ellison (from Archer's Mark), decided not only to adopt an AFM approach but also to create an impact campaign to promote this model (see Figures 5.7–5.12). AD expert Louise Fryer and I were hired as DATs for the film. This enabled us to coordinate the collaborative translation and accessibility of the film, which included the creation of a standard and an enhanced AD track, an audio introduction and the production of creative subtitles.

NOTES ON BLINDNESS

COGNITION IS BEAUTIFUL
⠉⠕⠛⠝⠊⠞⠊⠕⠝

In his writing, John Hull sought to 'overcome the abyss which divides blind people from sighted people'. By sharing his experience of sight loss, John believed he could help bring communities together and foster a common understanding.

The *Notes on Blindness* impact campaign builds on John's ambition. It aims to enhance the way people with sensory impairment experience film, television and access to cinema.

In the production and distribution of the BAFTA-nominated feature film, the team sought to set a new creative and technical standard for accessible filmmaking, using the release to demonstrate a model to inspire other filmmakers to embrace the creative potential in accessibility.

"Whether you're a dreamer, realist, young or old, sighted or non-sighted, films can take you to the magical world of imagination. Yet an entire audience is consistently ignored. Accessibility and inclusivity allows everyone to have those vital experience. This campaign is as crucial as ever."

SONALI RAI
THE ROYAL NATIONAL INSTITUTE FOR THE BLIND

Figures 5.7–5.12 Impact campaign document from *Notes on Blindness*

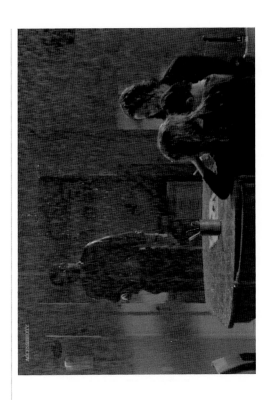

ACCESSIBILITY:
TOO OFTEN AN AFTERTHOUGHT

Usually the creation of AD and SDH takes place during the distribution stage of the filmmaking process. As a result, audio describers and subtitlers have to produce accessibility materials in a very limited time, for a small remuneration, and often with no contact with the film's creative team. Because accessible elements are considered 'add-ons', it's not uncommon that the director of the film will not hear, read or see either the AD or SDH - let alone make a meaningful contribution to their creation.

Accessible filmmaking attempts to tackle this dilemma by having each party involved in the other's creative process. The filmmakers and the audio describers / subtitlers enter a dialogue early on in the film's life, ensuring that the process becomes a true collaboration.

Figures 5.7–5.12 (Continued)

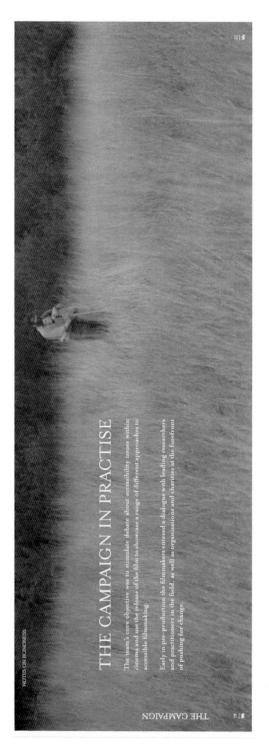

THE CAMPAIGN IN PRACTISE

The team's core objective was to stimulate debate about accessibility issues within cinema and use the release of the film to showcase a range of different approaches to accessible filmmaking.

Early in pre-production the filmmakers entered a dialogue with leading researchers and practitioners in the field, as well as organisations and charities at the forefront of pushing for change.

Figures 5.7–5.12 (Continued)

Dr LOUISE FRYER AND ALTERNATIVE SOUNDTRACKS

The filmmakers partnered with Dr Louise Fryer - one of the UK's leading figures in AD. Louise has written a PhD on the psychology of audio description, exploring the effect of language versus environmental sound in real and virtual environments. (Read more about Louise's 'Ecological Approach to AD *here*.)

Working closely with Louise, the filmmakers created four alternative soundtracks for the film, drawing on leading research on different approaches to accessible filmmaking to offer visually impaired audiences a choice of compelling, cinematic experiences.

STANDARD AD
A 'traditional' AD track that largely follows the existing conventions of the AD form.

CELEBRITY RECORDED AD
Building upon the increasing popularity of talking books, the team recorded an AD track performed by Tony-nominated British actor Stephen Mangan. The intention was to attract new audiences to experience AD, through using an approach that was more informal and more in keeping with the tone of the film.

ENHANCED SOUNDTRACK
Working with one of Europe's leading sound designers, Joakim Sundström, the team created a rich, immersive soundtrack, calibrated specifically for blind audiences. This track uses heightened sound design and additional audio from the characters in the film to guide the audience through the story. Instead of a narration-led model (as in the Standard or Celebrity AD track), this approach aims to create a rewarding audio experience that tonally coheres with the dramatic universe of the film.

DOLBY ATMOS SOUNDTRACK
The film was also released in Dolby Atmos. Dolby Atmos is an enhanced cinema experience, providing a more enveloping, immersive and true to life sound. As opposed to the conventional 5.1 or 7.1 channels of audio, as is the standard in the vast majority of cinemas, Dolby Atmos can offer up to 64 channels, including through speakers mounted in the ceiling of the auditorium.

The short video takes a single scene from *Notes on Blindness*, to showcase how these soundtracks compare to the standard version of the film.

Alongside delivering these alternative soundtracks, the team also created an audio-only introduction to be listened to in advance of the film screening. The introduction gave more information on the background to John's story and the characters in the film, as well as describing the filmmaker's creative approach such as the lighting, framing and the visual style.

The audio-only introduction can be found here.

Figures 5.7–5.12 (Continued)

PROF PABLO ROMERO FRESCO

The filmmakers' investigation into how subtitling could be improved led them to the work of Prof. Pablo Romero Fresco, an Honorary Professor of Translation and Filmmaking at the University of Roehampton, and author of the book *Subtitling Through Speech Recognition: Respeaking.*

For Notes on Blindness, Pablo's team pioneered a new form of subtitling – known as Creative or Integrated Subtitles. This approach aims to make the subtitles another element of a film's mise-en-scène (so that the placement of the subtitles feels as natural as lighting, staging, makeup and costume).

This integrated approach is rooted in the findings of eye-tracking technology, which Pablo has used to explore how placing text closer to the action – thus allowing an audience to spend more time watching the images than reading the subtitles – impacts on the overall experience of a film.

Figures 5.7–5.12 (Continued)

INTEGRATED SUBTITLING

With the use of non-standard fonts, display modes, effects and/or positioning, Integrated Subtitles work in synch with the film's rhythm, music and image, complimenting rather than distracting from what is seen on screen.

After discussion with the filmmakers, the typeface Adelle was chosen as it best complimented the aesthetic of the film, and thus helps maintain the film's visual identity. Roboto, a standard sans serif font, was used for any sounds coming from a TV or radio, with an innovative use of the superscript to indicate the source of the sound.

Add-on subtitles were also used to allow the reading of dialogue as it is heard, and to prevent subtitles from running ahead and giving information not yet provided by the dialogue. This same effect was used when the narration is particularly slow and reflective, again helping to maintain the tone conveyed by the film's image and sound.

A BENCHMARK FOR FUTURE FILMMAKERS

To document the achievements and lessons of the *Notes on Blindness* campaign, the filmmakers and their collaborators are publishing *The Accessible Filmmaking Guide*, an e-book that will bring together best practice in this area and help teach filmmakers how to produce films that are more accessible to sensory impaired audiences.

Drawing on more than twenty years of research in film translation and accessibility, the e-book will be a step-by-step guide to the options available for filmmakers to ensure that their vision is maintained in accessibility and that the deaf or blind audiences have a viewing experience that is as similar as possible to that of the original audience.

It will cover the use of standard, enhanced and creative AD for blind audiences, the

use of standard and creative subtitles for deaf and foreign viewers, and the ways in which these services interact with the different processes in the pre-production, post-production and distribution of a film.

These tools will not only provide instruction but also supply a Stamp of Approval for filmmakers and their accessibility efforts.

The website to host the project will be live in autumn 2017, with the publication of the e-book to follow shortly after.

The project is backed by major partners (BFI, The Doc Society, The Funding Network, Impact Partners, Erie Investments, Curzon Cinemas, Dolby, Debra McLeod and Jay Sears Foundation, the Chicago Media Project, and David Desjardins and Nancy Blachman).

Figures 5.7–5.12 (Continued)

Reflecting on this experience, Jo-Jo Ellison gives a producer's point of view regarding the benefits and challenges involved in applying the AFM model:

> Translations are more often than not taken into the distributors' budget, where the process is even further removed. If there are any reservations coming from producers it will all come down to cost and scheduling. Funders will often question anything but minimal spend on AD or subs, simply because they are not aware of the financial and creative benefits derived from accessible filmmaking. As the accessibility campaign that ran alongside *Notes On Blindness* continues to win awards and reach a wider audience, the necessity and appeal of accessible filmmaking builds traction. As a company, Archer's Mark are already applying the AFM model across all of their films and integrating it into their commercial work.
>
> (2018, personal communication)

Ellison's words are a reminder of the importance of raising awareness amongst producers about the benefits brought about by AFM, not least when it comes to reaching new audiences, which is one of their key priorities. As for the creative implications of using this model, it may be a good idea to give the floor to filmmakers Pete Middleton and James Spinney, whose experience during the production of *Notes on Blindness* serves as an apt ending to the case for a new and more inclusive approach to filmmaking made in this book:

> *Notes on Blindness* was our first experience with accessible filmmaking. The possibilities (and equally, the challenges) of accessibility felt crucial to a filmic treatment of John Hull's account of blindness. John stated the purpose of his writing as 'an attempt to bridge the abyss that separates different worlds of experience'. In this sense, the aim of his work is closely aligned with the ambitions of accessible filmmaking.
>
> Accessibility is so far from being embedded within the familiar production model that we really had no idea where to begin. It's strange to think that a process that is so crucial to the experience of a film, for so much of its audience, is often an afterthought, produced without the involvement of the filmmakers, who are so creatively involved in every other element in the film.
>
> Adopting an integrated approach to the accessibility on *Notes on Blindness* was an extremely creative and collaborative process. For us, the attention and thought given by the accessibility team meant that the process transcended basic considerations of clarity, comprehension, plot and was able to encompass aesthetic concerns, such as viewpoint, ambiguity, tension, tone, etc. Working in this way allowed the accessible versions to be an extension of the wider creative approach of the film. This is exemplified by the creative subtitles: rather than being detached from the image, they're embedded within the frame, in balance with the shot composition and tonal palette,

subtly suggestive of the emotion being conveyed. They are at one with the image.

Integrating the accessibility process into the production/post-production schedule stops it from being a rushed after-thought and allows for re-drafting and re-working which is, of course, so essential to any creative process.

Filmmakers may be daunted by the prospect of the additional involvement. This perhaps stems from a couple of things. Firstly, a lack of awareness of the difference the process makes to how the film is experienced by so much of its audience. And secondly, a lack of understanding of the sheer creative possibilities, which allow the same level of authorship as every other element in the film. If the obsessive impulse that drives filmmakers can be awoken in the area of accessibility, directors and producers will quickly become as fascinated and concerned with it as they would with any other department.

We're already making plans to try to bring an integrated approach to accessibility to our next project, which will bring new challenges and creative possibilities!

(2018, personal communication)

Chapter 6

Conclusions

Filmmaking normally involves a great deal of very significant financial, logistic and artistic efforts. Every aspect of the production process is carefully looked after, as it can have a potential impact on the nature of the film and its reception by the viewers. Whenever possible, filmmakers make a point of overseeing as much of this process as possible and they often resort to different cinematic techniques to control the viewers' attention and therefore their reception of the film. However, this close control over every filmmaking phase and over the viewers' experience does not apply to the millions of viewers who watch the translated or accessible versions of the film and who are simply disregarded in the filmmaking process.

The fact that these viewers contribute to creating 50% of the total revenue obtained by many of these films and that only 0.01%–0.1% of the budget is normally spent on translation/accessibility makes this neglect even more glaring. It also provides a (false) argument to justify it: Why should this be fixed if it works? The fact is that, as shown by decades of research in AVT and despite the translators' best efforts, it does not always work. Even more worryingly, filmmakers are often unaware of the fact that it does not work. Only this can explain why while they would not allow their films to be screened without watching the final edited version, they are happy to let translators and distributors take decisions that may cause their films to be seen, understood or felt differently as a result of this abdication of responsibility and of the relegation of translation and accessibility as an afterthought in the filmmaking process. Chapter 2 has addressed this gap between film and translation/MA, and especially between film studies and translation studies, by proposing a new theoretical framework that can contribute to bringing together these two areas. Firstly, it has put forward a wider and more inclusive notion of MA that includes both *access to content* and *access to creation*. Secondly, it has proposed a translation- and accessibility-oriented notion of film studies that promotes the consideration of (and the distinction between) original and translated/accessible versions in order to contribute to a fairer and more precise scholarly analysis of film. Filmmakers are asked here to take an interest in, and keep a certain degree of control over, the *global version* of their films, ensuring consistency in the nature and reception of their films across cultures and languages.

AFM provides them with a model to put this into practice by integrating AVT and accessibility into the filmmaking process. This is seen as a matter of responsibility, as it allows filmmakers to regain control of their films and to consider the experience of the foreign and sensory-impaired viewers. Chapter 3 has provided a thorough account of this experience by bringing together some of the most significant findings of 40 years of research on AVT and MA, including new original contributions such as the concepts of *the dubbing effect* and *subtitling blindness*.

The time is ripe for AFM. Co-productions that require scripts to be translated before the shoot are becoming increasingly common, as are multilingual films (films featuring several languages in their original version) and films using on-screen text for storytelling purposes. All these factors point towards the need to adopt a model that can integrate translation and accessibility at an early stage, as opposed to the current industrialised model that relegates them to the end as mere footnotes in the filmmaking process. Chapter 4 has presented a detailed description of how AFM can be implemented in the different stages of the filmmaking process, and more specifically in pre-production, production, post-production and before distribution.

As shown in Chapter 5, AFM is neither time-consuming nor costly. It makes financial sense, as it helps to reach a wider and more diverse audience, which is often highlighted by film commissions as an important criterion for funding. It also provides better working conditions for translators and MA experts, whose remuneration can be built in the main budget of the film and who, for the first time, find the opportunity to be part of a team with which to consult and share decisions. This may be done through the use of a *director of accessibility and translation*, a new professional figure in the filmmaking industry, and following the *AFM workflow* presented in Chapter 5.

Despite its relatively short life, AFM is not new. It has been implemented in different forms, albeit unsystematically, by filmmakers who understood from the beginning that translation and MA are part of the creative process of filmmaking. Over the past years, it has been applied more systematically in the areas of training, research and professional practice, and it has been endorsed by universities, film production companies, film commissions and the United Nations' ITU agency on accessibility. The new *Accessible Filmmaking Guide* (Romero-Fresco & Fryer, 2019) recently funded by the BFI to encourage the film industry to adopt this approach is a case in point. As shown in Chapter 5, the filmmakers who have applied this model have learnt how their films change in translation and accessibility and what options are available to them so as to ensure that their vision is maintained when it reaches foreign and sensory-impaired audiences. This experience has allowed them to see and understand their films differently, to find new ways of telling stories and to connect with a wider audience that they have so far not considered.

Whereas the focus has been placed here on directors, AFM applies to everyone involved in the making of a film, be they professionals or amateurs uploading

homemade films on the Internet to be seen by millions of viewers, including foreign, deaf and blind audiences.

Above all, though, AFM makes common sense and offers an opportunity to solve a problem that has been dragging for too long. The hope is that, just as it is now taken for granted that a toilet for people with disabilities should be included in the initial design of a building rather than added at the end, there will come a time when filmmakers will, by default, make films with not only the original audience in mind but also the audience of the translated and accessible versions; a time when AFM will be the norm, rather than an unorthodox practice, and the case presented here will be redundant.

Until then, there is no time to waste, so let this book be a small contribution for those filmmakers who care about foreign and sensory-impaired audiences as much as they do about their original viewers, that is, those accessible filmmakers who truly believe in making films for all.

Bibliography

AFNOR. (2017). *Information technology – User interface component accessibility – Part 23: Guidance on the visual presentation of audio information (including captions and subtitles)*. Geneva: ISO Copyright office.

Aguilar, C. (2019). Alfonso Cuarón Breaks Down the Use of Language in 'Roma,' Including Plans for Subtitles in Mixtec. *Remezcla*. Retrieved from http://remezcla.com/features/film/alfonso-cuaron-roma-interview-mixtec-subtitles/

Akin, F. (2007). *The edge of heaven*. Germany and Turkey: The Match Factory.

Albornoz, L. A. (2016). *Diversity and the film industry an analysis of the 2014 UIS survey on feature film statistics*. Montreal. Retrieved from https://fr.unesco.org/creativity/sites/creativity/files/diversity_and_the_film_industry_2016-en.pdf

Allen, W. (1972). *Play it Again, Sam*. Paramount Pictures.

Allen, W. (1977). *Annie Hall*. United Artists.

Allison, R. S., Wilcox, L., & Kazimi, A. (2013). Perceptual artefacts, suspension of disbelief and realism in stereoscopic 3D film. *Public*, *47*(12), 149–160.

Almodóvar, P. (1999). *Todo sobre mi madre*. Spain: Sony Pictures Classics.

Arregui, A., & Garaño, J. (2017). *Handia*. Spain: Moriarti Produkzioak.

Ávila, A. (1997). *El doblaje*. Madrid: Cátedra.

BA. (1999). *Broadcasting Act no. 4 of 1999,*. South Africa: Republic of South Africa.

Barbash, I., & Taylor, L. (1997). *Cross-cultural filmmaking a handbook for making documentary and ethnographic films and videos*. Los Angeles: University of California Press.

Bartoll, E. (2006). *Subtitling multilingual films*. MuTra 2006 – *Audiovisual translation scenarios: Conference Proceedings*. Copenhagen: EU-High-Level Scientific Conference Series. Retrieved from www.euroconferences.info/proceedings/2006_Proceedings/2006_Bartoll_Eduard.pdf

Bartoll, E., & Martínez Tejerina, A. (2010). The positioning of subtitles for the deaf and hard of hearing. In A. Matamala & P. Orero (Eds.), *The positioning of subtitles for the deaf and hard of hearing*. Bern: Peter Lang.

Baudry, J. L., & Williams, A. (1974). Ideological effects of the basic cinematographic apparatus. *Film Quarterly*. https://doi.org/10.2307/1211632

Beckman, R. (2008). An out-of-character role for subtitles. *Washington Post*.

Bekmambetov, T. (2004). *Nightwatch*. Russia: Gemini Film.

Benioff, D., & Weiss, D. B. (2011). *Game of Thrones*. Warner Bros.

Bergfelder, T. (2005). National, transnational or supranational cinema? Rethinking European film studies. *Media, Culture and Society*, *27*, 315–331. https://doi.org/10.1177/0163443705051746

Bermejo, A. (2015). *Living Afloat*. University of Roehampton.

BFI. (2015). *Diversity: Our commitment to diversity.* London. Retrieved from www.bfi.org. uk/about-bfi/policy-strategy/diversity

BFI. (2016). *BFI diversity standards.* London. Retrieved from www.bfi.org.uk/about-bfi/ policy-strategy/diversity/diversity-standards

Biocca, F. (1997). The cyborg's dilemma: Progressive embodiment in virtual environments. *Journal of Computer-Mediated Communication, 3*(2). Retrieved from http://onlinelibrary. wiley.com/doi/10.1111/j.1083-6101.1997.tb00070.x/full

Bird, B. (2004). *The Incredibles.* Buena Vista Pictures.

Birmingham, E., & Kingstone, A. (2009). Human social attention. *Annals of the New York Academy of Sciences, 1156*(1), 118–140.

Bisson, M. J., van Heuven, W., Conklin, K., & Tunney, R. (2014). Processing of native and foreign language subtitles in films: An eye tracking study. *Applied Psycholinguistics, 35*, 399–418.

Boon, D. (2008). *Bienvenue chez les Ch'tis.* France: Pathé Distribution.

Bordwell, D. (2002). Intensified continuity visual style in contemporary American film. *Film Quarterly, 55*, 16–28.

Bordwell, D. (2011a). *The eye's mind: Observations on film art.* Retrieved from www.david bordwell.net/blog/2011/02/06/the-eyes-mind/

Bordwell, D. (2011b). *Watching you watch there will be blood: Observations on film art2.* Retrieved from www.davidbordwell.net/blog/2011/02/14/watching-you-watch-there-will-be-blood/

Bordwell, D., & Thompson, K. (1997). *Film art: An introduction.* New York, NY: McGraw-Hill.

Borges, J. L. (1945). On dubbing movies. *Sur* (p. 128).

Boyero, C. (2007). *Estética y fría "Pozos de ambición." El País.* Retrieved from https://elpais. com/diario/2008/02/09/cultura/1202511603_850215.html

Boyle, D. (1996). *Trainspotting.* Miramax Films.

Boyle, D. (2008). *Slumdog millionaire.* Fox Searchlight Pictures.

Branson, J. (2017). *Bringing media accessibility in from the cold: A comparative analysis of collaborative and standard approaches to AD and SDH for The progression of love.* Unpublished MA dissertation. University of Roehampton.

Branson, J. (2018). Bridging the maker-user gap: The case of the Italian short film acquario. In *Understanding Media Accessibility Quality (UMAQ) conference, June 4–5, 2018.* Barcelona.

Braun, S., & Orero, P. (2010). Audio description with audio subtitling – an emergent modality of audiovisual localisation. *Perspectives: Studies in Translatology, 18*(3), 173–188.

Brioux, B. (2016). *Global TV companies keen to work with Canada in increasingly borderless industry. News 1130.* Retrieved from www.news1130.com/2016/10/27/global-tv-companies-keen-to-work-with-canada-in-increasingly-borderless-industry/

Brooks, J. L. (2004). *Spanglish.* Columbia Pictures.

Brown, W. (2016a). Non-cinema: Digital, ethics, multitude. *Film-Philosophy, 20*, 104–130. https://doi.org/10.3366/film.2016.0006

Brown, W. (2016b). What is non-cinema? cultural studies – film and TV. *Edinburgh University Press blog.* Retrieved from https://euppublishingblog.com/2016/02/24/ what-is-non-cinema/

Brown, W. (2018). *Non-cinema global digital film-making and the multitude.* London: Bloomsbury Academic.

Bruls, E., & Kerkman, E. (1989). Beeld, spraak en schrift: Ondertiteling van films en televisieprogramma's in Nederland. In K. Dibbets (Ed.), *Jaarboek mediageschiedenis 1* (pp. 165–182). Amsterdam: Stichting Mediageschiedenis.

Bucaria, C. (2008). Acceptance of the norm or suspension of disbelief? The case of formulaic language in dubbese. In D. Chiaro, C. Heiss, & C. Bucaria (Eds.), *Between text and image: Updating research in screen translation* (pp. 149–163). Amsterdam and Philadelphia: John Benjamins.

Buchan, J. N., Paré, M., & Munhall, K. G. (2007). Spatial statistics of gaze fixations during dynamic face processing. *Social Neuroscience, 2,* 1–13.

Buck, C., & Lee, J. (2013). *Frozen.* Walt Disney Studios.

Burton, T. (2005). *Charlie and the chocolate factory.* Warner Bros.

Burton, T. (2007). *Sweeney Todd: The demon barber of fleet street.* Paramount Pictures.

Busselle, R., & Bilandzic, H. (2008). Fictionality and perceived realism in experiencing stories: A model of narrative comprehension and engagement. *Communication Theory, 18,* 255–280.

Buswell, G. T. (1935). *How people look at pictures: A study of the psychology and perception in art.* Oxford, England: University of Chicago Press.

Caillé, P. F. (1960). Cinéma et traduction: Le traducteur devant l'écran. Le doublage. Le sous-tittrage. *Babel, 6,* 103–109.

Camacho, C. (2014). *Thursday morning.* University of Roehampton.

Cameron, J. (2009). *Avatar.* Lightstorm Entertainment.

Cano, A. & Cuba, L. (2018). *Locura al aire.* Alicia Cano.

Carroll, M., & Ivarsson, J. (1998). *Code of good subtitling practice.* Berlin: European Association for Studies in Screen Translation.

Catford, J. C. (1965). *A linguistic theory of translation.* London: Longman.

CerezoMerchán,B.,deHigesAndino,I.,Galán,E.,&ArnauRosselló,R.(2017).*Montajeaudiovisual e integración de la audiodescripción en la producción documental. inTRAlinea.* Retrieved from www.intralinea.org/specials/article/montaje_audiovisual_e_integracion_de_la_audiodescripcion

Chabris, C., & Simons, D. J. (2010). *The invisible gorilla: And other ways our intuitions deceives us.* New York, NY: Crown.

Chanan, M. (2012). *Secret city.* University of Roehampton.

Charles, L. (2006). *Borat! Cultural learnings of America for make benefit glorious nation of kazakhstan.* 20th Century Fox.

Chaume, F. (2004). *Cine y traducción.* Madrid: Cátedra.

Chaume, F. (2007). Quality standards in dubbing: A proposal. *TradTerm, 13,* 71–89. https://doi.org/10.11606/issn.2317-9511.tradterm.2007.47466

Chaume, F. (2013). *Audiovisual translation: Dubbing.* Manchester: Routledge.

Chazelle, D. (2016). *La la land.* Summit Entertainment.

Coen, J., & Coen, E. (2009). *A serious man.* Focus Pictures.

Cohen, J. (2001). Defining identification: A theoretical look at the identification of audiences with media characters. *Mass Communication and Society, 4,* 245–264.

Cole, A. (2011). *Do you really love me?* Tongue Tied Films.

Cole, A. (2013). Documentary film practice and accessibility. Presentation at the *Media for All Conference,* Dubrovnik, June 2015.

Cole, A. (2015). *Good Morning, Grade One. Language ideologies and multilingualism within primary education in rural Zambia.* Unpublished PhD Thesis. University of Edinburgh.

Cole, A. (2016). *Colours of the alphabet.* Scotland: Nick Higgins. Retrieved from http://coloursofthealphabet.com/about-the-film

Colusso, E. (2012). *Home sweet home.* University of Roehampton.

Connell, B. R., Jones, M., Mace, R., Mueller, J., Mullick, A., Ostroff, E., . . . Vanderheiden, G. (1997). The principles of universal design. In J. Mueller, R. Mace, & M. Story (Eds.), *The universal design file.* New York, NY: New York State University Press.

Coppola, F. F. (1990). *The godfather part III.* Paramount Pictures.

Cortés, R. (2010). *Buried*. Spain: Lionsgate.

Costa, J. (2010). *Para agorafóbicos con criterio. Fotogramas*. Madrid. Retrieved from www. fotogramas.es/Peliculas/Buried-Enterrado

Coutrot, A., Guyader, N., Ionescu, G., & Caplier, A. (2012). Influence of soundtrack on eye movements during video exploration. *Journal of Eye Movement Research*, 5, 1–10.

Crosland, A. (1927). *The Jazz Singer*. Jack L. Warner, Darryl F. Zanuck.

Crow, L. (2005a). *A new approach to film accessibility: Roaring girl productions*. Retrieved from www.roaring-girl.com/work/a-new-approach-to-film-accessibility

Crow, L. (2005b). *Making film accessible: Roaring girl productions*. Retrieved from www. roaring-girl.com/work/making-film-accessible/

Crow, L. (2005c). *Nectar*. Roaring Girl Productions.

Crow, L. (2007). *Illumination*. Roaring Girl Productions.

Crow, L. (2008). *Resistance*. Roaring Girl Productions.

Csikszentmihalyi, M. (1990). *Flow: The psychology of optimal experience*. New York, NY: Harper& Row.

Cuarón, A. (2018). *Roma*. Netflix.

Curtiz, M. (1942). *Casablanca*. Warner Bros, First National Pictures.

Cutting, J. E., Brunick, K. L., DeLong, J. E., Iricinschi, C., & Candan, A. (2011). Quicker, faster, darker: Changes in hollywood film over 75 years. *Iperception*. https://doi. org/10.1068/i0441aap

Dangerfield, K. (2017). *Accessible film project: Mentors, equipment, sight and sound*. Retrieved July 30, 2018, from https://blog.sense.org.uk/author/kdangerfield/

Dangerfield, K. (2018). The value of difference in media accessibility quality. In *Understanding Media Accessibility Quality (UMAQ) Conference, June 4–5, 2018*. Barcelona.

Dangerfield, K. & Smith, N. (2018). In Conversation with Amelia Cavallo. University of Roehampton, London.

Dangerfield, K., & Avruscio, A. (2014). *A grain of sand*. University of Roehampton.

de Higes-Andino, I. (2014a). The translation of multilingual films: Modes, strategies, constraints and manipulation in the Spanish translations of It's a Free World. . . *Linguistica Antverpiensia*, 13, 211–231. Retrieved from https://lans-tts.uantwerpen.be/index. php/LANS-TTS/article/view/47/307

de Higes-Andino, I. (2014b). *Estudio descriptivo y comparativo de la traducción de filmes multilingües: El caso del cine británico de inmigración contemporáneo*. Unpublished PhD thesis. Universitat Jaume I, Spain.

de Linde, Z., & Kay, N. (1999). *The semiotics of subtitling*. Manchester: St. Jerome.

del Toro, G. (2001). *The devil's backbone*. Spain: Sony Pictures Classics.

del Toro, G. (2006). *Pan's labyrinth*. Spain: Warner Bros.

Deryagin, M. (2018). Subtitle appearance analysis part 1: The font. *Max Deryagin's Subtitling Studio*. Retrieved from www.md-subs.com/saa-subtitle-font

DGA. (2014). *Directors' minimum conditions preparation, production and post-production*. Retrieved from www.dga.org/Contracts/Creative-Rights/Basic-Agreement-Article-7. aspx

Diaz Cintas, J. (2001). Striving for quality in subtitling: The role of a good dialogue list. In Y. Gambier & H. Gottlieb (Eds.), *(Multi)media translation: Concepts, practices and research* (pp. 199–211). Philadelphia: John Benjamins.

Díaz Cintas, J. (2008a). Audiovisual translation comes of age. In C. Heiss, C. Bucaria, & D. Chiaro (Ed.), *Between text and image: Updating research in screen translation* (pp. 1–9). Newcastle upon Tyne: Cambridge Scholars Publishing. https://doi.org/10.1075/btl.78

Díaz Cintas, J. (2008b). Teaching and learning to subtitle in an academic environment. In D. J. Cintas (Ed.), *The didactics of audiovisual translation* (pp. 89–105). Amsterdam and Philadelphia: John Benjamins.

Díaz Cintas, J., & Remael, A. (2008). *Audiovisual translation: Subtitling*. London: Routledge.

Dibetso, L. T., & Smith, T. (2012). *Lack of diversity (Repeat): Analysis of SABC news and programming*. Media Monitoring Africa: Johannesburg.

Di Giovanni, E., & Gambier, Y. (2018). *Reception studies and audiovisual translation*. Amsterdam and Philadelphia: John Benjamins.

Di Giovanni, E., & Romero-Fresco, P. (2019). Are we all together across languages? An eye tracking study of original and dubbed films. In I. Ranzato & S. Zanotti (Eds.), *Reassessing Dubbing: Historical Approaches and Current Trends*. Amsterdam/Philadelphia: Benjamins.

Dorr, M., Martinetz, T., Gegenfurtner, K. R., & Barth, E. (2010). Variability of eye movements when viewing dynamic natural scenes. *Journal of Vision2, 10,* 1–17.

Dreyer, C. T. (1943). *Day of wrath*. Denmark: Carl Theodor Dreyer.

Duchet, A. (2019). Captain Fantastic subtitled in French: Interview with Matt Ross and Anaïs Duchet. *L'Écran Traduit N°6*. Retrieved from https://beta.ataa.fr/revue/lécran-traduit-6/captain-fantastic-subtitled-in-french-interview-with-matt-ross-and-anaïs-duchet?fbclid=IwAR3N48UdlywUDtnpLufzyLDgJ5wCocBlsBn5I_i-uoo4qLpfxWtGnPMjvg

Ďurovičová, N. (1992). *Translating America: The hollywood multilinguals 1929–1933. Sound theory/sound practice* (pp. 139–153). New York, NY: Routledge.

Dwyer, T. (2005). Universally speaking: Lost in translation and polyglot cinema. *Linguistica Antverpiensia New Series, 4,* 295–310.

Dwyer, T., & Perkins, C. (2018). *Passing time: Eye tracking slow cinema*. (Trans. Dwyer, C. Perkins, S. Redmon). In J. Sita (Eds.), *Seeing into screens eye tracking and the moving image* (pp. 103–129). London: Bloomsbury Academic. Retrieved from www.bloomsbury.com/au/seeing-into-screens-9781501328992/

Dwyer, T., Perkins, C., Redmon, S., & Sita, J. (2018). *Seeing into screens eye tracking and the moving image*. London: Bloomsbury Academic.

D'Ydewalle, G., & De Bruycker, W. (2007). Eye movements of children and adults while reading television subtitles. *European Psychologist, 12,* 196–205.

Eastwood, C. (2006). *Letters from Iwo Jima*. Japan: Warner Bros.

Ebert, R. (2005). *Roger ebert on empathy*. Retrieved from www.rogerebert.com/empathy/video-roger-ebert-on-empathy

Edgar, J. (2018). *Isn't it time disabled actors and directors were allowed to make their own films? The Guardian*. London. Retrieved from www.theguardian.com/film/2018/feb/09/let-disabled-actors-and-directors-make-their-own-films-shape-of-water

Egoyan, A., & Balfour, I. (2004). *Subtitles: On the foreignness of film*. Cambridge: MIT Press.

Eisenschitz, B. (2013). Sous-titrage mon beau souci. *Mise au point, 5.* https://doi.org/10.4000/map.1481

Ekman, P., & Friesen, W. V. (1971). Constants across cultures in the face and emotion. *Journal of Personality and Social Psychology, 17,* 124–129.

Eleftheriotis, D. (2010). *Cinematic journeys: Film and movement*. Edinburgh: Edinburgh University Press.

Ellender, C. (2015). *Dealing with difference in audiovisual translation: Subtitling linguistic variation in films*. Oxford and Bern: Peter Lang.

Elsaesser, T., & Hagener, M. (2015). *Film theory: An introduction through the senses* (2nd ed.). London: Routledge.

Council of Europe. (2017). *Council of Europe convention on cinematographic co-production (revised)*. Retrieved from https://rm.coe.int/168069309e

Evan, D. (2016). *The McGurk effect . . . or why dubbing films should be banned*. Retrieved July 30, 2018, from http://didishy.tumblr.com/post/11233675717/the-mcgurk-effect-or-why-dubbing-films-should

Farhadi, A. (2011). *A separation*. Iran: Sony Pictures Classics.

Farhadi, A. (2013). *The past*. France: Memento Films Productions.

Fawcett, P. (2003). *The manipulation of language and culture in film translation*. In M. Calzada Pérez (Ed.), *Apropos of ideology: Translation studies in ideology – ideologies in translation studies* (pp. 145–163). Manchester and Northampton: St. Jerome.

Ferrer Simó, M. R. (2005). Fansubs y scanlations: La influencia del aficionado en los criterios profesionales. *Puentes*, 6, 27–43.

Fesser, J. (2008). *Camino*. Spain: Altafilms.

Fischer, David C. 1971. *Improvement in the utilization of captioned films for the deaf*. Unpublished PhD thesis, University of Nebraska, Dissertation Abstracts International, 1971, 32, 693A, University Microfilms No. T1-19842.

Fleming, V. (1939). *Gone in the wind*. Loew's Inc.

Flynn, N. (2016). *An Intimate Encounter: Negotiating Subtitled Cinema*. Open Library of Humanities, 2(1), e1. DOI: http://doi.org/10.16995/olh.14

Foerster, A. (2010). *Towards a creative approach in subtitling: A case study*. In J. Diaz Cintas, A. Matamala, & J. Neves (Eds.), *New in-sights into audiovisual translation and media accessibility: Media for All 2* (pp. 81–98). Amsterdam: Rodopi.

Fong, G. C. S. (2009). *The two worlds of subtitling: The case of vulgarisms and sexually-oriented language*. In K. K. L. Au & G. C. F. Fong (Ed.), *Dubbing and subtitling in a world context* (pp. 39–62). Hong Kong: The Chinese University Press.

Font, M. Á. (2016). *Xmile (S)*. Spain: HT Producciones. Retrieved from http://mangel font.wixsite.com/mangelfont/showreel

Fontaine, A. (2009). *Coco before chanel*. France: Warner Bros.

Ford, J. (1953). *Mogambo*. Sam Zimbalist.

Ford Williams, G. (2009). *Online subtitling editorial guidelines V1.1*. London. Retrieved from www.bbc.co.uk/guidelines/futuremedia/accessibility/subtitling_guides/online_sub_editorial_guidelines_vs1_1.pdf

Foulsham, T., & Sanderson, L. (2013). Look who's talking? Sound changes gaze behaviour in a dynamic social scene. *Visual Cognition*, 21(7), 922–944.

Fox, W. (2016). *Integrated titles: An improved viewing experience?* In S. Hansen-Schirra & S. Grucza (Eds.), *Eyetracking and applied linguistics* (pp. 5–31). Berlin: Language Science Press.

Fox, W. (2017). *A proposed set of placement strategies for integrated titles Based on an analysis of existing strategies in commercial films*. inTRAlinea. Retrieved from www.intralinea.org/specials/article/a_proposed_set_of_placement_strategies_for_integrated_titles

Fox, W. (2018). *Can integrated titles improve the viewing experience ? questionnaire data*. Berlin: Translation and Multilingual Natural Language Processing 9, Language Science Press. https://doi.org/10.5281/zenodo.1180721

Foy, B. (1928). *Lights of New York*. Warner Bros. Pictures.

Fozooni, B. (2006). All translators are bastards! *South African Journal of Psychology*, 36(2), 281–298. https://doi.org/10.1177/008124630603600205

Fraga, R. (2015). *Inner thoughts*. University of Roehampton.

Franco, E., Matamala, A., & Orero, P. (2000). *Voice-over translation: An overview*. Bern: Peter Lang.

Franzon, J. (2008). Choices in song translation. Singability in print, subtitles and sung performance. *The Translator, 14*, 373–399.

Fresno, N. (2017). Approaching engagement in audio description. *Rivista internazionale di tecnica della traduzione, 19*, 13–32.

Fryer, L. (2016). *An introduction to audio description: A practical guide*. London and New York, NY: Routledge.

Fryer, L. (2018). Staging the audio describer: An exploration of integrated audio description. *Disability Studies Quarterly, 38*(3). Retrieved from http://dsq-sds.org/article/view/6490/5093#endnote01

Fryer, L., & Freeman, J. (2012). Presence in those with and without sight: Implications for virtual reality and audio description. *Journal of CyberTherapy & Rehabilitation, 5*, 15–23.

Fryer, L., & Freeman, J. (2013). Cinematic language and the description of film: Keeping AD users in the frame. *Perspectives: Studies in Translatology, 21*(3), 412–426.

Fryer, L., Freeman, J. (2014). Can you feel what I'm saying? The impact of verbal information on emotion elicitation and presence in people with a visual impairment. In Felnhofer, A., Kothgassner, O. D. (Eds.), Challenging presence: Proceedings of the 15th international conference on presence (pp. 99–107).

Fuksas, E. (2012). *Nina*. Italy: Saulini, Giovanni.

Gago, Á. (2017). *Matria*. Gago, Álvaro.

Galán, D. (1981). *No title. El País*. Retrieved from https://elpais.com/diario/1981/10/11/cultura/371602810_850215.html

Gambier, Y. (2002). Les censures dans la traduction audiovisuelle. *TTR : Traduction, Terminologie, Rédaction, 15*, 203–221. https://doi.org/10.7202/007485ar

Garaño, J., & Goenaga, J. M. (2014). *Loreak*. Spain: A Contracorrientefilms.

Gates, R. R. 1970. *The differential effectiveness of various modes of presenting verbal information to deaf students through modified television formats*. Unpublished PhD thesis, University of Pittsburgh.

Gatiss, M., & Moffat, S. (2010). *Sherlock*. BBC.

Getino, O., & Solanas, F. (1969). Toward a third cinema. *Tricontinental*.

Gibbs, J. (2002). *Mise-en-scène: Film style and interpretation*. London: Wallflower Press.

González Iñárritu, A. (2006). *Babel*. Paramount Vantage.

González Iñárritu, A. (2010). *Biutiful*. Mexico, Spain: LD Entertainment.

González Iñárritu, A. (2015). *The Revenant*. Regency Enterprises.

Gosselin, F., & Schyns, P. G. (2001). Bubbles: A technique to reveal the use of information in recognition tasks. *Vision Research, 41*, 2261–2271.

Gottlieb, H. (1990). *Tekstning – synkron Billedmedieoversættelse*. Engelsk Institut.

Greco, G. M. (2013). Come e perché organizzare un evento culturale accessibile: Dalla teoria alla pratica. In *Paper presented at ArtLab13 Territori – Cultura – Innovazione in Lecce – on 24–28 September*. Lecce.

Greco, G. M. (2016). On Accessibility as a Human Right, with an Application to Media Accessibility. In A. Matamala & P. Orero (Eds.), *Researching audio description: New approaches* (pp. 11–33). London: Palgrave MacMillan.

Greco, G. M. (2018). The case for accessibility studies. *Journal of Audiovisual Translation, 1*(1).

Green, M., & Brock, T. C. (2000). The role of transportation in the persuasiveness of public narratives. *Journal of Personality and Social Psychology*, *79*, 701–721.

Guggenheim, D. (2006). *An inconvenient truth*. Paramount Classics.

Gunning, T. (2003). *Renewing old technologies, astonishment, second nature, and the uncanny in technology from the previous turn-of-the-century*. In D. Thorburn & H. Jenkins (Eds.), *Rethinking media change: The aesthetics of transition*. Cambridge, MA: MIT Press.

Hackford, T. (1997). *The devil's advocate*. Warner Bros. Pictures.

Haig, R. (1999). *Drive*. Northern School of Film and Television.

Haig, R. (2002). *Audio description: Art or industry? Dail (Disability Arts in London Magazine)*. Retrieved from www.rainahaig.com/pages/AudioDescriptionAorI.html

Han, C., & Wang, K. (2014). Subtitling swearwords in reality TV series from English into Chinese: A corpus-based study of The Family. *Translation & Interpreting*, *6*.

Hardwicke, C. (2008). *Twilight*. Warner Bros.

Harris, E. (2013). *The right to final cut approval: The struggle for creative control between the director and the studio in feature filmmaking*. Chicago-Kent College of Law at Illinois Institute of Technology. Retrieved from www.kentlaw.edu/perritt/courses/seminar/E Harris Final Seminar Paper.pdf

Hatim, B., & Mason, I. (1997). *The translator as communicator*. London and New York, NY: Routledge Taylor & Francis Group.

Hendler, D. (2016). *El candidato*. Cordón Films.

Henley, P. (1996). *The promise of ethnographic film. 5th international festival of ethnographic film*. Kent: Lecture given in honour of the late Professor Paul Stirling at the University of Kent.

Henley, P. (2010). *The adventure of the real: Jean rouch and the craft of ethnographic cinema*. Chicago: University of Chicago Press.

Hernandez, N., Metzger, A., Magné, R., Bonnet-Brilhault, F., Roux, S., Barthelemy, C., & Martineau, J. (2009). Exploration of core features of a human face by healthy and autistic adults analyzed by visual scanning. *Neuropsychologia*, *47*, 1004–1012.

Heymann, D. (2005). Stanley Kubrick's Vietnam. *The Stanley Kubrick Archives, originally.*

Hitchcock, A. (1960). *Psycho*. Paramount Pictures.

Hochberg, J., & Brooks, V. (1978). *Film cutting and visual momentum*. In W. J. Senders, D. F. Fisher, & R. A. Monty (Eds.), *Eye movements and the higher psychological functions* (pp. 293–317). Hillsdale, NJ: Lawrence Erlbaum.

Hohenadel, K. (2009). Bunch of guys on a mission movie. *New York Times*. Retrieved from www.nytimes.com/2009/05/10/movies/10hoha.html

Holmes, J. (1988). The name and Nature of Translation Studies. *Translated! Papers in Literary Translation and Translation Studies.*

Hooper, T. (2010). *The king's speech*. Momentum Pictures.

Hooper, T. (2012). *Les misérables*. Universal Pictures.

Hyndman, S. (2016). *Why Fonts Matter*. London: Virgin Books.

Ichioka, Y. (1995). *Ethnographic filmmaking for Japanese television*. In P. Hockings (Ed.), *Principles of visual anthropology* (pp. 441–456). De Gruyter.

Igareda, P. (2012). Lyrics against images: Music and audio description. *MonTI. Monografías de Traducción e Interpretación*, *4*, 233–254.

ITC. (1990). *ITC guidance*. London. Retrieved from http://audiodescription.co.uk/uploads/general/itcguide_sds_audio_desc_word3.pdf

Ivarsson, J. (1992). *Subtitling for the media: A handbook of an art*. Stockholm: Transedit.

Izard, N. (2001). *No title*. In M. Duro (Ed.), *La traducción para el doblaje y la subtitulación* (pp. 189–209). Madrid: Cátedra.

Jankowska, A., Milc, M., & Fryer, L. (2017). Translating audio description scripts... into English. *SKASE Journal of Translation and Interpretation* 10(2), 2-16.

Jarmusch, J. (1989). *Mystery train*. Orion Classics.

Jarmusch, J. (1991). *Night on earth*. Fineline Features.

Jensema, C., Sharkawy, S. E., Sarma Danturthi, R., Burch, R., & Hsu, D. (2000). Eye movement patterns of captioned television viewers. *American Annals of the Deaf, 145*, 275–285.

Johnson-Laird, P. N. (1983). *Mental models: Toward a cognitive science of language, inference and consciousness*. Cambridge: Cambridge University Press.

Jones, D. (2016). UK/European co-productions: The case of ken loach. *British Cinema and Television, 13*, 368–389.

Jones, K. (2015). *Hitchcock/Truffaut*. France: Arte France, Artline Films, Cohen Media Group.

Jordan, T. R., AlShamsi, A. S., Yekani, H. A. K., AlJassmi, M., Al Dosari, N., Hermena, E. W., & Sheen, M. (2017). What's in a typeface? Evidence of the existence of print personalities in Arabic. *Frontiers in Psychology, 8*, 1229. https://doi.org/10.3389/fpsyg.2017.01229

Juni, S., & Gross, J. S. (2008). Emotional and persuasive perception of fonts. *Perceptual and Motor Skills*. https://doi.org/10.2466/pms.106.1.35-42

Kanzler, M. (2008). *The circulation of European co-productions and entirely national films in Europe, 2001 to 2007*. Retrieved from www.coe.int/t/dg4/cultureheritage/culture/film/paperEAO_en.pdf.

Karamitroglou, F. (1998). A proposed set of subtitling standards in Europe. *Translation Journal, 2*(2).

Kaufman, C. (2008). *Synecdoche, New York*. Sidney Kimmel Entertainment.

Kechiche, A. (2013). *Blue is the warmest colour*. France: Wild Bunch.

Kilborn, R. (1993). Speak my language: Current attitudes to television subtitling and dubbing. *Media, Culture and Society, 15*, 641–660.

Kirby, D. A. (2003). Science consultants, fictional films, and scientific practice. *Social Studies of Science, 33*, 231–268.

Klapisch, C. (2002). *L'Auberge espagnole*. France: Mars Distribution.

Kofoed, D. T. (2011). Decotitles, the animated discourse of Fox's recent anglophonic internationalism. *Reconstruction, 1*.

Koolstra, C. M., Peeters, A. L., & Spinhof, H. (2002). The pros and cons of dubbing and subtitling. *European Journal of Communication, 17*, 325–354.

Krämer, M., & Eppler, E. (2018). The Deliberate Non-Subtitling of L3s in *Breaking Bad*: A Reception Study. *Meta: Journal des Traducteurs, 63*(2), 2, 365–391.

Kubrick, S. (1964). *Dr. Strangelove or: How i learned to stop worrying and love the bomb*. Columbia Pictures.

Kubrick, S. (1968). *2001: A space odyssey*. Metro-Goldwyn-Mayer.

Kubrick, S. (1975). *Barry lyndon*. Warner Bros.

Laine, T. (2015). *Bodies in pain* (1st ed.). Berghahn Books. Retrieved from www.jstor.org/stable/j.ctt9qd2gm

Lambourne, A. (2012). *Climbing the production chain*. Paper presented at *Languages and The Media Conference*, October 2012, Berlin.

Langton, S. R. H., Watt, R. J., & Bruce, V. (2000). Do the eyes have it? Cues to the direction of social attention. *Trends in Cognitive Sciences, 4*(2), 50–59.

Lee, S. (1987). *Spike lee's gotta have it: Inside guerrilla filmmaking*. New York, NY: Fireside Books (Simon & Schuster).

Lewis, C., & Walker, P. (1989). Typographic influences on reading. *British Journal of Psychology*. https://doi.org/10.1111/j.2044-8295.1989.tb02317.x

Lewis, E. D. (2004). *Timothy asch and ethnographic film*. London: Routledge.

Loach, K. (2000). *Bread and roses*. Lionsgate.

Loach, K. (2002). *11'09"01 September 11*. France, Egypt, Japan and Mexico, Iran: Empire Pictures Inc.

Loach, K. (2007). *It's a free world. . .* Rebecca O'Brien.

LoBrutto, V. (1997). *Stanley kubrick: A biography*. New York, NY: Da Capo.

Longo, R. (2017). A conversation with Tessa Dwyer on the risky business of subtitling. *Film Quarterly*. Retrieved from https://filmquarterly.org/2017/12/04/a-conversation-with-tessa-dwyer-on-the-risky-business-of-speaking-in-subtitles-revaluing-screen-translation/

Longoria, Á. (2012). *Hijos de las nubes*. España: Bardem, Javier; Lonforia, Álvaro y Hartley, Llily.

Luhrmann, B. (2001). *Moulin Rouge!* Australia: 20th Century Fox.

Luyken, G., Herbst, T., Langham-Brown, J., Reid, H., & Spinhof, H. (1991). *Overcoming language barriers in television: Dubbing and subtitling for the European audience*. Manchester: European Institute for the Media.

MacDougall, D. (1998). 'Subtitling Ethnographic Films', in D. MacDougall (ed.) *Transcultural Cinema*, Princeton, NJ: Princeton University Press, 165–178.

MacDougall, D. (2001). Colin young, ethnographic film and the film culture of the 1960s. *Visual Anthropology Review*. https://doi.org/10.1525/var.2001.17.2.81

Mace, R. (1976). *Accessibility modifications: Guidelines for modifications to existing buildings for accessibility to the handicapped*. Raleigh: North Carolina Dept. of Insurance, Special Office for the Handicapped.

Maguire, T. (2015). *Accessible theatre-making for spectators with visual impairment: Cahoots NI's The Gift*. Ulster.

Malick, T. (2011). *Tree of life*. Fox Searchlight Pictures.

Mangold, J. (2010). *Knight and day*. 20th Century Fox.

Marchant, P., Raybould, D., Renshaw, T., & Stevens, R. (2009). Are you seeing what I'm seeing? An eye-tracking evaluation of dynamic scenes. *Digital Creativity, 20*, 153–163.

Marks, S. (2014). *Fonts and feelings: Psychology in typography*. Retrieved October 30, 2018, from https://visual.ly/community/infographic/lifestyle/fonts-and-feelings-psychology-typography

Marshall, R. (2002). *Chicago*. Miramax Films.

Massaro, D. W., & Cohen, M. M. (1996). Perceiving speech from inverted faces. *Perception and Psychophysics, 58*(7), 1047–1065. https://doi.org/10.3758/BF03206832

Matamala, A., Romero-Fresco, P., & Daniluk, L. (2017). The use of respeaking for the transcription of non-fictional genres an exploratory study. *InTRAlinea, 19*.

Mattsson, J. (2006). *Linguistic variation in Subtitling: The subtitling of swearwords and discourse markers on public television, commercial televison and DVD*. Paper presented at the MuTra 2006 Conference. Copenhagen: MuTra Conference.

McClarty, R. (2012). Towards a multidisciplinary approach in creative subtitling. *MonTI. Monografías de Traducción e Interpretación, 4*, 133–155. https://doi.org/10.6035/MonTI.2012.4.6

McFarlane, M. (2013). *Here's looking at you*. London: Avon.

McLeod, N. Z. (1932). *Horse feathers*. Paramount Pictures.

Mercado, G. (2010). *The filmmaker's eye: Learning (and Breaking) the rules of cinematic composition*. Amsterdam: Focal Press.

Mereu, C. (2016). *The politics of dubbing: Film censorship and state intervention in the translation of foreign cinema in fascist Italy*. Bern, Berlin, Bruxelles, Frankfurt am Main, New York, NY, Oxford and Wien: Peter Lang.

Middleton, P., & Spinney, J. (2016). *Notes on blindness*. Archer's Mark.

Middleton, P., & Spinney, J. (2019). *Chaplin*. Archer's Mark.

Miquel Iriarte, M. (2017). *The reception of subtitling for the deaf and hard of hearing: Viewers' hearing and communication profi le and speed of subtitling exposure*. Unpublished PhD thesis. Universitat Autònoma de Barcelona, Spain.

Mital, P. K., Smith, T. J., Hill, R., & Henderson, J. M. (2011). Clustering of Gaze during dynamic scene viewing is predicted by motion. *Cognitive Computation*, 3, 5–24.

Molyneaux, G. (2000). *John sayles: An unauthorised biography of the pioneering indie filmmaker*. Los Angeles: Reinassance Books.

Monaco, J. (1992). *The movie guide*. New York, NY: Perigee Books.

Moore, I. J. (1981). *Dynasty*. CBS Television Distribution.

Morelli, C. (2017). *Mi Mundial*. Lucía Gaviglio Salkind.

Morgart, J. (2014). *Gothic horror film:From the haunted castle (1896) to psycho (1960)*. In G. Byron & D. Townshend (Eds.), *The gothic world* (pp. 376–388). Milton Park: Routledge.

Morris, N. (2007). *The cinema of Steven Spielberg: Empire of light*. London: Wallflower Press.

Murch, W. (1992). *In the blink of an eye*. New York, NY: Silman-James Press.

Murphy, H. (2007). Oscar noms not lost in translation. *Variety*. Retrieved from https://variety.com/2007/film/awards/oscar-noms-not-lost-in-translation-1117959519/

Navarra, J. (2003). Visual speech interference in an auditory shadowing task: The dubbed movie effect. In *15th international congress of phonetic sciences proceedings*. Barcelona. ISBN 1-876346-48-5.

Netflix. (2017). Timed text style guide: General requirements. *Netflix Website*. Retrieved from https://partnerhelp.netflixstudios.com/hc/en-us/articles/215758617-Timed-Text-Style-Guide-General-Requirements.

Neuenschwander, B. (1993). Letterwork – Creative Letterforms in Graphic Design.

Neves, Joselia. 2005. *Audiovisual Translation: Subtitling for the Deaf and Hard-of-Hearing*. Unpublished PhD thesis. London: University of Surrey-Roehampton.

Neves, J. (2008). 10 fallacies about subtitling for the d/deaf and the hard of hearing. *Journal of Specialized Translation*, 10, 128–143.

Neves, J. (2018). Subtitling for deaf and hard-of-hearing audiences: Moving forward. In Luis Pérez-González (Ed.), *The Routledge handbook of audiovisual translation*. London: Routledge.

Nida, E. A. (1964). Toward a science of translating. *Meta: Journal des Traducteurs*. https://doi.org/10.7202/003030ar

Night Shyamalan, M. (2000). *Unbreakable*. Buena Vista Pictures.

Night Shyamalan, M. (2008). *The happening*. 20th Century Fox[1].

Nix, Gary W. 1971. *The effects of synchronized captioning on the assimilation of vocabulary and concepts presented in a film to intermediate level deaf children*. Unpublished PhD thesis, University of Oregon, Dissertation Abstracts International, 1972, 32, 5074 A, University Microfilms No. 72-8584.

Nolan, C. (2008). *The dark knight*. Warner Bros. Pictures.

Nolan, C. (2014). *Interstellar*. Paramount Pictures.

Nørgaard, N. (2009). The Semiotics of Typography in Literary Texts. A Multimodal Approach. *Orbis Litterarum*, 64(2), 141–160.

Nornes, A. M. (1999). For an abusive subtitling. *Film Quarterly*. https://doi.org/10.1525/fq.1999.52.3.04a00030

Nornes, M. (2007). *Cinema babel: Translating global cinema*. Minnesota: University of Minnesota Press.

Nulph, R. G. (2007). Just what should I wear? *Videomaker Magazine*. Retrieved from www.videomaker.com/article/c14/12990-just-what-should-i-wear

Nyks, K., Hutchison, P. D., & Scott, P. J. (2015). *Requiem for the American dream.* Nyks, K. Hutchison, P. D., Scott, P. J.

Ofcom. (2006). *Television access services review.* Ofcom, Office of Communications.

Ofcom. (2015). *Ofcom's Code on Television Access Services.* London. Retrieved from https://www.ofcom.org.uk/__data/assets/pdf_file/0016/40273/tv-access-services-2015.pdf

Oppenheimer, J. (2012). *The act of killing.* Norway, Denmark, UK: Dogwoof Pictures.

Östlund, R. (2014). *Force majeure.* France, Norway, Sweden: TriArt Film.

O'Sullivan, C. (2011). *Translating popular film.* Basingstoke: Palgrave MacMillan.

Palencia Villa, R. M. (2002). *La influencia del doblaje audiovisual en la percepción de los personajes.* Unpublished PhD thesis. Universitat Autònoma de Barcelona, Spain.

Pavesi, M. (2006). *La traduzione filmica: Aspetti del parlato doppiato dall'inglese all'italiano.* Roma: Carocci.

Pedersen, J. (2011). *Subtitling norms for television.* Amsterdam and Philadelphia: John Benjamins.

Perego, E., del Missier, F., Porta, F., & Mosconi, M. (2010). The cognitive effectiveness of subtitle processing. *Media Psychology, 13,* 243–272.

Perego, E., Orrego-Carmona, D., & Bottiroli, S. (2016). An empirical take on the dubbing vs. subtitling debate. An eye movement study. *Lingue e Linguaggi.* https://doi.org/10.1285/I22390359V19P255

Pérez-González, L. (2012). Co-creational subtitling in the digital media: Transformative and authorial practices. *International Journal of Cultural Studies, 16,* 3–21. https://doi.org/10.1177/1367877912459145

Pérez-González, L. (2018). *The Routledge handbook of audiovisual translation.* London: Routledge.

Phillips, C. (2016). Notes on blindness review: A beautiful, accessible and thoughtful one-off. *The Guardian.* Retrieved from www.theguardian.com/film/2016/jun/15/notes-on-blindness-review-beautiful-accessible-thoughtful-one-off

Phillips, G. D., Welsh, J. M., & Hill, R. (2010). *The francis ford coppola encyclopedia.* New York, NY: Scarecrow Press.

Poffenberger, A. T., & Franken, R. B. (1923). A study of the appropriateness of type faces. *Journal of Applied Psychology, 7*(4), 312–329. https://doi.org/10.1037/h0071591

Pölsler, J. (2012). *The wall.* Austria: Studio Canal.

Puntoni, L. (2018). *Acquario.* Italy: Mediterraneo Cinematografica.

Rabiger, M. (2004). *Directing the documentary.* Amsterdam: Elsevier.

Ramis, H. (1993). *Groundhog day.* Columbia Pictures.

Raney, A. A. (2004). Expanding disposition theory: Reconsidering character liking, moral evaluation, and enjoyment. *Communication Theory, 14*(4), 348–368.

Rassell, A., Redmond, S., Robinson, I., Stadler, J., Verhagen, D., & Pink, S. (2015). *Seeing, sensing sound: Eye tracking soundscapes in saving private ryan and monsters, Inc.* In C. D. Reinhard & C. Olson (Eds.), *Making sense of cinema* (pp. 139–164). New York, NY: Bloomsbury Academic.

Rawsthorn, A. (2007). The director timur bekmambetov turns film subtitling into an art. *New York Times.* New York, NY. Retrieved from www.nytimes.com/2007/05/25/style/%0A25iht-design28.1.5866427.html?_r=0

Rayner, K., & Pollatsek, A. (1989). *The psychology of reading.* Englewood Cliffs, NJ: Prentice-Hall.

Readwin, S., Regan, S., Reynolds, C., Taylor, K., & Wood, T. (2011). *Geordie shore.* Lime Pictures.

Redfern, N. (2010). *Some notes on shot scales: Research into film: An empirical approach to film studies.* Retrieved from https://nickredfern.wordpress.com/2010/03/04/some-notes-on-shot-scales/

Remael, A. (2007). *Sampling subtitling for the deaf and the hard-of-hearing in Europe*. In J. Diaz Cintas, A. Remael, & P. Orero (Eds.), *Media for all* (pp. 23–52). Amsterdam: Rodopi.

Riou, A. (1987). Une énticelle inimitable! *Le Nouvel Observateur, Le Nouvel*, 52–54.

Ritchie, G. (2012). *Sherlock Holmes: A game of shadows*. Warner Bros.

Roach, J. (1997). *Austin Powers: International man of mystery*. New Line Cinema.

Roberts, A. (2017). Norman bates as "One of us": Freakery in Alfred Hitchcock's Psycho. *Trespassing Journal*, 109–122.

Robinson, J., Stadler, J., & Rassell, A. (2015). Sound and Sight: An exploratory look at saving private ryan through the eye-tracking lens. *Refractory: A Journal of Entertainment Media*, 25.

Rodgers, L. (2010). *The progression of love*. Luke Rodgers. Retrieved from https://vimeo.com/28053425

Romero-Fresco, P. (2006). The Spanish dubbese: A case of (Un)idiomatic friends. *The Journal of Specialised Translation*, 6, 134–151. Retrieved from www.jostrans.org/issue06/art_romero_fresco.php

Romero-Fresco, P. (2009a). More haste less speed: Edited versus verbatim respoken subtitles. *Vigo International Journal of Applied Linguistics*, 6(1).

Romero-Fresco, P. (2009b). Naturalness in the Spanish dubbing language: A case of not-so-close friends. *Meta: Journal des Traducteurs*, 54, 49–72. https://doi.org/10.7202/029793ar

Romero-Fresco, P. (2011). *Subtitling through Speech Recognition: Respeaking*. Manchester: St. Jerome.

Romero-Fresco, P. (2012a). *Joining the dots*. Sunday Films.

Romero-Fresco, P. (2012b). *Out of Kibera*. Sunday Films.

Romero-Fresco, P. (2013). Accessible filmmaking: Joining the dots between audiovisual translation, accessibility and filmmaking. *Journal of Specialized Translation*, 20, 201–223. Retrieved from www.jostrans.org/issue20/art_romero.php

Romero-Fresco, P. (2015a). *The reception of subtitles for the deaf and hard of hearing in Europe*. Bern, Berlin, Bruxelles, Frankfurt am Main, New York, NY, Oxford and Wien: Peter Lang.

Romero-Fresco, P. (2015b). Viewing speed in subtitling. In P. Romero-Fresco (Ed.), *The reception of subtitles for the deaf and hard of hearing* (pp. 335–343). Bern, Berlin, Bruxelles, Frankfurt am Main, New York, Ny, Oxford and Wien: Peter Lang.

Romero-Fresco, P. (2016). Accessing communication: The quality of live subtitles in the UK. *Language and Communication*. https://doi.org/10.1016/j.langcom.2016.06.001

Romero-Fresco, P. (2017). Accessible filmmaking in documentaries. *Intralinea*.

Romero-Fresco, P. (2018a). Eye-tracking, subtitling and accessible filmmaking. In T. Dwyer, C. Perkins, S. Redmon, & J. Sita (Eds.), *Seeing into screens eye tracking and the moving image* (pp. 215–235). London: Bloomsbury Academic.

Romero-Fresco, P. (2018b). In support of a wide notion of media accessibility: Access to content and access to creation. *Journal of Audiovisual Translation*, 1, 187–204.

Romero-Fresco, P. (2018c). Reception studies in live and pre-recorded subtitles for the deaf and hard of hearing. In E. Di Giovanni & Y. Gambier (Eds.), *Reception studies and audiovisual translation* (pp. 199–223). Amsterdam and Philadelphia: John Benjamins.

Romero-Fresco, P. (2019). Training in Accessible Filmmaking. *Linguistica Antverpiensia, New Series: Themes in Translation Studies*, 14 (Special issue: Media Accessibility Training).

Romero-Fresco, P. (2020). The dubbing effect: An eye-tracking study on how viewers make dubbing work. *Journal of Specialised Translation, Jostrans*, 33.

Romero-Fresco, P., & Fryer, L. (2013). Could audio-described films benefit from audio introductions? an audience response study. *Journal of Visual Impairment and Blindness*, *107*(4).

Romero-Fresco, P., & Fryer, L. (2016). *The reception of automatic surtitles: Viewers' preferences, perception and presence.* Paper presented at the Conference Unlimited: International Symposium on Accessible Live Events on April 29, 2016, Antwerp.

Romero-Fresco, P., & Fryer, L. (2019). *Accessible filmmaking guide.* London.

Rosen, S. (2006). "Night Watch" freaks the BOT; "CSA" score well in New York. *IndieWIRE*. Retrieved from www.indiewire.com/2006/02/night-watch-freaks-the-bot-csa-scores-well-in-new-york-77119/

Ross, M. (2016). *Captain Fantastic.* Electric City Entertainment.

Rowe, T. L. (1960). The English dubbing text. *Babel*, 6, 116–120.

Ruoff, J. (1994). On the trail of the native's point of view. CVA *Newsletter* (pp. 15–18). Retrieved from www.dartmouth.edu/~jruoff/Articles/CVANewsletter.htm

Salt, B. (2002). *How they cut dialogue scenes: Cinemetrics.* Retrieved from www.cinemetrics.lv/dev/cutdial.php

Salt, B. (2009). *Film style and technology: History and analysis.* London: Starword.

Sánchez Mompeán, S. (2017). *The rendition of English intonation in Spanish dubbing: La naturalidad de la entonación en doblaje y su traducción del inglés al castellano.* Unpublished PhD thesis, Universidad de Murcia, Spain.

Santacreu, M. (2015). *Common threads.* University of Roehampton.

Sante, L. (2001). *Mystery man.* In L. Hertzberg (Ed.), *Jim Jarmusch: Interviews.* University Press of Mississippi.

Sanz Ortega, E. (2015). *Beyond monolingualism: A descriptive and multimodal methodology for the dubbing of polyglot films.* Unpublished PhD thesis, University of Edinburgh, UK.

Savage, R. (2016). *Dawn of the deaf.* Cox, Douglas.

Sayles, J. (1996). *Lone Star.* Castle Rock Entertainment.

Sayles, J. (1997). *Men with Guns.* Sony Pictures Classics.

Scorsese, M. (2002). *Gangs of New York.* Miramax.

Scorsese, M. (2016). *Silence.* United States: Paramount Pictures.

Scott, T. (2004). *Man on Fire.* 20th Century Fox.

Secrest, J. M. (1947). Personalities in type designs. *Printers Ink, 218*, 52–53.

Senju, A., & Hasegawa, T. (2005). Direct gaze captures visuospatial attention. *Visual Cognition, 12*(1), 127–144. https://doi.org/10.1080/13506280444000157

Senju, A., Hasegawa, T., & Tojo, Y. (2005). Does perceived direct gaze boost detection in adults and children with and without autism? The stare-in-the-crowd effect revisited. *Visual Cognition, 12*, 1474–1496.

Serban, A. (2012). Translation as alchemy: The aesthetics of multilingualism in film. *MonTI*, 39–63. https://doi.org/http://dx.doi.org/10.6035/MonTI.2012.4.2

Shochat, E., & Stam, R. (1985). The cinema after babel: Language, difference, power. *Screen, 26*, 35–58. https://doi.org/10.1093/screen/26.3-4.35

Shook, F., Larson, J., & DeTarsio, J. (2000). *Television field production and reporting.* Amsterdam: Focal Press.

Shukla, A. (2018). *Font psychology: New research & practical insights.* Retrieved October 15, 2018, from https://cognitiontoday.com/2018/05/font-psychology-research-and-application/

Silverman, K., Beckman, M., Pitrelli, J., Ostendorf, M., Wightman, C., Price, P., Pierrehumbert, J., & Hirschberg, J. (1992). "TOBI: a standard for labeling English prosody", *ICSLP-1992*, 867–870.

Simón, C. (2017). *Estiu 1993.* Spain: Delpierre, Valérie.

Simon, D. (2002). *The wire*. HBO Enterprises.

Simons, D. J. (2007). Inattentional blindness. *Scholarpedia, 2*, 3244.

Simonton, K. (2011). Cinematic creativity and production budgets: Does money make the movie? *Journal of Creative Behaviour, 39*, 1–15.

Singer, E. (2016). Movie accent expert breaks down 32 actors' accents | WIRED. *Wired*. Retrieved from www.youtube.com/watch?v=NvDvESEXcgE

Sinha, A. (2004). *The use and abuse of subtitles*. In A. Egoyan & I. Balfour (Eds.), *Subtitles: On the foreignness of film* (pp. 172–190). Cambridge, MA: The MIT Press.

Sissako, A. (2006). *Bamako*. Mali, France, Artificial Eye, New Yorker Films.

Slaghuis, W. L., & Thompson, A. K. (2003). The effect of peripheral visual motion on focal contrast sensitivity in positive- and negative-symptom schizophrenia. *Neuropsychologia, 4*, 968–980.

Smith, E., Duede, S., Hanrahan, S., Davis, T., House, P., & Greger, B. (2013). Seeing is believing: Neural representations of visual stimuli in human auditory cortex correlate with illusory auditory perceptions. *PLoS One, 8*(9), e73148.

Smith, T. J. (2013). *Watching you watch movies: Using eye tracking to inform cognitive film theory*. In A. P. Shimamura (Ed.), *Psychocinematics: Exploring cognition at the movies* (pp. 165–191). New York, NY: Oxford University Press.

Smith, T. J. (2015). Read, watch, listen: A commentary on eye tracking and moving images. *Refractory: A Journal of Entertainment Media*. Retrieved from http://refractory. unimelb.edu.au/2015/02/07/smith/

Smith, T. J., Batten, J., & Bedford, R. (2014). Implicit detection of asynchronous audio-visual speech by eye movements. *Journal of Vision, 14*, 440–440.

Smith, T. J., & Henderson, J. M. (2008). Edit blindness: The relationship between attention and global change blindness in dynamic scenes. *Journal of Eye Movement Research, 2*, 1–17.

Smith, T. J., & Mital, P. K. (2011). Watching the world go by: Attentional prioritization of social motion during dynamic scene viewing. *Journal of Vision, 11*, 478.

Smith, T. J., & Mital, P. K. (2013). Attentional synchrony and the infl uence of viewing task on gaze behaviour in static and dynamic scenes. *Journal of Vision, 13*, 16.

Snyder, Z. (2013). *Man of steel*. Warner Bros. Pictures.

Spiekermann, E., & Ginger, E. M. (1993). *Stop stealing sheep and find out how type works*. Mountain View, CA: Adobe.

Spielberg, S. (2005). *Munich*. Universal Pictures.

Spiteri Miggiani, G. (2019). Dialogue Writing for Dubbing. *An Insider's Perspective*. London: Palgrave MacMillan.

Stanton, A. (2008). *Wall-E*. Walt Disney Studios.

Stephanidis, C. (2001). Adaptive techniques for Universal Access. *User Modeling and User-Adapted Interaction, 11*, 159–179. https://doi.org/10.1023/A:1011144232235

Stöhr, H. (2005). *One day in Europe*. Hoerner, Sigrid.

Stone, C. (2009). *Toward a deaf translation norm*. Washington, DC: Gallaudet University Press.

Strause, G., & Strause, C. (2007). *Aliens vs. Predator: Requiem*. 20th Century Fox.

Sutherland, A. (2008). Disability arts chronology: 1977–2003. *Disability Arts Online*.

Szarkowska, A. (2013). Auteur description: From the director's creative vision to audio description. *Journal of Visual Impairment & Blindness, 107*(5), 383–387.

Szarkowska, A. (2016). Subtitle presentation times and line breaks in interlingual subtitling. In *Paper presented at 2016 languages and the media conference*. Berlin. Retrieved from www.slideshare.net/agnieszkaszarkowska/subtitle-presentation-times-and-line-breaks-in-interlingual-subtitling

Tarantino, Q. (1992). *Reservoir dogs.* Miramax Films.

Tarantino, Q. (2004). *Kill bill: Volume 2.* Miramax.

Tarantino, Q. (2009). *Inglourious basterds.* The Weinstein Company.

Terni, A. (2018). *Mirador.* Amplitud, Halo.

Thomas Anderson, P. (2007). *There Will Be Blood.* Paramount Vantage.

Topolsky, J. (2011). *Matias Duarte on the philosophy of Android, and an in-depth look at ice cream sandwich.* Retrieved October 15, 2018, from www.theverge.com/2011/10/18/exclusive-matias-duarte-ice-cream-sandwich-galaxy-nexus

Traynor, R. (2011). *The incidence of hearing loss around the world. Hearing, health and technology matters.* Retrieved from http://hearinghealthmatters.org/hearinginternational/2011/incidence-of-hearing-loss-around-the-world/

Treuting, J. (2006). Eye tracking and cinema: A study of film theory and visual perception. *Society of Motion Picture and Television Engineers, 115,* 31–40.

Trinh, T. M-H. (1992). *Framer framed.* New York, NY: Routledge.

Truffaut, F. (1966). *Hitchcock.* New York, NY: Simon & Schuster.

Udo, J. P., & Fels, D. I. (2009). The rogue poster-children of universal design: Closed captioning and audio description. *Journal of Engineering Design,* 1–15. https://doi.org/10.1080/09544820903310691

Unkrich, L. (2010). *Toy story 3.* Walt Disney Studios.

Van Dam, D. (2013). *De weg van alle vlees.* Belgium: Van Dam, Deben and Vandendaele, Ben.

Vasey, R. (1997). *The world according to hollywood. 1918–1939.* Wisconsin: University of Wisconsin Press.

Vilaro, A., & Smith, T. J. (2011). *Subtitle reading effects on visual and verbal information processing in films.* Published abstract In Perception. ECVP abstract supplement, *40,* 153. European conference on visual perception, Toulousse, France.

Villeneuve, D. (2016). *Arrival.* Paramount Pictures.

Vinay, J-P., & Darbelnet, J. (1995). *Comparative stylistics of French and English: A methodology for translation (Google eBook)* (p. 359). Amsterdam and Philadelphia: John Benjamins. Retrieved from http://books.google.com/books?id=wxad_pxSWs0C&pgis=1

Vincendeau, G. (1988). Hollywood babel: The multiple language version. *Screen.* https://doi.org/10.1093/screen/29.2.24

Vincendeau, G. (1999). Hollywood babel: The coming of sound and the multiple-language version. In *"Film Europe" and "Film America": Cinema, commerce and cultural exchange 1920–1939* (pp. 207–225). Exeter: University of Exeter Press.

Vit, A. (2005). *Subtítulos en acción (Subtitles in action). Speak up.* Retrieved from www.underconsideration.com/speakup/archives/002231.html

Võ, M. L. H., Smith, T. J., Mital, P. K., & Henderson, J. M. (2012). Do the eyes really have it? Dynamic allocation of attention when viewing moving faces. *Journal of Vision, 12.*

Walczak, A., & Fryer, L. (2017). Creative description: The impact of audio description style on presence in visually impaired audiences. *British Journal of Visual Impairment, 35*(1), 6–17.

Wästlund, E., Shams, P., & Otterbring, T. (2017). Unsold is unseen . . . or is it? Examining the role of peripheral vision in the consumer choice process using eye-tracking methodology. *Appetite, 120,* 49–56.

Wenders, W. & Ribeiro Salgado, J. (2014). *The Salt of the Earth.* Decia Films.

Whitman-Linsen, C. (1992). *Through the dubbing glass: The synchronization of American motion pictures into German, French and Spanish*. Frankfurt am Main: Peter Lang.

Whittaker, T. (2016). Woody's Spanish "double": Vocal performance, ventriloquism and the sound of dubbing. In T. Whittaker & S. Wright (Eds.), *Locating the voice in film: Critical approaches and global practices* (pp. 119–136). Oxford: Oxford University Press.

WHO. (2018). *Prevention of blindness and deafness – Estimates*. World Health Organization Website. Retrieved from www.who.int/pbd/deafness/estimates/en/

Wissmath, B., Weibel, D., & Groner, R. (2009). Dubbing or Subtitling? Effects on Spatial Presence, Transportation, Flow, and Enjoyment. *Journal of Media Psychology, 1*, 114–125. https://doi.org/10.1027/1864-1105.21.3.114

Witt, A. (2004). *Resident evil: Apocalypse*. Screen Gems.

Yarbus, A. L. (1967). *Eye movements and vision*. New York, NY: Plenum Press.

Zabalbeascoa, P. (1993). *Developing translation studies to better account for audiovisual texts and other new forms of text production*. Unpublished PhD thesis, Universidad de Lleida, Spain.

Zabalbeascoa Terran, P., & Corrius, M. (2014). How Spanish in an American film is rendered in translation: Dubbing butch cassidy and the sundance kid in Spain. *Perspectives: Studies in Translatology2, 22*, 255–270.

Zachrisson, B. (1965). *Studies in the legibility of printed text*. Stockholm: Almqvist & Wiksell.

Zanotti, S. (2018a). Auteur dubbing: Translation, performance and authorial control in the dubbed versions of Stanley Kubrick's films. In I. Ranzato & S. Zanotti (Eds.), *Reassessing dubbing: The past is present*. Amsterdam and Philadelphia: John Benjamins.

Zanotti, S. (2018b). Investigating the genesis of translated films: A view from the Stanley Kubrick Archive. *Perspectives*, 1–17. https://doi.org/10.1080/0907676X.2018.1490784

Zdenek, S. (2015). *Reading sounds: Closed-captioned media and popular culture*. Chicago: University of Chicago Press. Retrieved from http://readingsounds.net/

Zeitlin, B. (2012). *Beasts of the Southern wild*. Fox Searchlight Pictures.

Zhang, J. (2012). The interaction between visual and written ethnography in subtitling. *Visual Anthropology*. https://doi.org/10.1080/08949468.2012.720200

Zillmann, D. (1994). Mechanisms of emotional involvement with drama. *Poetics, 23*, 33–51.

Index

Note: Page numbers in *italics* indicate a figure and page numbers in **bold** indicate a table on the corresponding page.